UVA'S BASIC GRIP BOOK

Uva's Basic Grip Book

Michael G. Uva and Sabrina Uva

Focal Press
An Imprint of Elsevier
Boston Oxford Auckland Johannesburg Melbourne New Delhi

Focal Press is an imprint of Elsevier.

Permissions may be sought directly from Elsevier's Science and Technology Rights Department in Oxford, UK. Phone: (44) 1865 843830, Fax: (44) 1865 853333, e-mail: permissions@elsevier.co.uk. You may also complete your request on-line via the Elsevier homepage: http://www.elsevier.com by selecting "Customer Support" and then "Obtaining Permissions".

 Recognizing the importance of preserving what has been written, Butterworth–Heinemann prints its books on acid-free paper whenever possible.

Library of Congress Cataloging-in-Publication Data
Uva, Michael.
 Uva's basic grip book / Michael G. Uva and Sabrina Uva.
 p. cm.
 Includes index.
 ISBN 0-240-80485-6 (pbk. : alk. paper)
 1. Cinematography—Handbooks, manuals, etc. 2. Grips (Persons)—Handbooks, manuals, etc. I. Title: Basic grip book. II. Uva, Sabrina. III. Title.
 TR850 .U93 2001

 778.5'3—dc21

 2001033508

British Library Cataloguing-in-Publication Data
A catalogue record for this book is available from the British Library.

The publisher offers special discounts on bulk orders of this book.
For information, please contact:
Manager of Special Sales
Butterworth–Heinemann
225 Wildwood Avenue
Woburn, MA 01801-2041
Tel: 781-904-2500
Fax: 781-904-2620

For information on all Focal Press publications available, contact our
World Wide Web home page at: http://www.focalpress.com

10 9 8 7 6 5 4 3 2

Printed in the United States of America

This book is dedicated to my wife, Sabrina. She has always put up with, and still puts up with, the long hours, the trips out of town, and all the meetings. She is my rock. I love you, Sabrina.

This series of books is also dedicated to all the "newbies" who want to "learn it all," to all the great production people who work so hard that they can't possibly "know it all," and last but not least, to the old salts who "invented it all." Thank you, "one and all."

—MIKE!

Contents

Contributing Companies

Manufacturers or Suppliers

American Studio Equipment
8468 Kewen Ave.
Sun Valley, CA 93152
(818) 768-8922
Fax (818) 768-0564

Anytime–Hollywood
755 N. Lillian Way
Hollywood, CA 90038
(323) 461-8483
Fax (323) 461-2338

Backstage Equipment, Inc.
8052 Lankershim Blvd.
North Hollywood, CA 91650
(800) 69-carts, (818) 504-6026
Fax (818) 504-6180
backstaged@aol.com
www.backstageweb.com
Attn: Cary Griffith

Bullet Grip
11717 Seminole Circle
Northridge, CA 91326
(818) 832-8707
Fax (818) 832-8807

Cardellini Products
22 Council Crest Drive
Corte Madera, CA 94925
(415) 924- 0294
Fax (415) 924-5833
cardellini@mindspring.com
www.cardelliniclamp.com

Chapman/Leonard Studio Equipment
12950 Raymer St.
North Hollywood, CA 91605
(888) 883-6559
Fax (888) 502-7263
www.chapman-leonard.com

Matthews Studio Equipment
2405 Empire Ave.
Burbank, CA 91504
(800) CE-STAND, (818) 843-6715
Fax (213) 849-1525
info@msegrip.com
www.msegrip.com

Modern Studio Equipment
7428 Bellaire Ave.
North Hollywood, CA 91605
(818) 764-8574
Fax (818) 764-2958

Ragtime Rentals, Inc.
755 N. Lillian Way
Hollywood, CA 90038
(323) 769-0650
Fax (323) 461-8065

UCLA Extension Entertainment Studios
10995 Le Conte Ave., Room 437
Los Angeles, CA 90024
(800) 825-9064, (310) 825-9064
Fax (310) 206-7435
espa@uclaextension.com
www.eclaextension.org/espa

VER Sales, Inc.
2509 N. Naomi Street
Burbank, CA 91504
(818) 567-3000
Fax (818) 567-3018

Illustrations

Christi Friesen
P.O. Box 1671
Tehachapi, CA 93581
(661) 822-6999

With added illustrations by:
Brady Mc Elroy (key grip local #80)
17953 River Circle
Canyon Country, CA 91351
(661) 298-2902

Letter from the Author

Hi, and thank you in advance for buying my book. I am trying with all my books to accomplish two things that I learned from the author Zig Zigler: "If you help enough people get what they want, you'll get what you want." I want to help as many folks who want to get into the film industry as I can. I absolutely love my jobs. Yes, I did say jobs. Because of my career in the film business as a grip, I have to be able to explore my other passions as well. I love to write, and I love to train students at my seminars. In this newly revised grip book, I have added some more need-to-know basic grip equipment. I have also learned from my many students and the folks that I have met that I should also include some basics about tools. So as you thumb through the new and improved *Uva's Basic Grip Book*, I'm sure there will be some things that you may already know. Good for you. But there are also many other people out there waiting for a chance to learn. I will quickly introduce what I feel is "need-to-know material." So sit down and peruse the book.

Thanks again,
Michael G. and Sabrina C. Uva

About the Author

Michael Uva is a highly motivated self-starter. He created one of Hollywood's largest privately owned fleets of rental trucks for grip equipment in just a few years and then sold it off. He learned his business strictly through on-the-job experience, having never attended any formal motion picture or cinema-related schools or classes.

When Michael began his career as a grip, no specialty books related to his craft were available. After several years of learning his craft from other key grips and grips, Michael wrote the first edition of this book to share his knowledge. That edition proved very useful to new and experienced grips alike, so Michael wrote a second edition. He also teaches at the University of California at Los Angeles on occasion. Michael's goal in writing this book is to help new students, other grips, and production members by providing a firsthand, fingertip reference guide to the grip equipment used in the industry.

Acknowledgments

I would like to take a few moments of your time and bore you with a bunch of names of the people that I want to thank. The only reason you should read this section is because if and when you do make it to HOLLYWOOD, these are the types of people you want to work with. These people are some of the best grips and other personnel still working in the business, and they have helped me on a relatively routine basis:

First and foremost is Doug Wood, key grip, I.A., Local 80. Doug gave me that first proverbial break in the business of making movies. This guy was not only a giant of a man in stature (his nickname's King Kong), but he was also probably one of the best, if not *the* best, dolly-grips you would ever see. (I looked up the word smooth in the dictionary and next to it was his picture.) All kidding aside, he was one of the best. I loved him like a brother. (Doug is now with the Lord).

Next on my list is Gary Welsh, key grip, I.A., Local 80. Doug Wood taught me the trade of the business; Gary taught me the business of the business. I have nothing but respect and admiration for this guy.

Then there is John Stabile, key grip, I.A., Local 80. This kid, as I call him, is one of Hollywood's youngest (looking, at least) and hottest key grips around. This guy looks eighteen years old, but has the knowledge and experience of a forty-eight-year-old. My humble hat is off to you, John.

These guys are only a few of what I consider to be the GREATS of the business. Look them up yourself when you hit Hollywood.

There are so many good grips whom I have worked with as well, but if I list them all, this book would really be boring and the only people who would read it would be those listed here. (There is no shortage of ego in this industry.) Perhaps that is why there are so many greats! Well, before I get on with the show, I really must say a special thanks to someone who has been my sidekick and is a cofounder of UVA'S Grip Truck Service, Mr. Jose A. Santiago.

I met Jose twenty-one years ago when I was just breaking into the industry. He was sweeping floors at the place I was working part-time. He had come to the continental United States from the Virgin Islands only three years earlier. At that time, Jose only spoke broken English, but he had, and still has, FLAIR. He swept the floor with a smile, cleaned toilets, whatever was required of his job. He showed me then, as he continues to do so now, that he could do any job assigned to him. Dirty or glamorous, you just need to show him how to do the job and allow him the chance to prove himself. After only eight years, he was driving a Delorian, had bought his second home with a pool, and was helping buy his mother a house in the Virgin Islands where she still lives. Jose is now one of Hollywood's most sought after key grips. Just another success story, I guess, but one we are both living.

Good luck to all of you who venture down this road. I would love to hear from one of my readers who has gotten the breaks and is making the big bucks.

Introduction

What This Book Is About

This book is designed to teach you about the basic equipment you will need and use on a daily basis. I will also lightly touch on some stage terms, tricks of the trade, and procedures. With this book, perseverance (and I mean LOTS of perseverance), and just plain old hard work, you can become a successful grip. I challenge you to do it. But let me get off my soapbox and get back to teaching you how to become a grip. I am writing this book based on my experience and the experiences of other grips with whom I have worked. There is a saying among grips that there are ten ways to do the very same job—and usually they all work. This book will help you to learn most of the names and ways to use basic grip equipment! (Every so often I will throw in the nickname of a piece of equipment.)

About the Equipment

In my series of books I have selected a cross-section of only the most professional equipment. I have not by any means listed all the super equipment available. First off, such a book would be too costly to produce, and secondly, I just want you to get the "feel" of what tools are available. I recommend that you go to any and all technical trade shows concerning the film/TV industry. You have no doubt seen the advent and widespread use of computers, with each one getting better, faster, and more readily available. Well, the TV/film industry has also grown in leaps and bounds. There are several fantastic remote control film and TV heads (fluid, remote, and geared heads). There are many new cranes and dollies, new and improved grip equipment, as well as redefined methods of gripping. I will try to cover a little of each to let you, the reader, know what's available out there.

If I don't show you a piece of equipment, I hope I have explained it in the glossary. Once again, this book is not the end-all of books; it's a thrust in a forward direction. I hope you gain enough knowledge from this book to justify its cost. If you learn one thing and use it to improve your skills, others will notice, and it might get you called back. That's one of the many things I have aimed for.

Tricks of the Trade—T.O.T.

I will use the acronym T.O.T. for all the Tricks of the Trade I'll be passing along to you. T.O.T. seems very appropriate because, as I like to think, a child (you

know, a tot) could remember most of these little tricks. You may have heard that old saying, "It's the little things that mean a lot." Well that certainly holds true in this business. Besides, these tricks will separate the men from the boys—and the women from the girls. ("Gosh, I just love this stuff.")

You will find T.O.T.s sprinkled throughout this book.

T.O.T.

Your attitude is of major importance in this business. I have hired one person over another even if the person I hired was a little less qualified. Why? Attitude! I need, and the film industry needs, people who can work hard and sometimes long hours, under really tough conditions. I am not saying you have to be a saint, but if you don't like it when it gets tough, let somebody else do it for you—and they will reap the rewards for their hard labor.

Getting Started

So you want to get into the movies. Well, so did I. Now I am in, and you can get in too. It doesn't take a college education (but it helps), and not even a high school diploma (but who the heck wants to walk around without one—not any grip I know). If you are halfway intelligent and can count to at least seven (7) two out of three times, I believe you can learn about the basic tools of gripping.

Let me begin by promising you the same thing I promise all of my students: nothing. You don't need someone to tell you that you will get rich, be famous, and live happily ever after if you buy this book. But if you like traveling and working with a group of highly skilled technicians, actors and actresses, directors and producers, this is the job you should try and pursue. I don't want to say it's the greatest job, but to give you an idea of how good it can be, I started writing the first edition of this book while I was on location in New Orleans—sitting in a room on the fifteenth floor of a luxury hotel, overlooking the Mississippi River.

When people ask what my job is like, my answer is very unconventional: it's almost pure freedom, like a singer singing a song. Singers must know all the words, but they put their own style and twist to it. For example, I must sometimes mount a $250,000 camera on a $100,000 car, but how I do it is my challenge. As a grip, you are kind of like an on-set designer, engineer, and administrator/worker, all rolled into one person. You are needed! You're one major support system. It is a great job. Give your all to whatever you do, and the future will develop itself. Trust me on this.

First and foremost, start by figuring out just what job you *think* you may want to do in the film industry. I use the word *think* because you may find that after you have reached that coveted position, it is not as fulfilling as you thought it might, would, or should have been—but that's another story. For now, let's assume you are absolutely, positively sure beyond a shadow of a doubt that you have made the right career decision. Good, let's get started.

Since gripping is the subject you have chosen, let me tell you what a grip is. A grip is the person who, as we grips like to think, solves other people's problems. A cameraperson might turn to a grip and say, "I'd like to rig a camera on top of a car, or on top of a mountain, or off the side of a building." As grips we're the guys and gals who have to figure out how to rig it safely and as quickly as possible because of the tight shooting schedules we usually have to work with.

Grips come in assorted sizes and colors. There are a lot of big, macho-type grips. You'll recognize them right off. They're the guys with the heavy moustaches who usually walk like small apes, including myself, of course. Several grips also come in the form of women. Gripping doesn't really take a lot of body strength, although it does require a lot of mental strength to outthink the object you're working on.

Let me illustrate. When I am asked, as I often am—Just what *is* a grip?—I like to tell to tell this story. First, imagine that you're in your home, say, in the early 1960s, at Christmas time. Uncle Milton suddenly runs into the room as the family is about to open the gifts, which have been lovingly placed around the tree by Mom. Well, good old Uncle Milty does not want to miss a single moment, so out comes the new 8 mm camera. He wants to save this special moment for all posterity. He flips on the switch, and a huge blinding light from the twin lamps on the camera is now burning the retinas out of everyone's eyeballs. Everyone in the room, almost in unison, raises a hand to cover what's left of their vision. Tight-lipped smiles quickly emerge (which say, "You're blinding me with that stupid light!"), and everyone gives a quick wave (which says, "OK! Enough already. Film the next person"). The twins, seeing this great fun, jump to their feet and dance a jig for their now "most favorite Uncle." Yes, they are on film. Their overlit, bright faces smile joyfully, while their harsh, heavy dark shadows dance like huge monsters on the rear wall, aping their every move. Aunt May (Milty's wife of 30 years) fans herself to relieve the tremendous heat from the camera lamps. Ah! The joys of home movies.

We have all seen this type of home film. Professional movie making could be very much the same; although it would cost a whole lot more, it could be just as boring. Now enters the grip department. We are the folks who place different materials in front of those huge light sources to make them a bit more flattering, or softer, or even colder looking. We have a million different tricks up our sleeve (OK, not really a million but a bunch).

Grips usually do not decide what material to put in front of a light; that is usually the cameraperson's job, along with the gaffer's (you'll learn what a gaffer does in a minute). But we can, on many occasions suggest something that will work for the shot. (Believe me, folks, it *is* a team effort.) Besides the soft materials in front of the lamp, we may also use a flag and cutter (I will explain later), or maybe a net to change the texture or the intensity of the lamp.

A grip is like an expert handyman—kind of the jack-of-all-trades—and, we like to think, a master of all as well. Most grips usually find they can do just about anything, but after a few years in the business you'll find that you begin to specialize. For example, you may become a *dolly grip*. (I'll teach you about dollies later.) The dolly grip does all the pushing and wheeling. Then there's the *rigging grip*, who

mounts cameras and lights anywhere they're needed, which is my forte. I like this aspect best—so much so that I wrote a book about it, *Uva's Rigging Guide for Studio and Location.* And then there's just the everyday grip, who does, you guessed it, just about everything. In this book we're going to be focusing on the basic tools of gripping.

As a grip, you will be working with the *gaffer.* This is the person who's in charge of the lighting. You'll also work with the *director of photography,* usually called the DP. The DP is the person who may tell us what light goes where, or who just tells the gaffer what sort of light mood he or she would like to see, for example, if it's a night scene, a day scene, it's raining, and so forth. Basically the DP tells the gaffer what he or she wants, and then the gaffer has the *electricians*, who work with him or her, go out and set up the lights where needed. You'll also work with a host of other technicians, sound people, makeup artists, and so forth, and you'll learn something about their specialties as you go along.

To be a grip, you must believe in yourself and be prepared to work long hours—and sometimes under not-so-Hollywood-glamorous conditions. It is not an easy task to become a film technician. You must have determination—and you must learn the equipment. If you know what a piece of equipment looks like by name and can be fast to retrieve it when called for, then you're well on your way to being a good grip.

A Little Grip History

Before I tell you more about what a grip is, let me tell you how the word *grip* came to be. Legend (and there are many of them in this industry) has it that in the heyday (another word for the beginning) of film, the basic film crews consisted of a director, a cameraperson, a few assistants, and workers. The workers set up all the equipment, lights, cable, stands, and so forth, so they were like the handymen on the set.

The worker/handyman carried his tools in all sorts of containers, such as a tool tray, a box, or a carpet bag (sort of like a doctor's bag, only larger). The bag that contained the tools of the handyman's trade was called a *grip bag.* (Starting to get the picture? Get it, the picture?) Over time, these workers developed their special talents. Some developed skills in building or rigging things. The unspecialized workers eventually separated into specialty groups: electricians did all the wiring and lighting, and the worker with the tools grabbed their tool or grip bags and built or rigged whatever was needed.

The modern-day grip is still the physical backbone of the industry. Trust me, all the other departments bust their butts, too, but it always seems like the grips are lifting or carrying something. They're sort of handy people to have around. The standing joke among grips is, "We fix other people's problems."

There is a cameraman I sometimes work for who has given me what I consider the best description of a grip: an intelligent muscle. This doesn't mean you have to be six foot six, weigh 280 pounds, and be built like a football player. Heck, I'm only five six. What it does mean is that you are smart enough to move a mountain if need be, because you know who to call to get the job done, quickly and safely.

The Grip Department

In the Grip Department there are the following positions:

Key Grip (Boss)
Best Boy Grip (could also be a Best Girl Grip)
Grips

Key Grip

The key grip is the head guy, the big cheese, the main man, the *bwana*, the keeper of the keys, the master who knows it all (and that's just what he thinks of himself; you should see what the rest of the crew thinks of him). His or her job is to gather a crew consisting of a best boy (second grip) and as many grips as needed to get the job done. If there are any preplanning meetings before the scheduled shooting day, the key grip will attend these.

WHAT A KEY GRIP MIGHT DO ON A SCOUT

1. Check which dolly the director of photography likes to use.
2. Determine how many feet of straight track will be needed.
3. Determine how much curve track and what diameter will be needed.
4. Decide what accessories will be used with the dolly.
5. Make sure that the equipment truck will be able to travel or fit into where you're shooting, and check for low branches and wires.
6. Make sure the equipment trucks can pass over all bridges (no weight restrictions).

 NOTE: Most equipment trucks are usually not higher than 12 ft. 6 in., and most wires are not lower than 13 ft. 6in. But this is not written in stone: "MEASURE IT SAFELY."

7. Have a compass. (Use to check for sunrise shots.)
8. Bring a 100 ft. and a 30 ft. tape measure.
9. Ask if a crane or remote head will be needed.
10. Determine if you will need special equipment, such as cherry pickers (how high), scissor lifts (how high and wide), or a mule (a four-wheel drive truck for the beach or rough terrain).
11. If there will be exterior shots on lawns or in parks, ask if there are any sprinkler systems and if they are on a timer.
12. Determine how much grip equipment you will need, then allow about 5% more for things such as apple boxes and sandbags. Since other departments sometimes do not think to order what they will need, you are covering for them as well.
13. Speak with the Director of Photography and the Director to find out what shots they may want.
14. Ask what kinds of light diffusion they like to use in front of which lights (216, 251, 250, 1,000 H, and so on).

NOTE: I recommend that you have the production company rent a package of equipment that carries expendables (foamcore, show cards, gels, and hardware) on an "AS USED" basis. This way production will only pay for what has been used.

15. Get the addresses of the location as well as the phone number. Also get the location contact's name and phone number in case of an emergency

The key grip will also have to determine what additional special support equipment (extra dollies, cranes, mounts, etc.) will be needed, if any, from this location scout meeting. After the location scout, the key grip will determine the production's needs. At that time, he or she will determine if any additional special support equipment (a second four-wheel drive truck, or a couple of snow mobiles, boats, etc.) are needed for this particular terrain in order to get the company's film equipment to a certain spot.

Once on location, the key grip works with the gaffer (head electrician) and starts directing what grip equipment goes where. While all this work is in progress, the key grip will begin to plan what will be needed for the next series of shots. He or she will anticipate this from years of experience, along with what has been derived from meetings with the producer, director, and cinematographer during preproduction.

Best Boy Grip

The best boy is an extremely important position in the grip department. He (or she) is the direct link between the key grip and the other grips. The best boy is like a foreman on any job. The key grip tells the best boy grip what she wants, and where and why. The best boy grip directs each grip, giving an assigned task to complete and instructions on when to report back upon completion of the task.

The best boy grip will also be in charge of all the grip equipment and expendables (tape, gels, nails, etc.) on the grip truck. He inventories the equipment, both as it leaves the truck and as it returns, ensuring that the company does not run out of expendables in the middle of a shoot. The best boy grip also provides a status report to the key grip on the work in progress, along with an honest estimate of how long each job will take to complete. He must be accurate within three to five minutes (time is money in this industry).

Grips

Grips are the workhorses of the industry. This is not to imply that the rest of the technicians don't work hard; they do. It is just that grips tend to do the dirty work, along with their electrical brothers and sisters.

Grips usually do most of the rigging of light support equipment (securing the lights in place). They mount the cameras in every imaginable place under the sun (and moon), and they are responsible for the safety of all the equipment they rig. When a stunt coordinator asks the grip department to help build a ramp or a safety stop—we're talking about a person's life or limbs here!—the stunt department, as well as the film industry, places its trust in the grips' ability to do it right.

Always Be Prepared

Since grips are Mr. and Ms. Fix-its on most sets, be prepared to help everyone. I always carry a 15-foot heavy-duty pair of jumper cables. I also have a car battery terminal cleaning brush. Trust me on this; you will use them often. I have a wire hanger in my tool box in my truck to retrieve keys left in ignitions. You can also get yourself a Slim Jim at a local flea market, swap meet, or open-air market. (Make sure they are legal in your state.) You can also carry a one-gallon "empty" gas can along with a hand siphon pump. You can get these at any good auto supply store. People really do notice this extra preparedness. You can also carry a tow strap to pull folks' cars out of ditches. You're not "kissing butt" by doing these things; you're helping others—and everyone likes dependable people. It has gotten me more than a few callbacks, I'm sure. (But don't get me wrong—I'm not telling you to tune-up and wash their automobiles!) I hope you as a grip are sometimes considered the answer to the question of the moment. Many grips are, and that's why you hear this so often on the set: "I don't know, ask a grip."

A Typical Day for a Grip

For a grip, a typical day on a film or TV set sort of goes like this:

Call Time

A lot of folks have feelings about the time one should be ready to work on the movie set. Some say that if the call time is set at 7:00 A.M. for example, this is the time to "begin" your work. With this statement I fully agree! If the call time is in fact at 7:00 A.M., this means to me that you have arrived at the set's location, parked your car (if necessary), put your tool belt on your hip, and are ready to swing your hammer *at* 7:00 A.M. This is my personal philosophy. I will tell you the same thing that I have told the *newbies* (new personnel just starting out) for years: "If you arrive early, you're on time; if you arrive on time, you're late; if you're late, you're fired!" I know in this politically correct world this won't happen, but recognize this: I do not have to call you back for the next job.

I am not trying to be a hard-nosed, intolerant key position person with a huge ego. I am just hoping that you get my thoughts on the matter. There are many, many people who would give their eyeteeth for a chance to be in this business. I want you to stay. (I really would not fire you.)

So getting back to this time-of-day stuff, you are supposed to be ready to start work on the set at the call time; the call time is *not* the time to "show up." Most production companies will "usually" have a self-serve sort of breakfast, either hot or maybe just donuts ("grip steaks") and coffee. This meal is usually served a half hour prior to call time. Remember, call time is "having had" breakfast, ready to work.

The key personnel for each department will usually have done their homework, which means they've already discussed what will be (should be) accomplished that day. The key grip will gather his or her personnel and explain what the

day's work will be. Then each grip will be assigned his task. Be ready to work, with both your tool belt as well as your radio on.

T.O.T.
Never enter a stage if there is a RED light flashing. This means they are rolling film.

Setting up a Shoot

Your first time on a stage will be something like this, or close enough for you to look like you know your way around. A makeshift movie set has been built by the construction set-building crew in a studio or soundstage. When you walk in, you will notice that above the set is a series of walkways that are built close to the ceiling. There will be a set or two of stairs mounted on the side walls of the stage leading up to these raised walkways. These walkways are permanently built into the stage, so they are called *perms* (short for permanent walkways or catwalks). The perms usually range from around 25 to 100 feet above the ground, and they are spread about 25 to 35 feet from each other, crisscrossing the entire stage. The perms are used for lights that are hung from its system of rafters and trusses, which supports the roof of most stages. From these perms we will also mount items such as rags and set walls, which are usually supported by rope or sometimes cable.

The grips will now build a second set of catwalks or portable walkways that hang by chains underneath the perms and over the newly erected set. These temporary walkways are called *green beds* because they are usually painted green. They hang above the set wall height and along the entire edge of the set. This portable scaffolding usually consists of walkways that are about 3 feet wide and about 10 feet long, but there are also longer and shorter ones as well as narrower ones about 2 feet wide. The green beds also have a cross catwalk.

All the walkways are guarded by safety rails. Between the walkways are a series of heavy-duty lumber boards ranging from 2 ft. x 8 ft. and 2 ft. x 12 ft., to 4 ft. x 4 ft. and 4 ft. x 8 ft. The space between the walkways is referred to as "the ozone." You never, no matter what the "old salts" may say, climb onto boards in the ozone area without wearing a full body harness and fall protection strap. The reason that you might have to climb over the safety rail and balance walk the lumber in the ozone would be to install a "stick" or cross from which to hang a lamp or set wall. This is one part of the grip job you do not try to "fake it till you make it." Be honest, and above all be safe.

T.O.T.
Never walk in "the ozone" without a full body harness and fall protection strap. Above all, be safe.

The *greens* (as we call them for short) are used for lighting as well as special effects or whatever items needs to be "flown" or hung just above the set. Since they are usually just about a foot above the set walls, they offer a great vantage area for lighting or effects. The greens are sometimes braced to the top of the set wall as well as from the perms. They are usually accessed from a ladder mounted from the floor to the beds, and they are also accessed from the perms.

Sometimes a *backing* will be flown or hung from the beds. These scenes will be placed behind the set so that they may be filmed as if the movie set were really at a given location. These backings, which are also called *drops* and *translights* (translights are huge slides, as for a projector), are also sometimes flown from the perms. They may even be flown or hung from sailboats (long adjustable poles, raised like a mast on a sailboat, that are welded to a very heavy base on wheels). These drops, backings, or translights will be seen through the windows or doors of an interior set, or behind the edge of a building on an exterior set. They will add depth and dimension to the film.

After all the green beds are built and the backings are hung, the lighting crew will start to add lights. We as grips will work with the electricians and put up any hardware (grip equipment, such as baby plates, set wall brackets, or whatever) that is needed to support the lights. After the lights are secure, safe, tied, and pin-pointed to the proper direction, the grips will add the necessary gels (diffusion or color). The gobos (flags, nets, silks, etc.) will also now be placed by the grips. This process will once again give an added feel of reality to be captured on film or video.

Warehouse Stages

With the rental cost of stages on the rise, a lot of productions are turning to warehouses as stages. This is a very economical way to make a film, yet keep the cost down. This is also where you, as a grip, really have to put in an extra effort. The warehouse stage will probably not have a high enough or strong enough ceiling to support a catwalk or perm system for lighting from above, so you will usually have to build and suspend a pipe grid system from the roof. You must be aware of the strength rating (sometimes referred to as the *snow-load* in cold climates) for the truss supporting the roof. If you suspend too much weight from the rafters, you can and will cause damage.

There is also a problem in the area of tying off ropes, such as for hanging a light. You will have to find a place to nail a wall cleat. Look for wood vertical support beams or wall rings. If there is no place to nail into, you may have to use a large pipe face C-clamp and bite onto a metal vertical support pole. I recommend using a pipe face and cranking (tightening) it down. You don't want anything falling from any slippage. I will usually use two pipe face C-clamps per pole in order to create a safety. If there is not a tie-off available, you can use a huge number of sandbags. Use enough sandbags to ensure that the weight on the other end of the rope will not move. If it is not 100% safe, don't do it.

T.O.T.
If you have to "decide" whether something is safe or not, IT IS NOT. There should NEVER be any doubt about safety. I cannot emphasize this enough.

How It Goes on the Set

The day has now begun. The lights are all set, then some flags, nets, or silks are also adjusted or tweaked. The actors will now come to the set and rehearse, first for themselves, as well as the director, and the director of photography. At that point a director may not like what he or she has seen and may order a complete change of script, a new mood for the scene, and different lighting. This is only one example, but what I am trying to illustrate is that things change.

When things change, and they often do, you may even hear some crew members grumble and say, "Why do we have to move everything again?" The reason is very simple: It's our job! As I always say, "Hey, it's their football, so we play by their rules." Translation: Filmmaking is a "work in progress." That's what makes it an art form. There are many ways to achieve the end goal. We are hired to help. We collaborate with others to make this happen.

Okay, let's say nothing has really got to be moved, just a little more tweaking. There, we are set. The grips will once again come into play during a film take (filming the action). A highly skilled dolly grip will move the camera at the exact times necessary during the filming on a camera dolly (a smart cart of sorts that travels fore, aft, sideways as well as in a circular motion). All the pushing power is supplied by the dolly grip. The dolly grip must also anticipate the actors' moves and knowing the film's dialogue. These cues will prompt certain actions, such as arming (lifting of the center post with hydraulic air pressure) as the cameraperson and camera raise up to a high-angle shot while pushing the dolly so that it will end up in the right spot at a given time. (This is an art form in itself.) There is a huge "team effort" now in play.

T.O.T.
1. All direction references are made from the perspective of what the camera sees.
2. *Camera right* is to the camera's right side if you're looking through the eyepiece.
3. *Camera left* is to the camera's left side if you're looking through the eyepiece.

Meanwhile, an entire additional group of grips and electricians might be "pre-lighting" another set (placing more equipment in place to expedite the next filming to be done), which may be used for shooting later in the day or the next day.

When you're working on a set for the first time, you will hear many terms that you may not know. I will clue you in to some of these throughout this book. Even though they do not directly pertain to the grip department, these terms do pertain to the project or film that you are working on. When you hear these terms, you will know what to do. For example, if the camera assistant calls out, "Hair in the gate!" that translates for the grip department as "Do not move anything." This phrase "hair in the gate" means that there was a small chip of film or debris caught in the corner of the camera gate (also called the pressure plate which holds the film flat as it move through the camera), possibly causing a small scratch. (We have all watched old movies with the white lines moving through it, or with little wiggly things that pass through.) This means we have to reshoot the last take.

If you are working on a set and the director of photography (DP) says, "Drop a double into that lamp," quickly look both ways for an electrician. If no one is close by, drop it in. Then tell the gaffer or the first electrician that a double has been dropped into the light. This will inform the gaffer that the light value has been reduced and insure that they get another light reading before shooting begins.

What to Expect

A lot of times you're in a hurry to get a piece of equipment the boss has called for. You race from the set and run smack dab into several people who seem to be "just standing around." You may find it hard to get to the equipment with a lot of people in the way and return to the set as quickly as you want. Let me tell you right now that this will happen a lot; just "roll with it." If you find this sort of situation to be a big problem, just ask yourself why they are standing there in your way. You have a couple of choices: (1) Beg your way through by saying a Bugs Bunny line like, "Excuse me, pardon me, excuse me," and then on the return trip say politely, "Watch your eyes" (as if that were possible). I personally say, "Knee caps and ankles," when I'm carrying C-stands. People will look down. Or, (2) Don't take up this line of work.

Other obstacles you will find in your way are:

People standing in the only doorway.
People sitting on stairs blocking your access.
People sitting on the ice chest full of cold drinks on a hot day.

What I'm trying to convey is: Don't get mad, and don't get even. Be polite—and get the *callback!*

Pace on the Set

You will also notice that it seems to take a little more time to do things at the beginning of a workday, but as the daylight starts to drop off, you work like crazy. As one director I work for said, "It's like shooting *Gone with the Wind* in the morning and the TV series *Happy Days* in the afternoon."

Words of Advice

What Key Grips Like

I have spoken to several other key grips to research this basic grip book, and almost all of them stated that they wanted a newbie to be a person who is seen and not heard unless asked or there's a safety issue. A lot of key grips will readily take your suggestions, and they may even ask for suggestions, but be sure your timing is good and that you know what you're talking about. Sometimes you may just have to stay quiet until you get your chance. No one likes to be upstaged, including you. I'm not saying you are not to suggest things, but try to phrase it correctly. You might try something like, "Hey boss [key grips love to be called boss], do you think it would work this way?" Every person loves the help now and then, but few like a know-it-all, especially if you are new. (It's sort of like driving a different car: you have to get the feel of the gas pedal.) Like most things in life, practice, practice, practice.

Trust me, when you're the new person on anything, you will probably be asked to follow and fetch. I know it sounds cold, but this is the reality. They don't let a brand-new doctor, just out of school, do brain surgery. (Thank God that gripping isn't brain surgery.)

A Professional's Point of View

Here's a point of view to think about: Be a professional. Keep in mind the writers who spent several weeks, months, or years to put this film project together. Think of the very talented actors and actresses who are doing their level best to make those thoughts on paper come to life. A great deal of time, effort, and money have been expended to set up the show on which you're working and for which you're being paid. It should be given every chance at success. Don't screw it up by talking and lollygagging around while others are doing their jobs. Be a professional.

Fraternizing with the Boss

Here's my advice about fraternization. Think of yourself as a homeowner. You are looking for a great general contractor. You get a name, call up the contractor, and interview by phone. It appears this person may be the one. The general contractor and the crew show up. They build exactly what you want and leave. This goes on for several jobs. The contractor is fantastic and does great work, as does the crew. All this time you have never invited the contractor over for supper. Then you do. Afterward, you sit around the table and swap stories. This happens a few times. You're still the boss, and the contractor is still the employee. Then you hire the contractor again for a big job. Well, your contractor, who is now your buddy, is in high demand. Because you are the contractor's new best friend, you'll understand why he is not available for you. When he does show up, he is in a hurry due to his busy schedule. His work is not as good, but you understand, don't you? What I am dramatizing is something I learned in the military: "Familiarity breeds contempt." Or to borrow a

line from the movie *Moonstruck*, delivered by Olympia Dukakis, "You don't s—t where you eat." Folks, there is an invisible line in all business. Try not to cross it, unless you plan on staying on the other side. That's Okay, too.

Advice for a Long Career

You may find yourself on a movie set minding your own business, and you may overhear something personal being said, perhaps by a famous actor or actress. Whatever the situation, don't repeat it to anyone. It is their business. You will probably see things as well. Once again, don't go to the press with it. Respect other folks. The bottom line regarding all that I am telling you is that it is up to you. You don't need to sell gossip to the tabloids to make a good living. I have made a very good living, ranging from $45,000 to over $100,000 at my highest (depending on the economy), on just my grip jobs.

Hotel Awareness

1. Stand in the hallway and get a sense of how far it is to an exit. Now count your steps to the exit, stop, and make a mental note whether the hallway lies to the left or right of the exit.
2. Determine whether you can jump to safety from your floor.
3. Determine whether you can open the window in your room; if not, find what you might use to smash it.

This is not paranoia. These are steps that you should actually think about. I always say, "Plan for the worst and pray for the best." This advice comes from being on the eighteenth floor of a hotel when a fierce electrical storm knocked out all normal electrical systems. It set off a false alarm at 1:00 A.M., shocking me and my lovely wife Sabrina awake. We ran to the stairs from the dark of our room to a very dimly lit hall. Upon reaching the exit, we found ourselves becoming almost claustrophobic at the surge of humanity that was now rapidly filling the staircase. Fortunately, a cadence was set, and we all found the ground level safely. Then the real tragedy began. Picture a huge casino and hotel complex on a holiday weekend.

The emergency was declared to be a false alarm due to a tripped emergency system by the storm. Normalcy returned in a few hours. But I had this "gut" feeling. Have you ever gone against your inner feeling, wishing that you hadn't later on? Fortunately, I did not yield to just letting it pass. I found myself very aware of what *might* have happened. I decided to walk off an approximate distance to several different exits in case one were damaged or closed. My wife, Sabrina, who just happened to be on location with me to visit our children nearby, came along. Although very tired, she was also keyed up from our rude awakening. She thought it was a pretty good idea, "just in case."

After walking the exit distances a few times, we decided to now trust our lives to God's hands again. After returning to our room on one of the now-working elevators, we discovered that the main electrical power was still off. The room was cold

but comfortable enough to allow us to return to our bed until the full power could be shortly restored to the hotel. Power, it seemed, was quite quickly returned to the gaming area (I assume it was closer to the electrical control room). We finally fell into a light sleep.

Wham! It was 6:45 A.M. and the huge suction of the air conditioner revived. The lights all came on at once (the switches had been left on from the ordeal earlier in the night). What, another rude awakening? How many more could I stand? Didn't these folks understand? I was there to make a commercial. The nerve. Well, my lovely wife, Sabrina, being the sweet woman that she is, said "You stay in bed, hon. I'll catch the lights, and we'll get a little rest before your unholy call time of 11 A.M. for a scout." As she turned off the last switch, she noticed that the very large and heavy blackout-style curtain was awry. Part of it had been sucked out over the wall vent, it appeared. As she approached the curtain, Sabrina discovered the faint smell of smoke, so she thought that possibly some dust had been heated up almost to the point of . . . well . . . smelling like fire. As she strongly pulled at the drape, filtered light from outside entered our almost pitch black room. Preparing to open and close the heavy material, Sabrina froze. "Mike, the hotel is on *fire!*"

Springing like a cat (something I don't do often at my age), I discovered a huge plume of smoke. Deep dark, black smoke, stretching for what seemed like miles. Then as if all hell was making a room service call, shards of molten fire fell on our window sill. It was as if someone were above our room sprinkling burning bits of paper in front of our eyes. The pieces rested for their final moments before being consumed rapidly by the eager fire. After doing all the safety checks, we opened the door and made our way out to the hallway and on to the emergency exit. I then noticed that there appeared to be a faint smell of smoke in the exit stairwell. I knew we could not stop and return like we were salmon, due to the folks behind us. Should we bolt out the next passing door to a hall? What if I couldn't open it? Was it the self-locking type, a one-way egress? I peeked over the rail just in time and noticed to my horror and delight that there was a motorized fan blowing outside air (containing some smoke) into the staircase. The delight came from knowing we could pass through this area without much inhaling.

Here's my advice. I sometimes say advice is usually worth what it cost you. Be afraid, be *very* afraid of fire. I travel with a small battery-operated smoke detector. They can be purchased inexpensively at home and building supply stores or any hardware store.

T.O.T.

Travel Advice
1. Carry a battery-operated smoke detector.
2. Carry a small, double AA flashlight (to see at night or through light smoke).
3. Keep a clear path to your exit door. Don't leave your travel bag there.
4. Eject, eject, eject!

Getting That First Job

First, buy this book!!
Second, read this book!
Third, learn all the equipment by sight from this book!

T.O.T.

Looking good in this business is almost as important as being good. I am not saying you have to dress like a model in *GQ*, but I am saying you must be neat and clean (without any holes in your clothes) if you want to get a start. Who would you give a break to first, if the choice were between two people you didn't know? A clean-clothed, halfway smart-looking person, or a slob? You choose! You don't have to have a short G.I. haircut or spit-shined shoes, but give yourself a chance. You need every advantage over the next person applying for the job. Get in, get the job, and prove yourself—then let your hair grow.

The Questions

I have been asked the following questions (as well as many others) for as long as I can remember. Before I reveal my answers, first let me explain that there will be several right answers. They are all somewhat correct, and they may just pertain to you. The answers have to do with where you live, what you believe you can do, and how hard you are willing to try. So without any further chatter, here are The Questions:

How do I get into the movie business to be a grip?
What is a grip's job function?
What is a key grip?
What's a best boy?
How do you get a job as a grip?
Who does the hiring?

Okay! Let me answer some of those questions for you. Here follow my answers, some of which will work for you.

The Answers

First and foremost, if you're going to become a grip, know your equipment. This part is simple; since you're reading this book, it means you want to learn this portion of the business.

Next, contact the film commission in your state. Almost every state in the United States has one. Call the 1-800 information number and ask for the number. If

there's no 800 number, call your state's information number for any film commission number. Now call for numbers to your state capital's film commission and your city's film commission. Call these numbers and ask for a list of the Key Grips, Best Boys, and Grips registered with the film commission, then call and/or write to everyone on your list.

Tell them the truth! Tell them you're a newbie, but that you will work like no one they have ever had work for them before. Promise them, and keep your promise, that if you're not the hardest worker that they've ever seen, you will never darken their doors again! I look at it this way: If I were going to add a new person to my crew, I would want someone who is hungry. Ask yourself: If you were to break someone into the business that you are now doing, would you give this person a chance? Most people would.

Next, find out from your film commission what films are being filmed in your state. See if they are close enough for you to get to the filming location. If they are, go to the set, ask who the key grip is and introduce yourself. First tell him (or her) that you're sorry to bother him (if it is a him), then state your reason for coming all that way to the set.

If you can afford to spend a day, offer your service at no charge. I am not telling you to give everyone free work. What I am saying is to tell the Key that you would love to learn the workings of the set, by just being there and offering a helping hand when you can. I know this works because I did it myself. This is just one of the many ways you show a perspective boss you're willing to learn the business. By the way, when you do get the different film commissions on the line, tell them you would like to register yourself on the books as a grip/helper/PA (Production Assistant).

> NOTE: For you folks out of the USA, get in touch with the film commissions in your countries. You may be surprised at how much filming is going on in your areas. Good Luck!

Now, back to other ways of getting that first job. Check if there are any motion picture and TV studio equipment rental companies in your area. You see, all the equipment used by a movie studio or TV company may not be owned by them. They sometimes rent their equipment from different vendors. So check it out.

Another way of learning how to be a grip is to check out the TV stations in your area. They don't always call their workers grips; they usually call them stagehands or stage managers. Then there are the local playhouses; they might need an intern. Remember, folks, you have got to learn how to walk the walk and talk the talk. Get around the entertainment industry and get a feel for it. You will know when you know. It's sort of like that first day at a new job, or when you move to a new place. At first it is all so strange, then, slowly, quietly, it somehow changes—and you are the old salt of the area. This business is just the same.

Now, this last bit of advice is only for the really, really, really determined people who will do just about anything to get into this business. ALL OTHERS MAY SKIP THIS ADVICE! Say that there is not a film commission in the area where you live or in the city where you reside. Does Hollywood know the city as well as you?

Possibly not. So, start your own film commission for your area. Sure, you should check with the city fathers and mothers. Get any necessary permits. Then call your state film commission and tell them who you are and what you are doing and how they can get in touch with you. As I have been trying to tell you, if it were easy, anyone could do it.

All the same, I truly wish you the best of luck. (You will find that the harder you work, the luckier you will be. It just seems to happen that way.)

Warning/Disclaimer

This book was written to provide pictorial information only on the subject matter that is covered. It has not been written or sold to give legal or professional service. If you need a legal expert for assistance, then one should be sought. Also, before you try to grip, find an experienced grip who is well qualified to train you properly. *This book is a great aid, but it is in no way the final word on this subject.*

This book does not reprint all the information that is available to the publisher and author. It has been written to complement and/or supplement other texts. This book is intended as a guide to help the reader identify a piece of equipment by sight and by the manufacturer's proper name. It was written to be as complete as possible in that regard, without attempting to train the reader to do this sort of work. I take responsibility for any mistakes, whether they are typographical or substantive.

This book is intended to be used as a pictorial reference only. The authors and the publisher will not accept any liability for damage caused by this book. It is *highly recommended* that the reader work with a *highly skilled, highly trained* motion picture film technician *first.* The sole purpose of this book is to entertain and educate. As they say on television: "Kids, don't try this at home." Buying this book will not make you a grip. It merely shows you the "tools of the trade," not how to use them. Work only with a trained professional.

Remember, safety first and foremost.
Safety is the number one concern of all persons who work on a movie set.
Take it personal!
Make it personal!

Thanks! And once again, *good luck.*

The Big Break

by Ron Dexter

MIKE'S NOTE: Ron Dexter has been a camera operator since 1962. He is a member of the National Association of Broadcast Employees and Technicians Election Board, a union negotiator, director of TV commercials since 1972, a member of the Directors Guild of America, and owner of a TV commercial production company since 1977. He is also an equipment designer, mechanic, and teacher. He has shot commercials in 20 foreign countries and 35 U.S. states. Ron inherited his business philosophy from his dad: "He said to give people more than they bargained for, and they will be so relieved about not being robbed that they will gladly pay the bill and not question it the next time."

I have had the pleasure of working for this acclaimed director-cameraman since the very start of my career. Consider this master's words of advice to be almost gospel. He truly knows the complete ins and outs of the commercial studio business. It gives me great pleasure to pass on some of his knowledge. Let me introduce director Ron Dexter, a cameraman, inventor, and a real Yoda of knowledge. "May his force be with you."

Most people prepare and wait for the chance to move up the ladder. Often that next chance is just a trial step to see whether you are ready. That chance usually is given when the opportunity-giver believes you are almost ready, not when *you* think that you are ready. In the following pages, I will offer a little advice on how to be a professional on the job. This should serve to help you get ready to move up the ladder in your field.

Your talk about moving up may be taken as normal ambition or a swelled head. Once you've been given a chance, don't assume too soon that you have made it. You may have to step back down to your old job for a little longer because of not being quite ready or just because there is no need for you in that new position at the moment. Breaks are often given on less demanding jobs so that you will have a better chance of succeeding.

Too often a break goes to one's head. You cannot become an old pro in just three weeks. Knowing the mechanical skills of a job is only part of the job. Every advancement requires additional communication skills. This is where people often have trouble at the next level. Sometimes both the mechanical and personal skills

suffer for a while. Running a crew is a skill that takes time to learn. How you give orders is very important. The following pages will offer advice on how to be a good boss once you've advanced to a leadership position.

It is wise to take on smaller challenges first before tackling the big ones. Getting the best help is also wise, as is asking for help from a more seasoned crew.

Often the opportunity for the next step up the ladder comes not from the boss for whom you have tried to make a good showing, but from a coworker who has noticed your honest effort and hard work. A recommendation from a coworker who has credibility is worth more than the observations of bosses who don't have time to notice much about the working situation.

The following sections will cover set etiquette, good/bad bosses, professional advice, equipment, health on the set, reflection/advice, and books.

Set Etiquette

Most people in the entertainment business at one time or another have a problem with set etiquette. For a newcomer on a set it's like being dumped in a foreign country. The language alone is a struggle. For people moving up the ladder, there are problems, and even old-timers can lose their bearings. The rules are often different than from those in the "real world," and the glamour factor can distort one's views.

The following is a compilation of issues as viewed by various professionals in the industry. These are not elaborate theories but observations and opinions gleaned from many years of working in the business. Things are done differently on different sizes and types of shoots. Without a carefully defined structure, a large shoot would be absolute chaos. On small shoots departmental lines can become blurred, but certain rules of etiquette still apply. Newcomers should consider all the rules until they are sure which ones apply. Here are a dozen universal rules for any set:

1. Show up a bit early for the call.
2. Be polite. Say "please" and "thanks."
3. Let people do their job.
4. Be humble.
5. Ask questions about assignments if in doubt.
6. Watch what's going on in *your* department.
7. Make your superior look good.
8. Don't embarrass anyone.
9. Don't be a "hero."
10. Listen very carefully before you leap.
11. Learn and use coworkers' names.
12. Work hard and willingly.

The following elaborates on some of these areas in more detail.

Call Time

Call time means the time to go to work or be ready to travel. It's not the time to pour a cup of coffee and catch up on the gossip. If you want to socialize, come a bit early and enjoy the coffee and donuts that are usually there.

New on the Set

If you are new on a job or production, it's best to let your knowledge be discovered slowly as you work with people. They will be more impressed if you don't try to show them everything you know right away. Some outspoken people really do know a lot, but it's the big mouths that make the truly knowledgeable ones suspect. For every outspoken knowledgeable worker, there are ten who are full of baloney.

Offering Expert Advice

If you have experience in a special skill, offering advice can be tricky, especially if you are new on a set. Humbly offer your advice to your immediate superior and let him offer it to the group, then it will more likely be heeded. If he gives you credit, good. If he takes the credit, he will remember that you made him look good. Try (*very softly*), "I worked construction for a few years and, well, you know, it might work here."

Offering a Hand

When should you offer to give workers outside your department a hand? When it doesn't threaten their job and your helping won't do more damage than good. Helping someone carry equipment cases is often allowed *if permission is given*. Spilling or dropping things is *not* help that's appreciated. Nor is setting a flag for a grip usually. A camera assistant who builds a good relationship with the grips may be allowed to adjust a flag as the sun moves *if* the grips know the camera assistant is not trying to make them look bad or eliminate their jobs, and *if* the assistant knows what he or she is doing. Getting a feel for what is appreciated and what is not is the key. Don't assume that people want help, and respect their refusal when they don't. Maybe they just don't have time to explain how to do it right just then.

Can We Help?

Our business is not an exact science, and there are often many ways to do things. A wise boss will listen, but some bosses (especially directors) are not secure enough to solicit help when they should. They are afraid to look dumb and can blunder ahead trying to be "the director." Crews have to be careful how they offer help. Asking, "What are you trying to do and can we help?" sometimes breaks the ice and opens up a dialogue when things have stalled. But sometimes even that is taken as doubting the director's ability.

Don't Be a Hero

For every mistake "a hero" discovers, there is someone who made that mistake. Don't let them be blamed publicly. If you see something that appears to you to be a mistake, say something quietly and humbly to your immediate superior. "This may sound stupid, but is the 'stupid' on that sign spelled wrong?" Let your boss go to her boss so she can quietly say something to the next person up the ladder. The sign might be out of frame or be so small that it won't make any difference, or it may have already have been decided that it's really Okay.

If you run out and yell something, "being a hero," you are taking a big risk. The person at fault will remember for a long time the public embarrassment created by the young "hero" on the set. The worst thing would be to go over your immediate boss's head to the director, AD (assistant director), or a different department. You won't hear, "Who is that smart kid?"

Titles

People are often very concerned about their job titles. A title is an objective measure of success. Respect people's titles. People who are the most secure with what they are doing usually care less about their titles. For others who may be less secure, it costs you nothing to call a prop person a prop master, if that's what they prefer. Take a cue from what people call themselves. You may give coworkers a boost by using a title when introducing them, even if they don't seem to care about their title. Here are some examples:

Rather Than	Use
Cameraperson	Cinematographer
Prop person	Prop master
Gaffer	Lighting director
Script clerk	Script supervisor
Wardrobe	Stylist
Someone's friend	Associate producer

Always Out of Line for Crews

- Inappropriate sexual jokes and talk around women.
- Political, religious, or racial jokes and slurs.
- Having such a good time at night on location that safety and performance are compromised the next day.
- Alcohol or drug abuse.
- Negative criticism of anything or anybody within the hearing of clients, producers, visitors, cast, and locals. Keep your opinions to yourself.
- Bad mouthing other production companies, equipment houses, and crews.
- Loud talking on the set.
- Radical wardrobe on location. Make your personal statements in your own neighborhood.

- Accepting conflicting jobs in the hope that you will somehow "work it out."
- Replacing yourself on a job without warning.
- Not saying anything when you see a dangerous situation evolving.

Even if people are dumb enough to take unnecessary risks, if you see danger evolving, you are morally obligated to say something. People often rely on others as a measure of how safe something is. Your concern may make people think twice. In our business there are many ways to make things look exciting that are not as dangerous.

Wrap Time

Wrap time means just what it says. Wrap it up. It's not time to break out the beer and slow down. The pay is the same (more if into overtime), and the performance should be the same. Although beer is a nice touch, alcohol or drug use invalidates most company insurance policies on the set and on the way home.

Being a Professional Crew Member

An Eager Attitude

Acting eager to work not only is a sign that someone is fresh out of film school but also says that work is a two-way deal. Eagerness shows that one is willing to make an effort for a good day's pay. Sometimes old-timers think it's not cool to look eager, but it really makes a difference when a crew seems eager: "What can we do for you?" "Yes sir!" "We're on it!" "You got it!" Eagerness is a key factor in getting callbacks from a production company. The following two sections will give you more tips on what to do to get hired again—and what not to do.

How to Get Hired Again

- Show up a early for the call and ready to work.
- Give 110% effort.
- Be honest and straightforward.
- Assume that people are honest and good until they prove otherwise to you. (You may have heard only one side of derogatory gossip.)
- Cheerfully help others if asked.
- Cover your immediate superior's interests.

How Not to Get Hired Again

- Demanding Hertz rental rates for your 10-year-old car.
- Demanding full equipment rental rates for your side line rentals. Negotiate, and ask "what's fair."
- Putting more on your time card than the rest of the crew without approval.

- Increasing your rate after you are booked. Don't say, "By the way, my new rate is" during the job.
- Obviously having just come off another job at call time.
- Spending too much time on the phone.
- Not observing what's going on in your department.
- Talking too loudly.
- Fraternizing above or out of your category.

Personality Problems

We are never the cause of unpleasant events on the job. It's always the other guy who has "personality problems." In most disagreements, both parties are usually right to some extent. Usually the "rightness" or "wrongness" has little to do with the job and a lot to do with our egos.

Winning an argument can lead to losing the war. If two people who don't get along have to be kept separate, one or both will lose work. If one of them has anything to do with hiring, it can be a disaster for the other.

Don't risk your future over making a personal statement. Tempers cool off when a job is over and pressures are gone. Then it's wise to be humble and apologize even if you are sure that you were right. Sometimes two people will fall all over each other claiming who was more at fault.

Good friends will not blindly support everything that we do. They should whisper in our ear that maybe, possibly, we are out of line. Advice on the spot in the heat of anger is sure to be rejected. If you see a coworker that is losing perspective, think about it a bit and even write down what you think. Making it clear on paper may make it more understandable. Even if you don't show your coworker the paper, look at it at after the job to see if you still agree with your observation. If it still seems appropriate, you may show it to the other person or talk about it.

Approach any discussion about behavior with caution. *Listen first.* You will be much more able to tailor your questions or comments to what they already feel. Often just their telling you about something, with a few questions from you, will help them understand a problem.

Sometimes we all have personal problems that are difficult to leave at home. Both production and fellow crew members should take this into consideration. There is an intimate relationship between work and personal life. If someone is unhappy on the job it's hard not to take it home and vice versa.

Résumés

Unfortunately some people exaggerate their experience on their résumés. That makes all résumés suspect. Personally, I throw most of them away. Most of my hiring is based on personal recommendations. It's much easier to bring in a person known by at least part of the crew. Most of my crews are hired by the department keys and the rest by the AD, producer, or coordinator.

Peer Evaluation

Many jobs come from recommendations from established crew members. They know when someone is ready to "move up." They also know when a certain project is over someone's head and when someone else with a bit more experience is needed.

The Answering Machine

People often don't want callers to know whom they have reached on an answering machine, and a cryptic or incomplete message greets the caller. For friends who recognize the voice it is entertaining. But for the stranger who wants to leave an important message, it creates distress. Is that the person I'm trying to reach? Was that the right number? Should I look for another number? Is he or she in town? Will he or she show up on the set at call time? Is that a nickname? Is that his or her child, wife or husband, or dog?

Try this: "You have reached 123-4567. This is William known as Will. I will return your call if you leave your name and number. If you need me immediately, page me at 234-5678. Dial in your phone number after the machine beeps." (Or, "I am out of town until the 16th.Call 456-7890 for my availability.") Thanks.

Company Vehicles

Being professional also includes how you treat production vehicles. Don't abuse a company or rental vehicle just because it's not yours. (By the way, these hints apply to any vehicle, even your own.)

- If you hear strange sounds, find out what they are. Occasionally turn the radio down so that you can listen for knocks and grinds.
- Don't drive a vehicle until it dies. If you suspect a problem, tell someone in production or transportation so things can be fixed. If you're on the road, stop and get it checked. Call production immediately.
- When you get gas, check the oil and radiator fluid. Engines die for the lack of either one. Check the tires for proper inflation.
- If the radiator needs a lot of water, check the antifreeze mixture. Engines rust up with too little antifreeze. Let someone know.
- Watch the gauges and warning lights.
- If a vehicle steers strangely and shimmies, drive below the shimmy speed and tell production or transportation about it.
- Don't trash a good vehicle with props and equipment. Protect the floor, roof, and upholstery.
- If a vehicle just clicks when you try to start it, check or have someone else check the battery cables. Push or jump start only if you know what you are doing.
- Lock up the vehicle when you are not in it.

- Remove props, tools, and equipment from the vehicle at night if your driveway, street, or parking garage is not perfectly safe. Stolen articles can mean disaster at the next day's shoot.

Etiquette for Leaders

You've been called back repeatedly for your professionalism, skill, and enthusiasm, and now you've been recommended for advancement. Here's some advice for how to be as good a production leader as you've been a grip.

- Say "hello." Introduce yourself, and get to know people a bit before you give orders. Ask about the families of crew members you know.
- Use names. Make a list.
- Thank people. "Yes, sir/ma'am" and "Thank you, sir/ma'am" implies respect. Try it. (It also works when you have forgotten a name.)
- Appreciate people's efforts even if they make mistakes. If they are trying, give them credit for trying. Maybe your instructions were inadequate or confusing.
- Assume that people are trying to do a good job and that they are trying to please you. Even if you think your instructions were clear, it is wise for you to take blame for not communicating. The person who messed up will not feel bad and grumble the rest of the day.
- In any conversation, listen first. Try to understand the other side first. It will give you time to plan your own approach. Your ideas will be better accepted if people are given a chance to contribute.

Leaders: Facilitators or Dictators

Leaders tend to be either facilitators or dictators. Your goal is to be a facilitator—the leadership style that is most effective for achieving the best results.

The Facilitator
- Appreciates all workers' efforts because she assumes they are trying to do the job right.
- Shows appreciation for hard work no matter how far off track it may be.
- Even if they are off track, he doesn't say so until he listens to their entire presentation.
- Doesn't point out flaws as she sees them, but asks for clarifications with noncritical questions to help workers discover the flaws themselves. Many flaws become apparent while someone is trying to explain something to someone else. It is better for someone to discover her own flaws.
- Readily admits failure to see the merits of a great idea; also avoids looking like a fool for not seeing its merits.
- Gives people public credit for good work.
- Uses *we* and *our,* not *me* and *mine*, except to admit a mistake.

- Gives workers enough time to work on a project and keeps them updated to avoid unnecessary work.
- Tries to let workers finish one project before adding another.
- Makes himself available.
- Makes allowances for personal ups and downs and evaluates workers on their long-term performance.
- Uses praise, raises, and titles as rewards for good work.

The Dictator

- Never finds anyone's work satisfactory.
- Approves of nothing because she might be held responsible if the project doesn't turn out well.
- Must improve everyone's work with his corrections, whether the work is perfect or flawed.
- Starts making improvements in someone's work as soon as she starts reading it.

Examples of Bad Bosses

- Their "improvements" will ensure that they take credit for "saving" the project.
- Their contributions must look good in the eyes of their superiors no matter what the effect on the project is.
- Any mistakes have to be covered up to avoid embarrassment, even if the results hurt a project.
- They don't give examples of what they want, and they avoid commitments by saying that they will know when it is right "when they see it."
- They never show up on time to a meeting of subordinates. They must always appear to be busy to justify their position.
- They schedule extra inconvenient meetings to make their staffs work harder.
- They are never available to approve work in progress that might save people some work.
- They never inform others about possible problems.
- They save problems as ammunition for criticizing their crews.
- They never blame outsiders for problems. By saying, "You should know better," they keep the blame at home.
- They never give praise, raises, or titles, for doing so would build too much confidence.
- They use the threat of firing to keep people in line.

My, My, My

A "my crew," "my set," "my shoot" attitude by a production manager or production coordinator rubs most people the wrong way. Along with the "my crew" attitude is often an attitude that future jobs are dependent upon making that produc-

tion person happy. "Do things *my* way, treat *me* right, and I will see that you work in this town again."

First of all, people are very uncomfortable working under such conditions. Directors, producers, DPs (directors of photography), key grips, and gaffers, can call their crews "my crew," but not the AD (assistant director) or production coordinator who only puts out the work calls. The crew is usually selected by the director, DP, and others. The coordinator is just making the calls.

Often accompanying this me-my-I attitude is never admitting to a mistake. A scapegoat for any mistake must be found and admonished—often with a job security threat. "If you want to work for me, you must make me look good in the boss's eyes."

On the other hand, DPs or department heads may talk affectionately about "my crew." They are saying, "you had better take care of them," "don't abuse them," and "talk to me before you try to take advantage of them."

If people congratulate you for doing a good job, give your crew credit for making it possible. Credit every good idea and effort so that people hear it. It costs nothing.

Being a Good Communicator

Let's say a director has very carefully researched and planned how to do something mechanical. Instead of telling the crew exactly what to do, he might start with, "I'm sure that you have a better way of doing this, but I had to plan this before you were on the job," or "I didn't get a chance to ask you about this. Let's get through it and see if my idea will work at all." You can reduce their resistance to your offering expert information by being humble. Even if your way is best, a crew may be able to add shortcuts and insure safety. Do listen and let them do their job.

Be sure to listen to and communicate clearly with runners and assistants as well. Confirm that they understand your instructions. Instruct them to call back if there are problems finding something or if things cost much more than expected. Sometimes limited availability will require finding substitutes. Often suppliers will offer better solutions. Tell runners and assistants to call in as things change. Take the time to explain what you want so that the runner has some idea of whether something will work. But warn runners not to make major changes unless they call first. Giving a priority to items can help. Simple things may seem insignificant, but they could be crucial for the first shot. Ask for forgiveness if you have to repeat things or explain things that your crew or assistants may already know.

Teachers and Students

This last point is worth elaborating. Like almost every seasoned person in the business, I am happy and feel obligated to pass on what I know to the younger generation. When there is time I like to explain not only how to do something, but also the principles behind how it's done. Unfortunately, sometimes people are insulted when they're told something that they already know. Perhaps I forgot that I told

them the same thing before, or I have no way of knowing what they already know. My intent is to pass along useful information. Prefacing information with "you probably already know . . . ," will help avoid any suggestion of insult. I start a job with a new crew with, "Forgive me if I repeat myself or tell you things that you already know."

On the other hand, I never expect people to know more than what I know they should know. Asking me how to do something or how to approach a problem or situation only makes me, the teacher, feel better in passing along my infinite wisdom. I am never bothered by being asked again how to do something even if I have already explained it before. On the other hand, if someone doesn't ask the second time and does something wrong, I am perturbed. I know that people can't absorb all the information that is thrown at them. When things are not understood, I give people the benefit of the doubt and assume that I was the one who failed to make myself clear.

There is so much to learn about our business that there are few on-the-job situations that will teach us all that we have to know. One has to eat, sleep, and live the film business to keep ahead of the competition. The grip must learn mechanics; the electrician, the theory of light; the camera operator, photography; and they know how to operate all of the equipment besides. Our business always has someone waiting in the wings for us to falter if we do not keep up with the times. When we feel secure that we have it made is when the competition catches up.

Being Professional When You're Boss

The Morning of the Shoot

1. Arrive *before* call time and assist the AD or transportation captain in placing the grips' electrical generator far enough from the location yet close enough not to impede a fast setup and departure.
2. Bring a shot list and confer with the AD to check if there have been any last-minute changes.
3. Inform the best boy what equipment will be needed first and any additional equipment that may be needed later. Try to get a "jump" on the next shot.
4. Key grips should have their ears keenly tuned to at least three voices: the director, the director of photography, and the first AD. This minor eavesdropping will allow the key grip to keep abreast of this trio's desires and of changes as they occur during the course of the shoot.

Always in Line for Production

- Uniform deals for the whole crew.
- Paying per diems promptly.
- Paying for a wrap dinner.
- Prompt equipment rental checks.
- Keeping crews informed about job scheduling.

Always Out of Line for Production

- Booking crews when a job is not yet firm.
- Not sharing cancellation fees with canceled crews.
- Holding checks or time cards.

Filling Out the Time Card

"Don't ever hire Fred again!" "Why?" "He pads his time card."

What really happened: The crew went into meal penalty by 420 minutes. The production manager went to three "almost staff" people and asked them to waive meal penalty. This means that the crew did not stop filming to eat "on time." Usually, six hours after call time, they are paid a penalty for the time that they did not eat until the meal is called to break. With that concession the manager went to the rest of the crew with "Everyone is waiving meal penalty" and got concessions from everybody but Fred, who was in the darkroom. Fred feels that rules are rules; he was the only one who put in for meal penalty, and he was blackballed for it.

Yes, this happens too often. If the rules of filling out time cards are being bent in any way, it has to be a group effort so that no one has hours that are different from the rest. Production will use all kinds of reasons to keep the hours down. If the department works as a group, talk to the contact with the producer to reach a fair settlement. Fewer problems will arise.

Some producers have no idea how many extra hours camera assistants, prop persons, and PAs put in. (That's why PAs with no clout often have to work for a flat rate.) Warning your contact with production ahead of time that there will be extra hours on a given day will take the burden off your back. If you don't clear putting in extra hours, it might be wise to "eat" some of those extra hours.

For example, let's say you find out that a turnaround is necessary to complete a job for tomorrow's shoot. You had best get permission to do so. Production may decide that putting on another person to finish the job might also solve the problem. You should have some idea of how long it should take to do a job.

Turnaround is not a device to pad your time card; it's a device to prevent producers from working people so long that it becomes dangerous. You need your sleep. It's your responsibility to get enough rest and to plan your work to avoid too many hours.

Crew Issues to Address

The following is a list of dos and don'ts on a film set by the crew members.

- Film students and relatives on the set.
- Renting every new toy to try it out.
- Always "making do."
- Old pros who ration their own efforts, teaching younger people not to hustle and thus making everyone look bad. There is a balance between abuse by management and featherbedding by crews.

- Who is responsible for safety.
- Turnaround, meal penalty, OT (overtime), kit rentals, travel pay.
- Who looks out for the crew.
- Flat rates.
- Key grips picking seconds (best boys), including producers, coordinators, PAs. Ensure that they are qualified.
- Loyalty—"You paid me peanuts when you didn't have money. Now that you have a big budget you are hiring all expensive professionals."
- Crews who test new directors and DPs.
- Crews who always want more help.
- Unqualified assistants hired by production.
- Seeing that the director or DP could do things differently to make it easier.
- Crew invited to dailies.
- The time and a place for appropriate conversation, such as a PA who is asked about his aspirations by a director whom he is driving home one night and is ignored the rest of the shoot. He or she may harbor ill feelings. Loose lips sink ships—maybe yours.
- "It's not in the budget."
- Definitions—call time, wrap, kit rental, booking a job, replacing yourself, flat rate, union, P and W, O.T., turnaround, meal penalty, and so on. A new person on the set needs to know these terms (see Glossary).
- "All producers care about is money."
- "We'll take care of you next time."

From Production

The following are tips from production:

1. All orders go through production!
2. Get start slips, W2 forms, and time cards.
3. Order all special tools or equipment through production, including pickup trucks, all-terrain vehicles, cranes, insert cars, jibs, and so on.
4. When working for a production company, ensure that you get all your paperwork done first.

From Other Departments

Check with all departments that may appear to need support from the grip department.

Location Etiquette—Getting Along with Locals

Whether you're the leader of a crew or working on the crew, don't think that just because you are in the TV or movie business you are something special. To a local person, you may be a once-in-a-lifetime opportunity to fame, or an emissary

from hell. Your success on a location—and the success of future crews on that location—depend on your behavior. Everywhere you go you are treading on someone's turf. Tread lightly. The locals' opinion of you will determine how cooperative they will be. The first impression is often the most important.

The first contact should be made by the crew member who is the most diplomatic person and who has the most in common with the people who live in the area. Say, "Hello, how are you? You might be able to help us. We are trying to find out who owns" Don't say, "We're here from Hollywood and we're going to" They may see Hollywood, TV, movies, and the big cities as the reasons that their children are tempted by drugs and sin. Or you might be the first convenient person to vent anger upon about something that you have nothing to do with. To a shopkeeper, you could be a potential customer or shoplifter. Clothes appropriate to the area make you stand out less.

Start any conversation with a perturbed local with, "I'm sorry, let me get these people out of your way. " Don't say, "We'll be a minute" Being there legally or having permission from a higher authority may not apply locally. The local residents may have a battle going on with that same higher authority.

Drivers should park out of people's driveways and parking spaces. Get permission. Don't block traffic. When it's time to leave, get directions to the next location, get oriented, and be ready to roll.

Treat motels and lodgings with respect. Use heating, cooling, and lights as needed. Don't "borrow" towels for your own or company needs. Close the door and turn off the lights when you leave. Be quiet, especially early and late. Park in stalls. Keep a low profile with the camera gear. Don't tempt. Word gets around a small town about your behavior.

An obvious effort to protect people's property will soften the blow when the unavoidable damage does occur. Make a vocal effort to remind your crew to be careful. Cover floors, and have people whose homes or businesses you're using put away their valuables. Your crew is probably very honest, but bystanders may not be.

Some Thoughts on Equipment

Crews and Their Own Equipment

Buying equipment to supplement your income can be wise, but don't assume that it will help you get work. Would your employers be glad to rent from you *and* would you then become competition to your own regular suppliers? If a camera assistant buys filters and batteries to rent, she is cutting into one of the moneymakers for the camera rental house. Rental houses lose money on camera body rentals, but make it up on accessories such as batteries and filters. You might jeopardize your own standing with the rental houses.

It's tough deciding how to charge for equipment that you happen to bring along to the job. If something is requested, a rental price should be agreed upon. If you happened to bring along something that saved the day, be careful about how to

collect for it. Some producers are fair and some are not, no matter how much time and money you might have just saved them. Sometimes your future job may be at risk. It could be assumed that because you are not in the rental equipment business, what you bring along might be regular tools of the trade.

Asking for a little something is better than demanding it. First save the day, then humbly ask for compensation. Try, "What's fair?" I know, production rarely scrimps on their own comforts. But it's your job to make a good film, and their job to save money. In collecting for your equipment, don't "nickel and dime." Let people feel they are getting a bargain. "Give me regular rates for X and Y and I will throw in Z." "As used" deals (where an employee gets paid for equipment only if it is used) are generally welcome, if you can live with them.

Remember that your garage operation is in competition with the established businesses that have more overhead to support (insurance, rent, employees, etc.). In short, be cautious with your sideline business. Don't let it interfere with your job, which is your major source of income. It's better to give something away than to lose work. If your toys make you a better technician, they are worth the cost even if you don't make a lot on them.

Your job performance should in no way be compromised by your equipment rentals. You should deliver your equipment as any other rental house would do and not get paid to deliver it. You can't spend all your efforts on the set just watching out for your equipment. It's there just like anyone else's stuff. Everyone's equipment should be taken care of. If you show concern for everyone's equipment, then others are more likely to respect yours too.

Don't bother a company about equipment checks. Many rental companies have to wait for money, as do producers of commercials.

The Professional Look

There is a good reason to use professional-looking tools and equipment—to protect yourself if things go wrong. If you have the accepted standard equipment, you can always blame the equipment. If your equipment looks homemade, problems can become your fault for not ordering the right thing. Although saving the day with a tool jury-rigged on the set can be heroic, bringing the same tools to the set can look unprofessional.

I have watched crews with chrome-plated tools in fancy cases make expensive mistakes and then charge the client an arm and a leg with a smile. I have also seen some bare-bones riggers do wonders with surplus junk for peanuts, then watched them have to argue about a few real extra dollars after saving the client thousands. Yes, the impression is important. A coat of paint and some painted boxes might be a good compromise.

Your knowing how to make your rigs work will cover for some lack of flash, but do consider the impression. People are fooled by fancy-looking equipment even if it doesn't work very well. The world is impressed with technology and fancy wrapping even when it doesn't work very well.

Health on the Set

To survive in a world full of germs and viruses we have to build an immunity to them. If we were raised in a sterile environment, we would die from contact with the first germ. Less sanitized societies have a stronger resistance to germs. Our overpurified food and water may even increase our susceptibility to sickness.

We are a society obsessed by cleanliness, but with the spread of new powerful diseases, people's concerns about their health should be everyone's concern. Cleanliness on the set should be maintained at a level with which even the most fastidious will feel comfortable. Some situations to consider are as follows:

Soft Drinks

All actors should have their own bottles for soft drink casting. During the shoot with the *hero* bottle or glass (the bottle or glass to be filmed), each actor's bottle or glass should be refilled or washed in a sanitary washing system. Restaurant supply houses sell disinfectant washes.

Coffee

Steaming coffee is always a problem. Liquid hot enough to steam is too hot to drink. A-B smoke (simulated smoke made with two chemicals by a special effects team) is pretty strong to sniff. One solution is to add steam to the film or video in postproduction, which is not difficult nowadays.

Kissing

How do you cast and shoot a close-up toothpaste commercial? Check with SAG (the Screen Actors Guild) about rules about kissing, and don't push actors to do something they aren't comfortable with.

Cold and Flu

Infecting fellow crew members is somewhere between careless and criminal. In Japan people wear masks when they have a cold. It's a badge of concern for even a stranger's health. We have magic medicines to hide cold symptoms, but we are no less infectious. Keep your distance if you have a bug or think you might be getting one. Some say that colds are more infectious when you first get them. Many people find that vitamin C helps prevent colds, but doesn't do much after you have one. Do keep warm. Cold bugs don't grow in hot weather or a warm body.

Smoke Masks

There is much debate about smoke on the set from created fog or sprayed special effect smoke. If masks are used, everyone should be provided one if they re-

quest. Problems arise when one grip has a Darth Vader-type industrial-strength mask and makes a big deal about health risks. It looks like everyone else is less well protected. We have been told so much about health safety problems by production that it's difficult to draw a clear line on what smoke is safe and how much. Some crew members are more fatalistic about their safety and ignore the concern of the more sensitive.

Spray Paints

The smell of spray paints is strong, and efforts should be taken to protect cast and crew from having to breathe it. Outside with a little breeze an actor can hold her breath if only a little dulling is necessary. *Ask* whether it's OK. Don't *tell* her it's OK.

Camera Eyepiece

We can catch infections through the eyes. Some people have very sensitive eyes. Assistants should be protective of the camera operator or DP who says he has a problem. A separate cup or cover should be standard procedure if requested. Eye problems can put people out of work.

Hot Weather

People often don't drink enough water. Sipping cold water may not be good for us. Lots of slightly cool or air temperature water should be provided. Personal plastic jugs with a name on each for the crew is wise on hot shoots. Everyone should be encouraged to drink water.

Cold Weather

Any day can turn cold and wet. It's smart to bring clothes for a wet, cold, or even a hot day. Get in the habit of carrying a bag with rain gear and a change of clothes.

Bee Stings

Many people are allergic to bee venom. Parks, where the food table can attract bees and wasps, are particularly bad. Be sure to cover the meat, especially. A can of stinky cat food some distance from the shoot may lure bees away.

Makeup and Hair Products

The Directors Guild of America and Screen Actors Guild have rules covering many of the makeup and hair products for any pyrotechnical procedures.

Last Thoughts and Parting Advice

"Juices"

We talk about creative juices in our business. Here are some (very unscientific) thoughts on the matter.

The best juice is adrenaline. It flows into our systems when we skydive, bungee jump, downhill ski, or finish a great shoot day. It flows when we see good dailies or—the ultimate—a great cut.

Adrenaline keeps us young, with an upturned mouth from a continual smile. Every smile releases a little adrenaline, a laugh even more, and keeps us well. Have you heard about laugh therapy? It works. We only become ill after a hard shoot when our adrenaline releases are down.

Adrenaline accelerates the creative process and helps the mind to think clearly and see things that we normally wouldn't. It puts us on a roll. We pump more adrenaline on shoot days. Our efficiency is three times that of a prep day. At the end of a shoot day, it takes a couple of hours to come down from the adrenaline pumped up. At dinner we can fall asleep over the soup. At the end of a shoot it takes a few days to rebuild our stores. Relaxing too much is dangerous. Without a cut to see or a new job to start, we relax and don't pump adrenaline. That's when we catch the cold that we had suppressed during the shoot. We also get addicted to adrenaline just like any addiction. We need to do something exciting or creative. Is that why we become workaholics?

The worst juice is bile. We pump it when no one listens. A good idea dies just because it wasn't someone else's. Bile flows when last-minute changes arrive or the rig doesn't work.

When we have bile in our systems our brain grinds to a halt. Solutions don't pop up like they did with adrenaline. All we want to do is get it over with. We give up. "If you insist on garbage, I'll give you garbage." Bile turns our mouth down and makes us old.

How about other juices? It's said that not many creative juices flow during a $200 lunch. True, but we can discover that others can be reasonable about baseball, babies, movies, and food. Maybe after lunch we can also be reasonable about a storyboard and each other's ideas. The juices needed to digest lunch may also buffer the ego-juices, and the delivery of ideas may be less charged with emotion, or the need to defend one's precious ideas may be a bit dulled. For more of this kind of thinking, try reading Kurt Vonnegut.

Success and the Ego

Success in the entertainment business can be rocket propelled. But DPs and directors often don't know how to handle success any better than a rock star, a politician, or a whiz kid. Making big bucks and having everyone desiring one's services can go to one's head. Ghandi kept himself humble by doing humble things every day. We often don't have the time or inclination to practice being humble. It's human nature—power corrupts. A formerly humble worker can become a tyrant in a

new job that has a little power. One of the casualties of the demise of the studio training system was gradual advancement through the ranks. Now people can move too fast, sometimes from the bottom to the top in one or two steps. Be humble. Don't be a threat to people. Let them feel worthwhile. Let them succeed. Give them plenty of credit for their efforts.

Financial Responsibility

One measure of success is the ability to buy things that we couldn't afford on the way up. All the goodies out there to buy sometimes strap the technician, camera assistant, or budding director with payments that can be a chain around the neck when the "real break" arrives. One often has to work for a lot less money—or none at all—when taking the next big step up the ladder.

Lots of vans, boats, and even houses are lost for nonpayment when the economy slows. Losing hard-earned possessions is a blow to one's self-esteem. You can blame the economy, some union out on strike, or changes in the business, but how far one extends oneself financially is one's own decision.

Ron Dexter's Suggested Book and Source List

Sources

Birns and Sawyer (213) 466-8211 carries a good stock of motion picture and TV technical books. Still camera stores like Sammy's, (323) 938-2420 and (800) 321-4726, carry many books on still photography, but the stock varies. Opamp Technical Books, (323) 464-4322 and (800) 468-4322, orders and ships anything in print with a credit card order, as does Book Soup, (310) 659-3110. For used books, try Book City, (818) 848-4417, and Larry Edmunds, (323) 463-3273. Samuel French, (323) 876-0570, on Sunset Blvd. in Hollywood also has used books. SuperCrown and Bookstar offer special order services and discounts. Try Barnes and Noble as well as Amazon.com on the Internet.

Publishers

Focal Press, (800) 366-2665, has a very informative collection of books on photography, film, and video. The books are quite well-edited for a particular focus on a subject and are aimed at a specific level of reader. They contain gold mines of material.

Amphoto publishes a very good line of books on still photography. Many have sections and techniques applicable to TV and motion picture work. The books, with the exception of their camcorder book, are well-edited and focused on a subject.

MIKE'S NOTE: This list suggests just some of the many sources out there in the world. If you want to learn, start asking questions. Go to your local library. Call bookstores. Visit bookstores, ask colleges, and just keep trying to find what you're looking for until you are satisfied.

Grip Equipment Guide

The majority of equipment pictures in this book are courtesy of Matthew's Studio Equipment. There are many other great studio equipment manufacturing companies in Hollywood as well. Here are just a few: American Studio Equipment, Modern Studio Equipment, Norm's Studio Equipment, and Paladin. Check them all out. They truly are the best that I know of. Remember, all of them can usually manufacture any specialty rig that you may need.

Well, here we go. I am going to expose you to the biggest collection of knobs, knuckles, and kooks (cucolorises) that won't make a lick of sense until you finish each section. There will be a pictorial identification and explanation of each piece of equipment and its usage. In addition, throughout this book, I will expose you to several terms you will no doubt use on a daily basis as a grip, such as *rigging, mounts, scrims,* and so on.

I am going to show you a picture of a piece of equipment, one at a time, with a name and an explanation for each particular piece. Then, as we progress, I will show you how one piece is used with another and why. These pieces of equipment tend to be used in this basic configuration on a daily basis on most movie shoots, shows, and commercials. It is important to note that most grip equipment that is affixed to another piece of equipment is either clamped on, slips into or onto a 1 1/8 in. receiver, or has a 5/8 in. pin attached to it that a receiver slips over or that the 5/8 in. pin slips into.

Oh, don't forget common sense. It plays a large part in being a grip.

Okay, enough of this. Turn the page, and let's get started.

Basic Equipment

Apple Boxes

An apple box is a wooden box (tough, huh). Why it is called an apple box, I can only guess. But legend has it that the forerunner to this modern-day box was, in fact, a box that really carried apples. Grips would just flip the open side down and stand on it. An apple box has multiple purposes. It can be used for sitting, standing, prop elevation, and leveling off uneven heights. Apple boxes come in four common sizes, as illustrated in Figure 1.

Apple Box Sizes

Full apples are	12 in. x 20 in. x 8 in.
Half apples are	12 in. x 20 in. x 4 in.
Quarter apples are	12 in. x 20 in. x 2 in.
Eighth apples are	12 in. x 20 in. x 1 in.

The eighth apple box is also called a pancake. The nickname for the apple box is the *man-maker* (kind of an inside joke: it will make a man taller). Apple boxes are usually made of a strong wood that is glued and/or nailed together. In the center of the better built boxes is a stiffener or center support, which enables the boxes to withstand a heavy load.

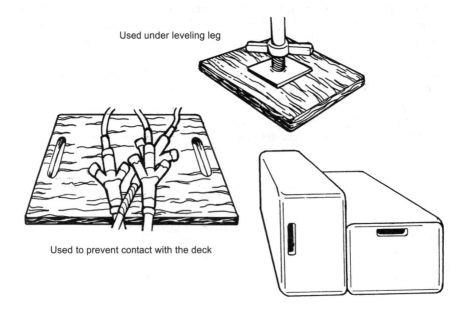

Used under leveling leg

Used to prevent contact with the deck

Figure 1 Apple boxes.

T.O.T.

Poor man's vehicle process: Put a lever under the frame of the car and pump it up and down while filming. It gives the effect of movement.

T.O.T.

For a quick flag for a light on a beaver board or skid plate you can use an apple box.

T.O.T.

Elevate electric connectors on an apple box, wrap in Visqueen (plastic material) or a piece of plastic bag, and tape closed in rain conditions.

T.O.T.

Listen like a field mouse, but be ready to spring like a leopard when needed. This proves two things:

1 You're paying attention (good for points).

2. You can anticipate what's needed (better for callbacks). Trust me on this. This practice works for any profession.

Baby Plate

Baby plates are used for holding down small fixtures or grip heads. They can be nailed to the top of set walls or practically any surface into which a nail can be driven, such as a tree or apple box.

1. Baby plates are available in three sizes:
 a. 3 in.
 b. 6 in. to 12 in.
 c. right angle
2. The pin size is 5/8 in. (make a note of this size). The 5/8 in. pin has a small hole through it, near the end, for a safety pin or wire to go through. Something should be slipped through this hole and secured to prevent a light from falling off in an underslung or inverted position.
3. The pin has a recessed area near the end in which the lamp's locking pin/knuckle rides. This allows the lamp to rotate on the pin without falling off when the light is being panned.

NOTE: Always check the weld on the pin to the plate first, before use.

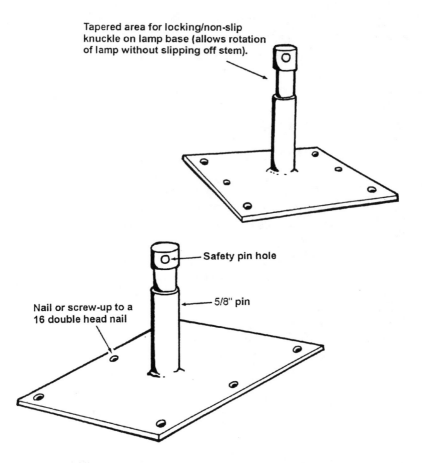

Tapered area for locking/non-slip
knuckle on lamp base (allows rotation
of lamp without slipping off stem).

Safety pin hole

5/8" pin

Nail or screw-up to a
16 double head nail

Figures 2a and 2b Baby plates.

T.O.T.

Never mount a baby plate to just a set wall unless you hit a stud. If you must
mount a baby plate, have another grip hold up two pieces of cribbing stacked
to protect his or her hands and as a back plate to screw into; otherwise the
screw will pull out of the thin luan (it's only about 1/16 in. to 1/8 in. thick). Al-
ways put a short safety line on the baby plate. Trust me on this, I have seen
baby plates pull out of the wall and crash on the ground.

T.O.T.

You can use a baby plate in a high-roller head if the need arises.

Bar Clamp Adapter Pin

This pin is a mounting accessory that was initially intended to slide onto the bar of a furniture clamp in order to affix small lighting fixtures or grip equipment. Another application of the bar clamp adapter is to insert the 5/8 in. pin into a grip head and employ the locking shaft opening to secure a particular device.

1. 5/8 in. pin (in size) about 3 in. long
2. The pin slides on a bar clamp (AKA) Furniture clamp

 NOTE: The pin works great on a gobo arm (AKA) "C"-stand arm

T.O.T.

Carry wood or lumber with one end high and the other end low in order not to smack anyone.

T.O.T.

Use speed rail as a track to get a Chapman dolly down a short staircase.

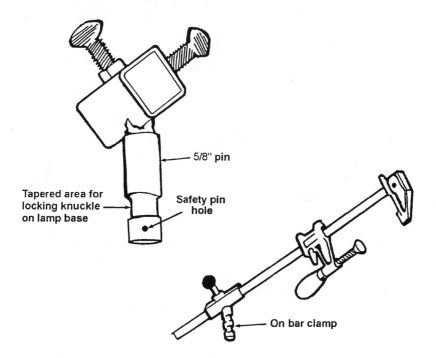

Figure 3a and 3b Bar clamp adapter pin.

Figure 4 Basso blocks.

Basso Block

The basso block works like a smaller version of an apple box. It's very handy and stores easily. Basso blocks come in several sizes: full, half, and quarter. A full basso block is equal to a half apple, and a half basso block is equal to a quarter apple.

T.O.T.
Put a steel double in front of a large HMI light before you shut it down on an extremely cold day. This will help the fernell (the glass lens on the lamp) cool more slowly and thus help prevent the glass from cracking. (Contributed by Gaffer Mike Laws, I.A. Local 728.)

Bazooka

A bazooka is a device for mounting lighting fixtures onto studio catwalks (see next T.O.T.) Along the floor of a catwalk, spaced roughly every 18 in. apart, there are a series of holes measuring 1 1/8 in. in diameter into which lighting fixtures or grip accessories may be inserted.

1. A bazooka has a 1 1/8 in. receiver on one end, which is called the *junior receiver end.*
2. At the other end is a 1 1/8 in. pin that fits into the deck of the catwalk or perm.
3. A 90-degree plate, which is attached to the bazooka, hooks over the perm handrail. The plate has several holes drilled through it for nailing or screwing it to the handrail, as a safety.
4. The bazooka has a knob for one riser on it. This is for making minor adjustments to raise a light just high enough to allow its beam of light to focus through the perms.

NOTE: Always safety the light separately to the safety rail.

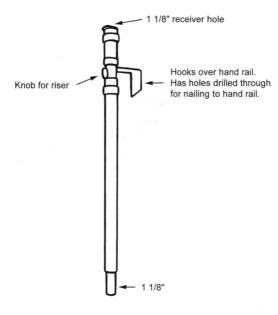

1 1/8" receiver hole

Knob for riser

Hooks over hand rail.
Has holes drilled through
for nailing to hand rail.

1 1/8"

Figure 5 Bazooka for perms and green beds.

T.O.T.

Catwalks are sometimes referred to as *decks*, *greens*, *green beds*, or *perms*. Perm is short for permanent, because these catwalks or walkways are permanent fixtures suspended above a studio set. Using the term greens or green beds (because they're often painted green) for the catwalks is actually incorrect. The studio catwalk is in fact "the decking or flooring" of the perms, and the greens are built temporarily to "hang" from the perms.

T.O.T.

Use whatever is available to get the shot. I once needed a long dolly shot in front of a peru (a small swamp boat) in the Louisiana swamps. The actor would stand in his small craft and push himself off with a long rod off the bottom of the swamp floor. It's a slow-paced movement. The director wanted a long, slow move down the center of this bayou. A boat would rock, creating unwanted camera action. I used two floating platforms that were square and flat-bottomed. I placed the camera, the cameraperson, and the camera assistant on the camera platform, which was tied to the front platform where the excess camera gear and two grips were. A 600-foot rope was tied to a tree down the bayou. I pulled the rope, setting the pace asked for by the cameraperson.

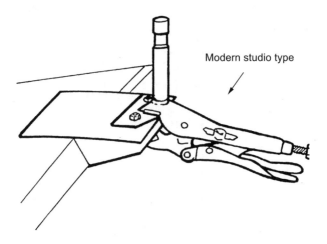

Modern studio type

Figure 6 Bead board holder.

Bead Board Holder

1. The bead board holder is a vise grip with two large plates attached to the grippers.
2. The plates provide a larger surface area to bite the bead board tightly without breaking the material.

Other names for the bead board holder are *onkie-bonk* and *platypus*. (Trust me! I really don't make up these names.)

T.O.T.

Purchase and mark your own personal headset for the walkie-talkies that are used on set.

T.O.T.

Develop what I call "set ears." Tune your hearing to the voices of the director, the cameraperson or director of photography (DP), the gaffer, and your boss, the key grip, as well as the best boy. If you hear that any one of them would like something, you as a grip should call out that it is on the way or that you will retrieve it. This shows that you have set consciousness and are willing to work.

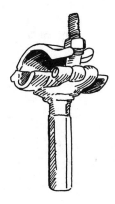

Figure 7 Big Ben clamp.

Big Ben Clamp

One end of this clamp will accept any junior receiver. The other end will fit onto a pipe or tube with a 1 3/4 in. to 3 1/4 in. diameter.

Branch Holder

The branch holder is used by sliding a limb of a small branch into the receiving mechanism. It employs a clamping action to tighten the knuckle-locking through bolt, which can be adjusted to smaller branches.

There are two types of branch holders: the tree branch holder (see next section) and the C-clamp type.

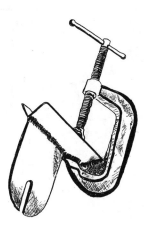

Figure 8 Branch holder.

1. The C-clamp branch holder has a 4 in. to 6 ft. iron plate welded at a 90-degree angle to one face of the C-clamp. (See Figure 8.)
2. This type of C-clamp has a small 2 in. angled plate welded to its opposite face, which makes it more versatile and gives it a better biting action on the tree branch.
3. The bottom of the C-clamp has a spade welded onto it, which allows the clamp to fit into a high roller.

Branch Holder—Tree

The second type of branch holder is known as a *tree* branch holder.

1. It is no more than a tube, either 2 in. or 3 in. in diameter, into which the branch slides.
2. A 5/8 in. pin is welded to the outer case, and the branch is locked into place by a small knuckle.
3. The small branch holder has a 1 3/8 in. inner diameter (ID) that is fitted with a 5/8 in. pin, and the large branch holder has a 2 3/4 in. ID fitted with a forked receiver for the 4 1/2 in. grip head. (See Figure 9.)

Although the tree branch holder is not as versatile a branch holder as the C-clamp, this handy device may be used to conveniently position a multitude of items.

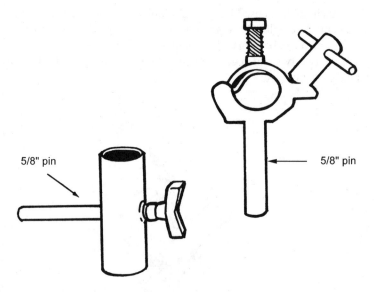

5/8" pin

5/8" pin

Figure 9 Branch holder—tree.

T.O.T.

To get rid of unwanted glare from the glass of a picture frame, angle the picture on the wall by means of a ball of tape or a Styrofoam cup that is placed behind the picture to tilt it outward, downward, or sideways. It will look strange to your eyes, but the camera will record it as hanging flat.

T.O.T.

When you measure doors to determine if they're wide enough to pass equipment through, be sure to watch out for the hinged side of the door, which makes the doorway smaller than it at first appears. For example, Bank of America's 70 in. double-wide door may be only 54 in. when it is hinged open. Always measure a door in the position it will be in when you are going through it.

Cable Crossovers

Cable crossovers are necessary on any shoot in which a car may have to drive over electrical cables. A crossover has a hinged heavy-duty polyurethane cover that opens to expose four to five valleys for cables. These covers make it safe for cars to drive over the cables and also for people to walk over them without tripping. Ensure that either the grip or the electrical departments have cable crossovers on their trucks. They come in several sizes, ranging from two channels (or valleys) to five channels.

T.O.T.

Use a can of Dust-Off to blow away chalk lines.

C-Clamps

C-clamps are used when an extremely secure quick mount is demanded. C-clamps for motion picture use come fitted with two 5/8 in. pins.

1. They come in many sizes. We use them as small as 1 in. and all the way up to 12 in. The type we use in the film industry has either
 a. pipe face, or
 b. flat face,
2. The pipe face has a small 1 in. to 2 in. piece of iron or channel iron welded to the flat face at a 90-degree angle. This gives the clamp a better clamping action when it is attached to a pole or pipe.

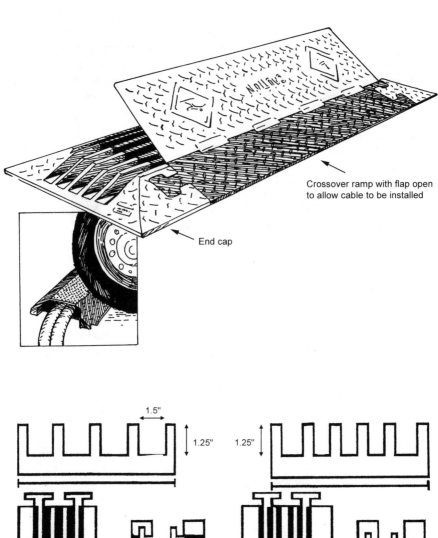

Crossover ramp with flap open to allow cable to be installed

End cap

1.5"

1.25"

1.25"

End cap

Shows how they fit together

Figures 10a and 10b Cable crossovers.

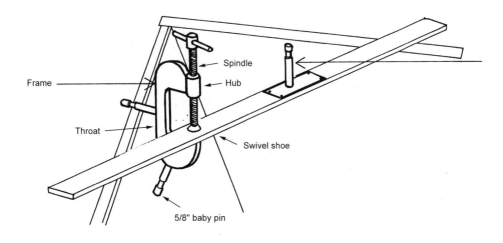

Figure 11 C-clamp with a baby pin and a baby-pin plate.

3. Most of the C-clamps that grips use have either a 5/8 in. baby pin or a 1 1/8 in. junior receiver mounted vertically and/or horizontally.
 a. Both clamps come in either pipe face or flat face.

 NOTE: Never use a pipe face C-clamp on a wood surface; the edges of the face will create indentations on the wood surface. If there are no flat face clamps available, you may use a pipe face with two pieces of cribbing sandwiched between the surface you're working on and the clamp.

T.O.T.

Answer all requests over the radio by repeating what's needed. For example: The Key Grip calls out, "Give me a baby plate, a C-stand arm, and a postage stamp single." You should then reply, "One baby plate, a C-stand arm and head, and a 10 x 12 open-ended single. Roger. Flying in." This example illustrates that both parties involved know what is needed. The key grip knows that the call was transmitted, and your acknowledgment confirms that it was received. Communication is a major player in the movie industry. I am not trying to harp on the subject or be redundant, but I just want to drive home key points that will aid you and make you look a little better than the next person who wants the job or the next call back if they shrink the crew. The grip department is a team. I am not advocating upstaging your peers; I am saying— Give it your all.

Camera Wedge

A camera wedge is the same as a regular wedge, only it's smaller and gets into tighter places. It is about 4 in. long and tapers from 1/2 in. to 1/16 in. wide.

T.O.T.

If you have a need for a camera wedge and there is none available, you can sometimes use a clothespin. Just remove the spring, and voilà, two small wedges.

T.O.T.

Here is something for you to chew on as a grip: "Say what you mean, mean what you say, but do not say anything mean." Mom was right, if you do not have anything nice to say, do not say anything. I can promise you this: if and when you do let your mouth run, it *will* come back to bite you in your behind in this or any business.

Figure 12 Camera wedges.

Cardellini Clamp

This clamp is excellent. It is quick, lightweight, and fast, and it has many designs.

T.O.T.

During installation of a remote head on a jib arm or a crane arm in an under-slung position, I have found it easier to loosen all four leveling bolts on the head, which allows the leveling head to move freely with its four-way tilting action. Set the remote head on the ground (or deck) with the threaded portion upward, if the head permits this position. With the arm balance out, lower it to the threaded end of the remote, then gently slide the receiver hole over the threads of the remote, making sure not to damage the threads. Align the key way (slotted area), then install the winged/gland nut on the threads and rough

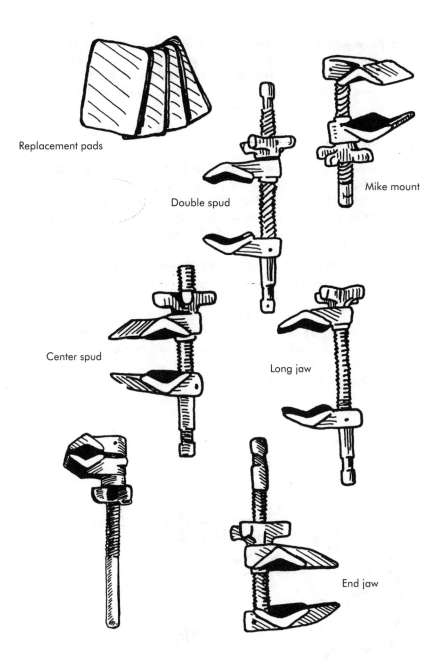

Replacement pads

Double spud

Mike mount

Center spud

Long jaw

End jaw

Figures 13a and 13b Cardellini clamps.

level it in place. Add weight to the bucket end of the jib or crane to rebalance the pivot point of the arm. Raise the arm to a working height. (Usually a six-step ladder under the arm will do nicely for judging the right height.) Now install the camera and safety. Rebalance the arm for the camera weight.

Chain Vise Grips

1. The chain vise grip can be used on any pipe with a 6 in. diameter or less.
 a. The back of the chain vise grip has a 5/8 in. pin welded onto it.
 b. The tightening knob also has a 5/8 in. pin welded onto it. If need be, several chain vise grips can be "locked" together.
2. After the chain vise grip has been locked into place, it is a good practice to wrap a piece of gaffer tape around both handles to secure them together. This prevents the locking action from "popping" or accidentally unlatching.

T.O.T.
The grips will usually rig the condor (cherry picker) with the mounts (candle stick or condor rail mount), and the electricians will rig the lights into the mounts. They work together to ensure safety.

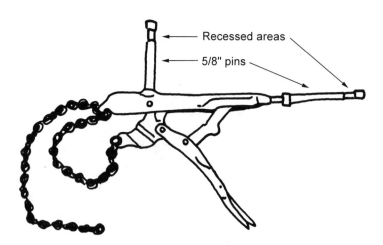

Recessed areas

5/8" pins

Figure 14 Chain vise grip.

Figure 15 Clipboard.

Clipboard

1. Clipboards are lightweight, wooden devices that are designed to be clipped to the barn doors (light shapers attached to a light fixture) of a light in order to provide an additional plane or degree of control. This sometimes precludes the necessity of setting a flag.
2. Clipboards come in three sizes:
 a. baby
 b. junior
 c. senior.
3. The clip rotates on the board tightly so that you can use it in several directions.

T.O.T.

Always move the crane arm after releasing the brake. This is a safety check to ensure that the brake is fully off.

T.O.T.

Use a rubber-coated lead in a swimming pool. It can be rented from the Fisher Dolly Company or a crane company.

Condor Bracket

These brackets are designed for use in a condor (cherry picker). They will fasten directly to the front or the edge of the condor basket or bucket. This leaves room for an operator. Remember: never exceed the weight restriction of the basket.

T.O.T.

Know all your exits on stage.

T.O.T.

To measure approximately how much time is left before the sun sinks behind a mountain or building at sunset, extend your hand and arm toward the sun, place your lower fingers on top of the horizon or mountain range, then count the number of fingers between the horizon line and the bottom of the sun. The thickness of each finger represents about 10 to 15 minutes. It's just a ball-park guess, but this really works. Be sure to wear your shades! And do not do this if your eyes are sensitive. Remember: never look directly at the sun.

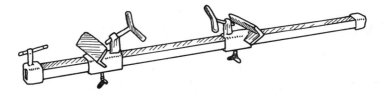

Figure 16a Condor bracket, modern type.

Figure 16b Condor bracket, mount-rail type (shown in stored position).

Figure 17 Cribbing, 2 in. x 4 in.

Cribbing

1. Cribbing is short boards used to elevate, level, or block a wheel or chair or other pieces of equipment.
2. Cribbing is made from 1 in. x 3 in. x 10 in. or 2 in. x 4 in. x 10 in. lumber.
 a. Usually edges are rounded to prevent splintering.

 NOTE: Cribbing can be any length, but 10 in. fits into a legal milk crate perfectly. (A legal milk crate is either rented or bought.)

T.O.T.

Cut pieces of 1/8 inch plywood to line the sides and bottom inside a milk crate. This will prevent equipment from protruding and getting jammed.

T.O.T.

Before taking or building a crane onto a stage floor, check and see if the stage is elevated. Sometimes you have to lay titan track (large planks of wood that can hold the weight of the huge crane).

Crowder Hanger

1. The crowder hanger is similar in design to a set wall bracket.
2. The crowder hanger mounts onto a 2 in. x 4 in. or 2 in. x 6 in. piece of lumber without nailing.
3. It will accommodate a stand adapter, or it can work as a 1 1/8 in. receptacle only.

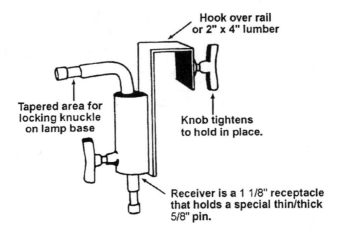

Hook over rail
or 2" x 4" lumber

Tapered area for
locking knuckle
on lamp base

Knob tightens
to hold in place.

Receiver is a 1 1/8" receptacle
that holds a special thin/thick
5/8" pin.

Figure 18 Crowder hanger.

T.O.T.

Know the placement of all fire extinguishers on the set.

T.O.T.

Safety all objects (lights, clamps, etc.) so that they will swing away from the center of the set toward the set wall if they fall. This will prevent it, we hope, from hitting the talent.

Cucoloris

1. The cucoloris is used to create a shadow pattern on a backdrop or any subject.
2. When it is positioned in front of a light source, the cucoloris breaks up an evenly or flatly lit area into interesting pools of light and shadows. For example, this broken lighting effect can represent sunlight that has filtered down through tree branches.
3. The cucoloris is made from wood or wire mesh.
 a. The wood cucoloris is opaque with open pattern areas.
 b. The wire mesh or (celo) cucoloris is more like a mesh scrim with the open patterned areas burned into it. The celo is more durable due to the strength of its wire mesh material. It also creates a more subtle pattern due to its wire mesh construction, which reduces the light output rather than completely blocking it.

 c. The closer a cucoloris is to the light source, the more diffused the result-
 ing pattern will be on the subject.

 d. The closer a cucoloris is to the subject, the sharper the shadow patterns
 will be.

 e. The nickname for the cucoloris is a *cuke* or *cookie*.

 f. Both wood and celo cucolorises come in:
 1. 18 in. x 24 in.
 2. 24 in. x 36 in.
 3. 4 ft. x 4 ft.

NOTE: A tree limb supported in a branch holder can also be called a cucoloris or
branch-a-loris.

T.O.T.

The closer you get to the subject, the harder the shadow. Try this: hold your
hand between a light and a wall, close to the wall. Notice how dark the shadow
is on the wall; this is called a *hard shadow.* Now pull your hand back in the di-
rection of the light and watch what happens to the shadow. It weakens or soft-
ens, becoming a *soft shadow.*

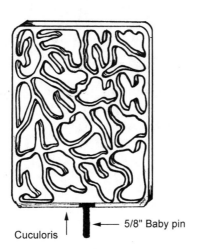

Cuculoris ←—— 5/8" Baby pin

Figure 19 Cucoloris.

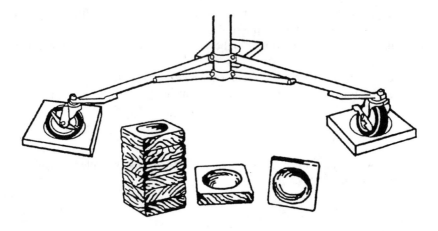

Figure 20 Cup blocks.

Cup Blocks

1. Cup blocks are made of wood and designed to be placed under wheeled objects, such as light stands or parallels, to prevent them from rolling.
2. They are also used as an apple box would be, to elevate a table, desk, or chair.
3. The average size is 5 1/2 in. x 5 1/2 in. x 1 1/2 in. thick with a dished-out center (about a 1/2 in. deep dish).

T.O.T.

The yellow or red lines 4 ft. from stage walls on stage or indicate the "no block zone." This zone must be left free and clear in case the stage fills with thick black smoke, preventing people from seeing where they are or how to get out. The 4 ft. "no block zone" allows people to make their way to any wall and feel their way to an emergency exit.

Doorway Dolly

As the name suggests, the doorway dolly was designed to be an inexpensive camera dolly that is narrow enough to fit through most standard doorways. Over the years doorway dollies have been used not only for this purpose but also as efficient equipment transporters for camera cases, lighting fixtures, cable, and other pieces of equipment.

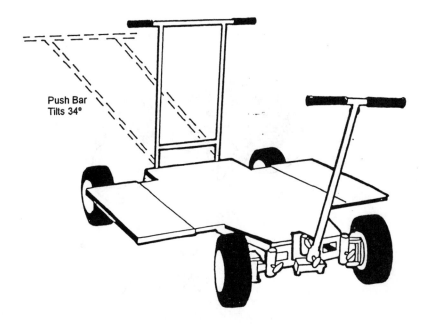

Push Bar
Tilts 34°

Figure 21 Doorway dolly.

Pneumatic tires are standard on the doorway dolly, but it can also be fitted with track wheels for use on straight dolly track. Steering is accomplished by using a pull handle (like a wagon). A new steering feature has been added recently that allows the operator to steer from onboard the dolly. This is accomplished by inserting the pull handle through the push bar at the front of the dolly. A recent addition available for the push bar is an angled fitting to allow the bar to tilt down 34 degrees for more clearance between the dolly and the dolly operator. The basic construction is a wooden platform attached to a steel tubing frame.

The platform is fitted with a recessed camera tie-down area , and it is carpeted for a nonslip, low-maintenance surface. For extra-low-angle shots, the dolly can be inverted, thereby positioning the platform closer to the ground. This dolly also includes the ability to extend the rear wheels outward in order to provide greater operating stability.

Dots and Fingers

Dots and fingers function along the same lines as scrims or flags—with one functional difference! Whereas scrims and nets are generally used to reshape a beam of light, dots and fingers are employed to alter or correct an isolated, internal segment of light without affecting the overall pattern.

Figure 22 Dots and fingers.

1. For instance, a man's bald head is giving off an unwanted highlight. A dot strategically placed would hold down that small portion of light hitting the bald spot, without affecting the remainder of the scene.
2. Both dots and fingers have long handles to facilitate their placement and angle.
 a. They may be secured with grip heads or articulated arms (flexarms).
 b. Due to the thin wire constructions of the outer frame, no frame shadows are cast on the subject matter.
3. Basically, dots and fingers are shaped like little nets and flag, or like a little cutter or a dot.
4. Dot sizes are 3 in., 6 in., and 10 in.

5. Finger sizes are 2 in. x 12 in. and 4 in. x 14 in.
 a. Both dots and fingers are available in various thicknesses and materials:
 1. Single
 2. Double
 3. Silk
 4. Solid
 5. Lavender

NOTE: Remember this: as you move the dot or finger closer to the light, the shadow gets larger, but it will also become softer.

T.O.T.

To get the feel for each dolly:
 a. Turn the knob a few times to get the "feel" of the hydraulics of each dolly.
 b. Raise and lower the arm by lifting the beam up and down a few times.

Drop Ceiling Scissor Clamp/Cable Holder

1. This is one of the greatest inventions you will ever find for working in an office with false ceilings, or drop ceilings.
2. The drop ceiling mount is designed to, as its name suggests, scissor open and close over the conventional T-bar drop ceiling frames.
3. The clamp or holder is fitted with a standard 5/8 in. pin.

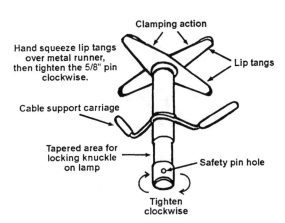

Figure 23 Drop ceiling clip.

NOTE: This mount is used for smaller lighting fixtures only, so care should be taken not to hang too much weight from any drop ceiling.

4. The drop ceiling cable holder works in conjunction with the scissor clamp to provide a neat, efficient way to run cable to the fixtures.

T.O.T.

Play the sag load (that is, the weight of the light unit that is being rigged) when you rig. Add a little extra pull, then let it sag into place.

Drop Down, 45-Degree Angle

As the name implies, take a look. This is used in applications that require a reflector or lighting fixture to be positioned lower than the top of the combo stand with a 1 1/8" receiver.

1. The 45-degree drop down permits the unit to be mounted on an inverted plane.
2. The angle allows the unit to be swung or tilted without interference from the stand.
3. The mounting pin and receiver accommodates 1 1/8 in. equipment.

T.O.T.

When pushing the dolly, watch the actor with your peripheral vision. Look at your stop marks and watch the camera operator for any signals, such as a hand gesture to go up or down or in or out.

1 1/8" JR receiver

Figure 24 Drop down (45-degree angle).

T.O.T.
When you push the dolly, always put down a tape mark every time you park the dolly. A lot of times the DP will say, "Hey Mike, go to that last mark." I will usually have three or four different color tapes pre-torn with tabs ready for such an occasion.

T.O.T.
Sometimes the key grip is considered the unofficial safety expert.

Empty Frames

Empty frames are great. You can cover them with whatever expendable material you may need, and they will hold it in place perfectly.

The most common empty frame standard sizes are:

18 in. x 24 in.
24 in. x 36 in.
4 ft. x 4 ft.

Of course, if these frames are not large enough, build your own. Normally we use 1 in. x 3 in. lumber to build a larger frame, say to make a 10 ft. x 10 ft. or a 6 ft. x 9 ft. odd size. When building your own uncovered frame out of wood, be sure to put a gusset in each corner to give strength to the frame and keep it from distorting when moved. A frame built out of wood can also have a baby plate attached to each side of it so that it can be held in place by a C-stand.

To fly (hang) a frame that you have built, drill a small hole in it (if time permits) to tie ropes through it. You can also tie ropes to the gussets if the gussets are securely fastened.

To apply a gel to the frame, you can spray an adhesive or use ATG (automatic tape gun) tape, then just lay the gel on, and voila, it's ready! If you're in a hurry to gel a frame, use four grip clips. Another thing to remember when you apply gel to a wood frame that you have built is always to use a tab of tape (1/2 in. x 1/2 in. long) on the gel, then staple through the tape to the wood frame. This tab of tape will help the gel from tearing. (Without the tape, it is almost guaranteed that the gel will rip).

Here is some advice that can help you identify a frame that someone has requested, for example, a "4 x 4 ½ CTO" (color temperature orange). (Gel colors are very close—1/8, 1/4, 1/2, full—and it can be hard to tell the difference.) First, check the edge of the frame. Often there will be a piece of tape, attached by a pin, that is marked to identify which gel is on the frame. If there is no such tape, pull out the frame and check for a magic marker description on the gel itself, usually in the corner. If there is no marking, check along the edge of the gel—it will sometimes be printed along the entire edge of a new roll. If that fails, resort to a swatch book of gels. Hold the sample and the gelled frame up to a light source. After a few tries of

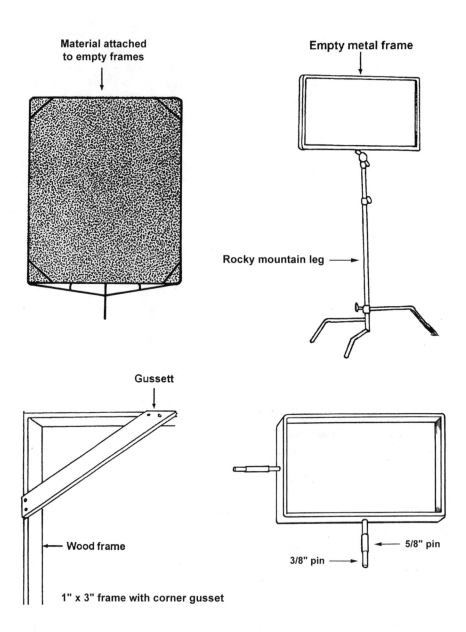

Figure 25 Empty frames.

making a match, you will get the hang of it. Always be sure to tell the boss of any possible problems.

T.O.T.
When you skin on an empty frame (install gel or filters), please clean up your mess after you (and anyone else) have finished. We don't want to get the blame for any gel scraps or a messy work area.

T.O.T.
To make a fast rain hat for the camera and lights, use a gelled frame, which is usually available. Make sure you angle the rain hat so that the water runs to the rear and side. Never let the rain hit the glass of the lamps. When using a gel as a temporary rain hat, aim the gel side up and the frame side down; this way it will not fill with water and cause the gel to separate from the frame.

T.O.T.
If a gel has been put into a frame, placed in front of a light on an exterior location, and the wind starts blowing the gel back and forth in the frame, it may create noise problems. If it makes noise during a sound take (filming), there are ways to stop the noise:
1. Hold the gel by hand.
2. Use clear cellophane tape X'd over the gel.
3. Use a C-stand arm offset just enough to apply pressure on the gel in its center to hold the gel in place. This only works on a large light source, due to the shadow it might cast using a small light.

T.O.T.
Identify a gel on a frame by marking the gel name and type with magic markers in the corner of the gel. This will not show when projecting a light through it.

T.O.T.
Pre-tape empty frames with 1-inch-wide cloth tape *before* applying ATG tape. This makes it easier to take off the old gel when you change to a different one.

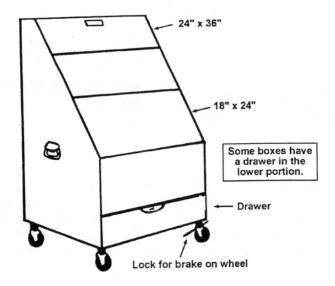

Some boxes have a drawer in the lower portion.

← Drawer

Lock for brake on wheel

Figure 26 Flag/scrim box.

Flag Box/Scrim Box

1. The scrim box is a box with dividers in it.
2. The 18 in. x 24 in. flags fit perfectly in front, with just the handles exposed. This will protect the scrim flags when not in use, such as during transportation to and from the job.
3. The box has two handles, one on each side, with a detachable wheel frame with catered wheels.
4. The 24 in. x 36 in. flags and scrims will fit in the rear slot.

T.O.T.

To make a hard shadow, pull the fernell lens (the front glass) from a light. This is a trick used by electricians, and you can suggest it if they don't already know how to do it.

Flags and Cutters

Flags and cutters are opaque instruments designed to stop or totally hold back light from areas where light is not desired. They are also called *gobos*. Gobo is a

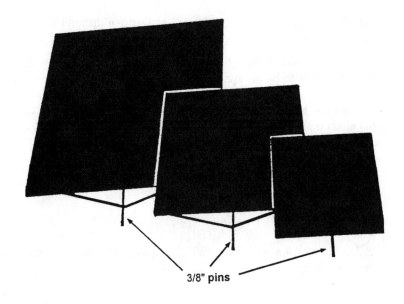

3/8" pins

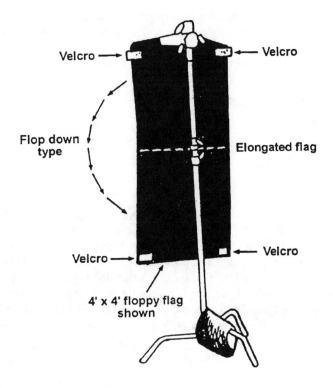

Velcro

Velcro

Flop down type

Elongated flag

Velcro

Velcro

4' x 4' floppy flag shown

Figure 27 Flags and cutters.

term found in the dictionary, where it is defined as a strip of material used to block light from a camera.

1. Essentially, flags and cutters are very similar. The main difference is that flags are usually closer to being square in shape, and cutters are longer and narrower.
2. Flags and cutters are made of black, fire-resistant cloth, which is sewn onto a closed metal frame.
3. Their handles are usually painted black.
4. They come in various sizes. But, the two most common sizes are:
 a. 18 in. x 24 in.
 b. 24 in. x 36 in.

T.O.T.

When called for, the grips sometimes call a flag a *solid* instead of a flag, but it means the same thing.

Cutters

The cutter is usually used for a larger lighting unit, when you have to get farther away from a light, or when light would leak or spill off the end if a smaller flag were used.

Cutters usually come in various sizes, the most common are:

10 ft. x 42 in.
2 in. x 36 in.
18 in. x 48 in.
24 in. x 60 in.
24 in. x 72 in.

T.O.T.

Use a 1 in. x 3 in. x 4 ft. piece of lumber on floppies (flags) with grip clips, or use a 40 in. gobo (C-stand) head and arm to prevent the floppy part (the *flop*) from blowing in the wind. Clip one end of the flag with a grip clip, wrap the board or the arm on the opposite side of the center of the stand with the flag, then clip or use the head of the C-stand arm to bite the floppy part of the flag. This will prevent the flop from blowing up in the wind. When using the gobo head and arm, just open the plates on the head and sandwich the corner of the flop's edge in it. Do the same with the gobo arm plates as close to the other side as you can.

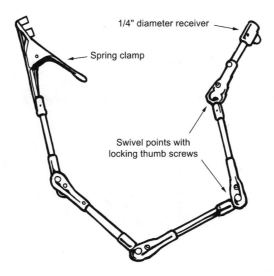

Figure 28 Flexarms.

Flexarms

1. Flexarms are also referred to as articulating arms.
2. They are designed primarily to hold fingers, dots, and flex scrims.
 a. The joints of flexarms are thumbscrew locking in order to support more weight.
 b. The flexarm terminates in a spring clamp at one end and a 1/4 in. diameter locking receiver at the other.

T.O.T.

Place a flag far enough away from a light to prevent burning, or use Black Wrap on the flag.

T.O.T.

Have production put ice in the actors' mouths before they speak on a cold night shot. This helps prevent steam (a sometimes unwanted effect) from coming our of their mouths for a few moments.

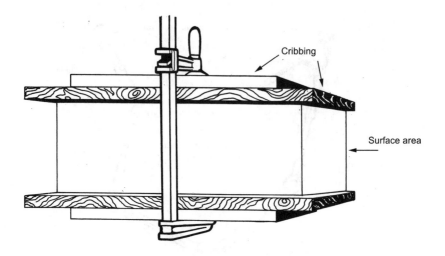

Figure 29a Furniture clamp with cribbing.

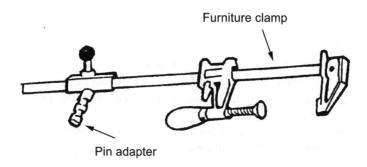

Figure 29b Furniture clamp.

Furniture Clamp

1. As the name implies, the furniture clamp is similar to the type of clamps used by the furniture industry. It is also called a *bar clamp*.
2. Furniture clamps are available in 6 in., 12 in., 18 in., 24 in., and 36 in. lengths.
3. Furniture clamps are adjusted by the use of a spring release over a serrated bar, which locks into any notch on the bar.
 a. Fine adjustments of the clamp are made with a worm-screw handle.
4. The furniture clamp usually works with a bar clamp adapter on it.
 a. When using a furniture clamp on any surface, always try to use two pieces of 1 in. x 3 in. cribbing. The reason for this is that if the clamp is

tightened to the surface wall, it will have only a small surface area on the foot of the furniture clamp.

b. If too much pressure or weight is too far out on the arm of the bar, the foot could punch a hole through a wall or dent the surface, leaving a mar or causing the light to shift, or falling off. A couple of 1 in. x 3 in. cribbing pieces are thin enough not to take up too much room, but they will provide greater surface area for the pressure being applied, thus helping the clamp have a better grip on the surface.

c. Another reason for using cribbing is a common grip concern: not to damage any area or structure on which he or she is rigging this clamp. If you take extra precaution and consideration for someone else's belongings, it shows a lot of professionalism.

NOTE: Never install a light on a clamp without a rope or wire safety. Trust me on this. It will never be just "one quick shot" as grips are so often told. Just make it "one quick safety."

T.O.T.

When bringing equipment to a house, building, trailer, or other structures, *most* doors open toward the visible hinge (unless it's a double swing hinge), so allow for reduced clearance unless the door opens 180 degrees.

Furniture Pad

Furniture pads, also called sound blankets, are heavy-duty quilts that are used for a multitude of applications.

1. Sound technicians use furniture pads for acoustic deadening and isolation.
2. Camera operators use them when shooting low angles. They give him/her a pad to lay or sit on.
3. Grips use furniture pads for protecting existing furniture, wall, floors, etc.

Some furniture pads have grommets (eyelets like those in your tennis shoes), so that they may be hung.

T.O.T.

Before removing any set wall, check to see if the seams have been cut, or if there are any lights or braces on it.

Figure 30 Furniture pads.

T.O.T.

Rebar covers (covers the ends of metal rods) are the red, orange, or yellow plastic covers seen at construction sights. Use rebar covers on rebar (steel) rods. They can also be used as safety tips on any protruding objects, such as C-stand arms. You can also make another protective cover by cutting a slice into a tennis ball and placing it on the object.

Gaffer Grip

1. The gaffer grip is a multi-use device that is unique in that it comes with two 5/8 in. pins. One pin is on the handle and one is on the jaws.
2. Adjustable jaw openings provide normal expanded mounting capabilities.
3. Gaffer grips are normally used for quick-mounting small light fixtures to virtually anything, such as a door, pipe, furniture, or light stands.

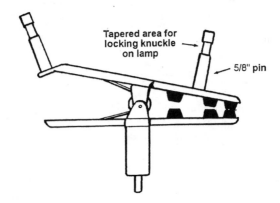

Figure 31 Gaffer grip.

4. One of their many applications is as a means of securing foamcore.
5. They are also called *gator grips* due to the style of the rubber teeth in the jaw.

T.O.T.
I recommend that you carry carabiner clips in your tool box. They are handy when you want to send several things up high, say to the perms. Tie a bowline and just clip on the carabiner. You now have a quick release.

Grid Clamp

1. Baby grid clamps are designed for maximum hold. The baby grid clamp fits a 1 1/4 in. to 2 1/2 in. pipe.
 a. When the bottom nut has been securely fastened, the grid clamp is virtually unmovable.
 b. It terminates in a 5/8 in. pin.
2. Junior grid clamps are the same as the baby grid clamp, only they terminate in a 1 1/8 in. receiver.

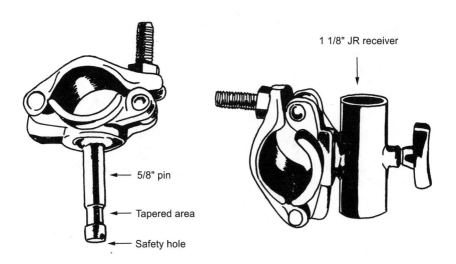

1 1/8" JR receiver

5/8" pin

Tapered area

Safety hole

Figure 32a Grid clamp with baby pin.

Figure 32b Grid clamp with junior receiver.

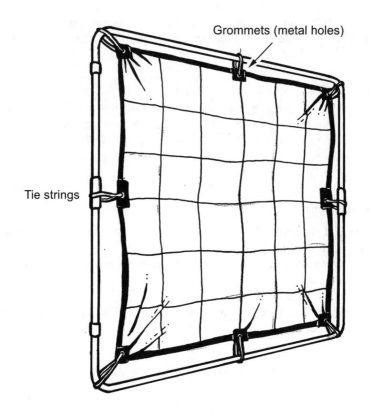

Grommets (metal holes)

Tie strings

Figures 33a Grifflon.

Grifflon

Okay, let me explain a grifflon to you. It is an extremely durable material made of three-ply high-density rubber. It looks like cloths with webbing woven through it so that it doesn't rip. A grifflon takes a direct light and bounces it back onto the subject. If the sun were backlighting them, for instance, it would bounce the sun back onto the subject's face.

The most common sizes of grifflons are:

1. 6 ft. x 6
2. 8 ft. x 8 ft.
3. 12 ft. x 12 ft.
4. 20 ft. x 20 ft.

NOTE: If the grifflon should get a tear, there is a grifflon material tape specifically for that purpose. Apply the tape, which is made of the same material as the grifflon, directly to the tear. Voila! The hole is fixed.

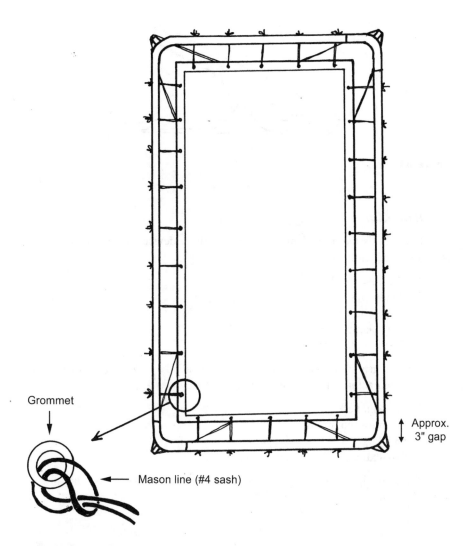

Grommet

Mason line (#4 sash)

Approx.
3" gap

Figures 33b Grifflon.

T.O.T.

When hanging a backing or translight on a stage, you may not have any place to tie off the grommets from the sides. Here's a trick that works. Drop a rope from the perms about 3 ft. from each side of the backing or translight, then nail the rope to the floor. Make the rope as tight as possible. Now tie off the backing sides from the grommets to the rope.

Figure 34 Grip clip.

Grip Clip

Grip clip is the most common name for these devices. Other names that are used quite frequently are:

1. Hargrave #1, 2, 3, 4
2. Handy clamp
3. Spring clamp
4. Pony clamp
5. Brinks and Cotton

When a grip clip is called for, it is usually called by size. The number comes from the manufacturer: for example, Hargrave #1.

1. #1—smallest
2. #2—most common
3. #3—large
4. #4—extremely large (hardly ever used)

The grip clips are nothing but large reusable metal clothes pins. They seem to be used on almost every shoot. You'll see.

T.O.T.
Put a styrofoam cup over a sprinkler head in a building to deflect heat from a lamp under it.

T.O.T.
Use a #1 grip on your tool belt to hold your gloves.

Figure 35 The grip/electrical stage box.

Grip/Electrical Stage Box

1. The grip/electrical stage box or grip box, as it is usually called, is nothing more than an extra-heavy-duty chest of drawers.
2. It has a metal wheel frame that is detachable.
3. This box is loaded with common hardware, from bolts, nuts, wire, and nails to power tools.

Grip Helper

This is another special bracket. It allows a flag or scrim to fasten securely to a heavy-duty stand. The grip helper has a 1 1/8 in. pin on the bottom and a 1 1/8 in. receiver on the top. The pin drops into a 1 1/8 in. receiver on the stand. The light then slips into the top end of the receiver, remaining perfectly in the center. The arm extends from 3 ft. to 6 ft. and will rotate 360 degrees. It is fixed at a 45-degree down angle. The grip helper's other end has a 4 ½ in. grip head mounted on it. A 40 in. single extension arm mounts into the 4 ½ in. head. This extension arm has a 2 ½ in. grip head on it that will hold the flag, frame, or net.

Figure 36 Grip helper.

Figure 37 Ground rod/tent peg.

Grounding Rod/Spike

1. Grounding rod/spikes are for electrical ground hookups or for securing guide wires or ropes.
2. They are all steel rods (usually hardened).
3. They are about a 24 in. to 3 ft. 6 in. long spike.
4. Their nicknames are:
 a. Ford axle (they used to use old automobile axles to make them).
 b. Bull pr-ck (use your imagination).

T.O.T.

Use P-tons (little spikes with rings or holes on them) in cracks in asphalt for tie-offs.

Hand Truck

A picture is all you need to explain this tool.

T.O.T.

Watch for DP hand moves during the shot and always float your moves on the dolly. Feather your starts and stops.

T.O.T.

A lollipop is a 4 1/2 in. gobo (large C-stand-style head) with a junior pin attached to the bottom of it, for mounting into a 1 1/8 in. receiver.

Figure 38 Hand truck.

Figure 39a Ladder.

Figure 39b Rolling A-frame ladder.

Ladder

There are two basic types of ladders:

1. Ladders made of wood or fiberglass.
2. Ladders made of aluminum.

 NOTE: Never use an aluminum ladder when working with anything electrical. This could be the fastest way to a short career. It could ground out and cause injury or death. And remember! Don't use the top step; get a taller ladder.

 Other types of ladders you will find on stage are:

3. Rolling A-frame ladder. This ladder has a center ladder that can be raised or lowered as needed.

T.O.T.

Almost every ladder built today has a level or height that should not be exceeded. For example, a six-step or 6-foot ladder has five steps and a top platform, but this top platform is NOT A STEP. Nevertheless, people get careless and use it. *Don't* use the top step; get a taller ladder instead.

T.O.T.

The proper angle of an extension ladder is 4 to 1.

Lamppost System (by Back Stage Equipment)

These lamppost systems are excellent for any pre-rigs or last-minute changes. They are perfect for those swing sets (moving walls) that we squeeze into tight corners of our sets. They are held in place with just four screws.

Mafer Clamp

1. The mafer clamp is a great little clamp. It looks like a C-clamp that has a 5/8 in. pin on it.
2. It has a rubber tip that will attach to most pipes and flat surfaces.

Matt Pipe Adapter Baby

1. The matt pipe adapter baby is a simple yet effective means of securing a light or grip equipment to a pipe or tubing.
2. It terminates in a 5/8 in. pin.

Figure 40a Lamppost system.

Figure 40b Lamppost system with offset.

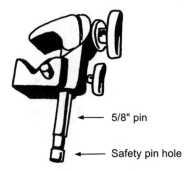

5/8" pin

Safety pin hole

Figure 41 Mafer clamp.

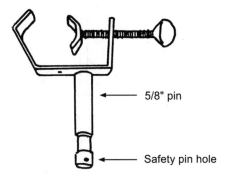

5/8" pin

Safety pin hole

Figure 42 Matt pipe adapter.

Matt Poles—Polecats

1. Polecats are adjustable poles that will support lightweight lighting and grip equipment.
2. They can be used vertically or horizontally.
3. A unique cam-action lock exerts pressure to securely wedge the suction-cup-affixed ends into place.

 NOTE: Only use a mafer clamp or a light-action clamp device on this tool. The reason is that the walls of the tube are thin and designed to have only light equipment hanging from it.

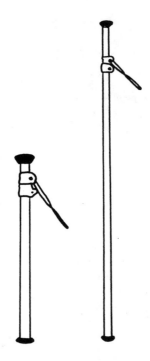

Figure 43 Matt poles—polecats.

Meat Ax

1. The meat ax is a grip-arm-like accessory.
2. The meat ax is designed to clamp onto the hand rail of a studio overhead catwalk or any other suitable surface on which you can put a clamp.
3. The long extension arm is adjustable to pivot in all directions around the clamp.
4. The end of the arm is equipped with a gobo head.
5. A small handle is affixed at the opposite end to facilitate adjustment and positioning.
6. The meat ax comes with two clamp styles, one for the 2 in. x 4 in. handrail and the other for a pipe clamp.

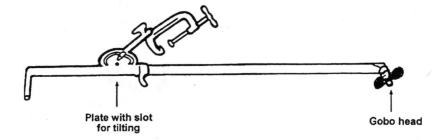

Plate with slot
for tilting

Gobo head

Figure 44 Meat ax.

Miniboom

1. As the name implies, the miniboom is a miniature boom arm designed to support lighting fixtures.
2. The arm is designed for when a limited amount of extension is required.
3. The unit is lightweight, yet provides stability through the use of counterbalance weights.

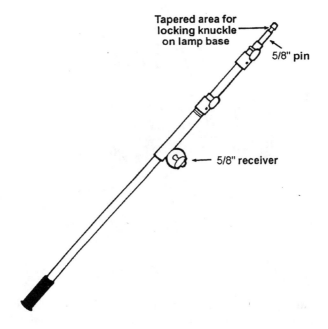

Tapered area for
locking knuckle
on lamp base

5/8" pin

5/8" receiver

Figure 45 Miniboom.

T.O.T.

NEVER safety, rig, or tie off any equipment to a fire sprinkler line.

T.O.T.

I recommend that you get yourself a personal headset. There are two good types. One is like what the Secret Service uses; the headset wraps over one ear with a clip-on mike to attach to your shirt. The other type has an over-the-ear headset with a mike attached.

Muscle Truck (by Back Stage)

The muscle truck, as its name suggests, is a heavy-duty cart. It is used to transport sandbags, cable, or any heavy object that will fit in its well.

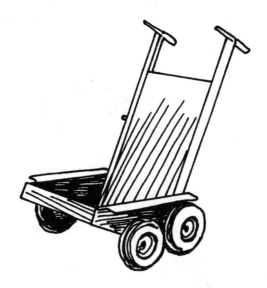

Figure 46 Muscle truck (also known as a *sandbag/cable cart*).

No-Nail Hanger

This bracket easily fits over a 2 in. x 4 in. or 2 in. x 6 in. piece of wood. It will also fit over a door. It has a 1 1/8 in. receiver and will easily convert to a baby pin with a C-stand adapter pin.

Figure 47 No-nail hanger.

Offset Arms

An offset arm will offset the light, for example, when you have to hide the stand outside the room and have only the light itself inside the room.

1. Offset arms are similar to side arms.
2. These are arms that have a receptacle that will fit on a stand that is 5/8 in.
3. A junior offset is the same thing, only with a 1 1/8 in. receptacle at one end and a 1 1/8 in. pin on the other.

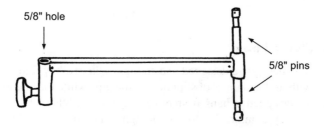

5/8" hole

5/8" pins

Figure 48a Baby offset.

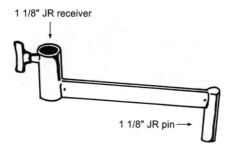

1 1/8" JR receiver

1 1/8" JR pin →

Figure 48b Junior offset.

Parallels

1. Parallels, when totally assembled, are portable scaffolding designed for use as an elevated platform for camera or lighting equipment.
2. All elements are constructed of lightweight steel tubing and are designed to fold for easy storage and transportation.
3. The upper platforms are two sections that may be removed to facilitate the hoisting or lowering of equipment.
4. Parallels can also be supported on screw jacks for leveling on feet or wheels.
5. You can stack one set of parallels on another.

 NOTE: I don't recommend stacking more than three sets of parallels (18 ft. high) when they are built on wheels. You can build the towers without wheels higher, but it is *not recommended*. If you must build such towers higher than three sets, be sure that you tie the tower off at every other level (four-point tie-off) and brace it as much as possible. Remember, *be safe!!*

T.O.T.

When putting a camera on a set of parallels, always screw down a 4 ft. x 4 ft. x 3/4 in. sheet of plywood as a base on the top platform for stability.

Pipe Clamp Baby

1. Pipe clamp babies are designed and strengthened to allow fixtures to hang on a pipe without the danger of slipping off the pipe while the clamp is loose.
2. These are designed to hang from either theatrical or other heavy steel pipes.
3. They are not recommended for use on lightweight or thin-walled pipe or tubing, because as soon as you tighten up the bolt, you'll probably break right through a tube that is too thin.
4. The lock-off bolt can be tightened to hold the pipe clamp any desired position with ease. It terminates in a 5/8 in. pin.

T.O.T.

Always keep your eye on the key grip and the director of photography. Learn to listen for their voices in the middle of a crowd. Try to remember what style of lighting they do and anticipate if a flag or scrim is needed.

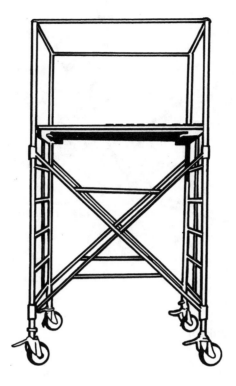

Figure 49a Parallels.

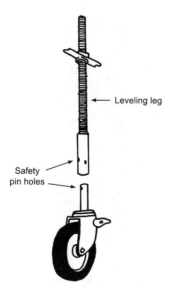

Figure 49b Parallel screw jack.

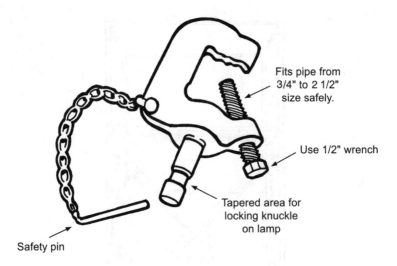

Fits pipe from
3/4" to 2 1/2"
size safely.

Use 1/2" wrench

Tapered area for
locking knuckle
on lamp

Safety pin

Figure 50 Pipe clamp baby.

Pipe Clamp Junior

1. The junior pipe clamp terminates in a 1 1/8 in. receptacle.
2. You can also use a stand adapter pin (also known as a *spud adapter*) with a 5/8 in. pin on one end. The other end has a 1 1/8 in. pin.

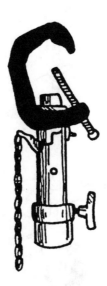

Figure 51 Junior pipe clamp.

Pipe/Tube/Sled Dolly

A pipe/tube/sled dolly is a specialized dolly that was originally designed to ride on sections of standard straight dolly track or tubing. The tube dolly was created to serve as a tracking platform for the older conventional crab dollies (which were not capable of being adapted for track use). The crab dolly would be physically loaded onto the tube dolly. The rear carriage of the tube dolly is back-and-forth adjustable to compensate for the differing wheel lengths of crab dollies. Another application of the adjustable rear carriage is to serve as an outrigger platform for lighting or sound when a camera is riding on the main platform.

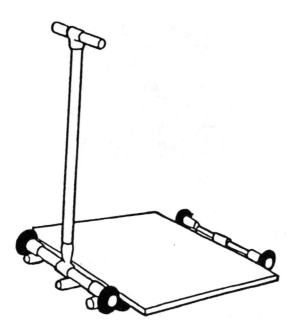

Figure 52 Pipe/tube/sled dolly.

Pony Pipe Clamp

The pony pipe clamp is a heavy-duty clamp that has an adapter with a 5/8 in. pin attached to it. This is a ultra-heavy-duty type of furniture clamp. The clamp consists of a 1 in. outer diameter (OD) tube/pipe that may be changed in length as needed.

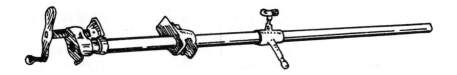

Figure 53 Pony pipe clamp

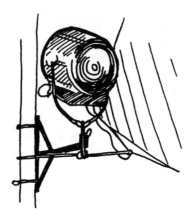

Figure 54 Poultry bracket.

Poultry Bracket (Matthews)

This bracket can be used on a tree, pole, or other items. It has a 1 1/8 in. junior receiver on the top of its arm. On the bottom of its arm it has a 5/8 in. baby pin.

Putty Knife

1. The putty knife is designed to place a 5/8 in. pin where it is nearly impossible to put any other mounting brackets.
2. It is wedged into an area, such as a door frame or window sill.

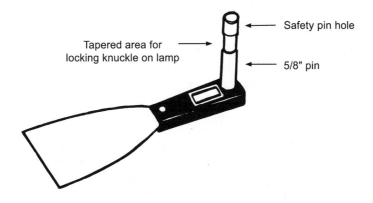

Safety pin hole

Tapered area for
locking knuckle on lamp

5/8" pin

Figure 55 Putty knife.

Reflector

A reflector is designed to redirect or bounce natural or artificial light. The reflector has two sides to it:

1. On one side, it is a very smooth surface. This is called the *hard side*. It will give you a very hard or bright light. It is identical to the practice of using a mirror in the sun to redirect light. It is sometimes called the *lead side*.
2. The other side is called the *soft side*. The soft side of the board will give the subject a diffused pattern of light. A good comparison is a sheet of aluminum foil. When it's fresh from the roll, it's like a mirror, giving a hard side bounce. After crumpling and then uncrumpling the foil, however, it reflects light less strongly and clearly; because of all the wrinkles in the foil, the light is not all bouncing in the same directions, so less light reaches the subject.

At the present time, reflectors usually come in silver, but gold is becoming very popular:

1. Gold boards are used a lot with African American actors and actresses, because it gives the dark skin a nice tone.
2. Gold boards are also used on plants to give them a warmer amber color, much like the color of the "magic hour"—almost the warm, golden yellow-orange color of sunset.

If a reflector is too shiny, we can put on what is called scrim in front of it. This will reduce the intensity of the reflected light, without changing the pattern, from hard to soft. Usually this is accomplished by simply moving the reflector back a few feet. If we cannot move a reflector back, then we use scrims. Scrim sizes are 42 in. x 42 in., and they clip on the board by means of an elastic bungee cord.

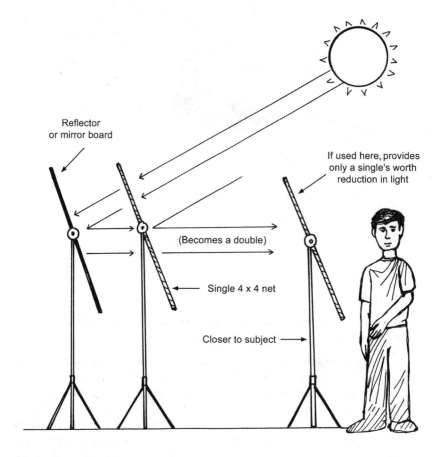

Reflector
or mirror board

If used here, provides
only a single's worth
reduction in light

(Becomes a double)

Single 4 x 4 net

Closer to subject

Figure 56a Reflectors.

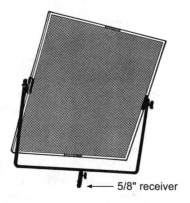

5/8" receiver

Figure 56b Hand reflector board.

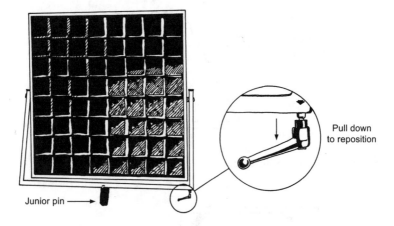

Figure 56c 4 x 4 reflector with soft side shown.

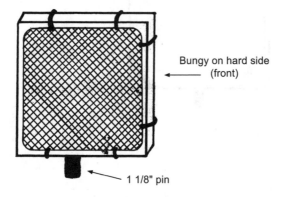

Figure 56d Attaching slip-ons.

Reflector Slip-ons (Scrims)

1. Reflectors can also use a 42 in. x 42 in. slip-on single or double (nets to reduce light) that is held in place by means of an elastic strap.
2. They can only be used on the hard side.
3. If reflector slip-ons are used on the soft side, they will remove all the leaf that is lightly attached to the board.
4. If a single or double worth slip-on is needed in front of a soft side, place the single or double net on an uncovered close-end 4 ft. x 4 ft. empty frame; then put it in place *after* the sun has struck the board. The reflected light is reduced,

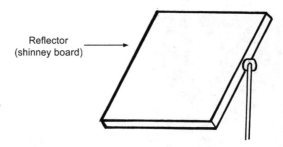

Figure 56e Reflector (Shinney board).

Figure 56f Reflector (back side shown).

for it passes through the slip-on only once. The reason it is done this way is that it is easier to control the reflected light and because there is no damage to the soft side.

Sandbags

1. Sandbags are made from canvas or heavy vinyl bags filled with sand or shot (lead pellets).
2. The bags are placed on all light and grip stands once the stand has been set.
 a. They usually just lay over one leg, but they are sometimes hung by their strap-handle to a low knuckle on the stand being bagged.
3. The bags can come in several sizes. The most common are 15 lb. and 35 lb. bags.
4. Their nicknames are silent grips, because they will quietly hold a stand in place—unlike a grip.

Figures 57a and 57b Sandbags.

T.O.T.
If you do not bag a lamp or stand, it might fall.

T.O.T.

If you are on location and a sprinkler system comes on, quickly put sandbags on the heads closest to where you are shooting.

T.O.T.

When carrying a combo stand with a reflector on it, use a sandbag as a shoulder pad. This way you have your bag right there once you have set your stand.

Scrims—Grip

Scrims are also referred to as nets, which are nonelectrical dimmers. They provide a simple, versatile, yet extremely controllable means of reducing light output without affecting color, temperature, or generating electrical interference. They may be used to reduce the entire beam of light or just a portion of it to creatively control highlights and shadows. Open-end scrims are constructed of spring steel frames to provide constant tension on the net material. The open end facilitates feathering or blending of the edge of the light beam without causing a harsh visual line. Scrims come in three basic configurations—single, double, and lavender. First we will start with the single:

T.O.T.

Sometimes the gaffers or DPs just call for an open end. They don't say the size, and like magic you're supposed to just know what they want.

This is what should be said: "Hey Joe, please get me a 24 in. x 36 in. open-end double," or "Get me an 18 in. x 24 in. single."

Remember! Always bring what is called for in the size wanted plus the other scrim not called for. For example, if a single is wanted, bring it along with a double. It will save you many a return trip when the DP or gaffer sees the single in place. It may not be enough light reduced. Conversely, if a double is called for, too much light may be reduced, thus requiring a single.

T.O.T.

Don't stack large or small nets together; if they fall over, the pin might punch a hole through them.

Single Net

1. The single net will reduce about 30% of the light that shines through it.
2. Its handle is usually painted white or green.
3. On the newer equipment, the outer edge of the net that connects to the frame has a white or green cloth covering for ease in identification.
4. The single is one layer of material only. It looks like the material you make a veil out of, only without a design in it.

T.O.T.

To make a single or double reduce more light, wing (turn) the net's open ends away from its parallel position, laying it almost 45 degrees to 90 degrees from the light.

Double Net

1. The double net will reduce the light shining through it by 50%.
2. It is the exact same material construction as the single net. The major difference is that this one, as the name implies, has two layers of net material. The double net's handle and outside cloth cover is red.

Lavender

1. This is a very delicate net. It will reduce the light by about 15%.
2. The handle's cloth covering on the edge is painted blue or purple, hence the name.

T.O.T.

To make a nice cover for a lavender net and protect the frailness of the material, I will usually cut a piece of show card, fold it in half, and make a sleeve.

Silk

1. The silk net will provide diffusion plus cutting (reducing) of the light. It also causes a softening of the light source.
2. The silk has a gold handle cloth edge.

The actual extent of light reduction for scrims will vary according to the relative placement of the scrim to the light and the subject.

Scrims come in various sizes, and the most common sizes called for are:

1. 18 in. x 24 in.
2. 24 in. x 36 in.

T.O.T.

Before setting a flag, first use your hand at the proper angle to make a shadow; it will save you time.

T.O.T.

The angle of a flag should match the angle of light.

T.O.T.

If you need to use a net, flag, or diffusion next to a window, you can sometimes just tape it to the window with paper tape.

T.O.T.

If too many nets are layered, they will broadcast a design on the subject. This is called a moray pattern. It is similar to looking through a screen door.

Scrims—Butterfly Kits

Okay, let's get to butterfly kits. There are butterfly kits and overhead kits.

1. Butterfly kits are usually smaller in size, usually about 5 ft. x 5 ft. or 6 ft. x 6 ft., and they can be supported by a single stand (although this is not a good practice).
2. Overhead kits are larger, about 12 ft. x 12 ft. or 20 ft. x 20 ft.
3. Butterfly and overhead frames are portable.
4. Both use lightweight tubes.
5. They both can support any lighting control material such as a:
 a. Silk (which diffuses light)
 b. Net (which reduces light)
 c. Solid Black (which cuts light)
 d. Grifflon (which reflects light)
6. Setup time is usually under five minutes.

 NOTE: These textile materials are color-coded for easy identification.

 1. White indicates a single scrim.
 2. Red means a double scrim.
 3. Black signifies a black solid.
 4. Gold/yellow means a silk.

T.O.T.
A word of caution. An overhead kit, such as a 20 ft. x 20 ft., presents 400 square feet of surface area to the wind. This much sail can move a boat 15 knots or better, so don't underestimate the forces that are at play here. Grips have a joke: "Seems like every time you set up a 20 ft. x 20 ft. overhead kit, the wind will come up." So every time you set one up, make sure you have ropes on all four corners; usually 1/4 in. hemp is sufficient. You must tie down a 20 ft. x 20 ft. or a 12 ft. x 12 ft. when you fly it. Otherwise you may be flying to the next county to pick it up.

T.O.T.
It seems that everybody is still just asking for a butterfly kit, even when they want a 20 ft. x 20 ft. or a 12 ft. x 12 ft. kit, which is technically an overhead kit. They assume that a 6 ft. x 6 ft. or a 5 ft. x 5 ft. kit—a real butterfly kit—is the same thing. Oh well; we'll just have to live with it.

Each kit (butterfly or overhead) will usually include a

1. frame,
2. single,
3. double,
4. silk,
5. solid,
6. and sometimes a grifflon (but you better check when you order, never assume).

That makes up a butterfly kit. A grifflon is a separate unit. I will explain what each one does as we go along. Remember when I told you in the scrims section that the material is made out of a veil-like material? You have your single, which is one layer of material, and your double, which is basically two layers of the same material. Butterfly kits are the same as the scrims described earlier, only in larger sizes.

T.O.T.
When using 12 ft. x 12 ft. or 6 ft. x 6 ft. silk, place it with the seam up; otherwise the seam's shadow may show on the actors or product.

T.O.T.
Always put a minimum of four (4) ropes on a 12 ft. x 12 ft. butterfly or larger frame, one in each corner, to tie off the frame when it's in place.

T.O.T.

Blackouts (drops) (e.g., 6 ft. x 6 ft.,12 ft. x 12 ft., or 20 ft. x 20 ft. or larger) will be destroyed by the chlorine in pools. I have been told that there is something in the fire-retardant that has a reaction to the chlorine.

Silks

We use two types of silk:

1. One is called taffeta.
2. One is china silk.

The silk that we use most often is taffeta, which is an artificial silk material. It's more durable than real silk.

The other is a china silk, which is a very fine actual silk.

NOTE: China silk is very expensive, and it rips or snags very easily, so we shy away from using it.

NOTE: Always wrap a silk (china or taffeta) into a ball. Never fold it. The reason for this is that the silk may develop a crease, which will causes a shadow to form on the subject. Also, always use a silk (if possible) with the seams facing up or away from the subject. The seam may also cause a shadow on your subject if it is too close.

T.O.T.

All scrims, silks, grifflons, and muslins are usually made smaller than the frame. For example, for a 12 ft. x 12 ft. frame, the rag (silk, scrim, etc.) will measure approximately 11 ft. 6 in. x 11 ft. 6 in. This undersize allows for tightening the scrim or silk tightly into place by their draw strings (also known as *mason lines*).

T.O.T.

To prevent a tarp from blowing up and down or lifting (flexing in the wind), I always add additional ropes every 10 feet when the tarp or solid is dead hanging (vertical), or I use an X-shaped pattern of ropes across the top and the bottom when the solid (rag) is flown in a horizontal position. A 1/4 in. hemp rope is fine to use.

T.O.T.

When deciding the difference between a bleached and unbleached muslin by eye, the bleached will appear very white, like a sheet, and the unbleached will appear almost like the color of light beige. The Kelvin difference is about 800 degrees, I am told.

Scrims—Flex

1. Flex scrims are lightweight smaller versions of regular scrims.
2. They are designed to be used in conjunction with articulating arms (flexarms).
3. Their usage is similar to that of fingers and dots.
4. Their size is usually 10 in. x 12 in..
5. They come in:
 a. open-end singles
 b. open-end doubles
 c. open-end silks
 d. closed end
6. They are used where a larger flag will not work.

Figure 58 Flex scrim (also known as a *postage stamp*).

Figure 59 Side arm.

Side Arms

Side arms, which are adjustable in length, are designed to clamp onto a round surface of 1 in. to 1 3/4 in. in diameter.

1. They provide a mounting platform for lighting or grip equipment.
2. Common applications include attaching them to lighting stands for low-angle placement.
3. Another common use is hanging the arm from overhead pipe grids.
4. The baby side arm terminates in a double-ended 5/8 in. pin.
5. The junior has a 1 1/8 in. receiver.

T.O.T.

To *pan* means to rotate the camera right or left

Stair Blocks

1. Stair blocks are small wooden blocks attached together like a set of miniature steps, offering a variety of elevations.
2. They are commonly used for elevating a table, couch, and other items.
3. Each step is approximately 2 in. higher than the last, with approximately 4 in. between steps.

T.O.T.

Legal Milk Crate = Not Stolen.

2" x 4" step blocks Step blocks in stored position

Figure 60 Stair blocks.

Stand Adapter Pin

1. The stand adapter pin is a pin with a 1 1/8 in. base and a 5/8 in. pin on top.
2. This pin will go into a combo stand or high roller with a receptacle, if an adapter is needed.
3. The nickname for the stand adapter pin? It is usually called a *spud*.

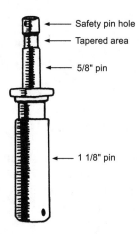

Safety pin hole

Tapered area

5/8" pin

1 1/8" pin

Figure 61 Stand adapter pin.

T.O.T.

A dollar bill is 6 in. long.

T.O.T.

Charlie bars are long wooden sticks usually 3 to 4 feet long with different widths, ranging from 1 in. wide to approximately 6 in. wide. They are made from luan (thin plywood) or 1/8 in. to 1/4 in. thick plywood. A 3/8 in. pin is attached for mounting a C-stand. Charlie bars work great as gobos, flags, or shadow-makers to make a soft shadow, such as a window pane or whatever is needed. They are also known as *sticks*.

Stands

Okay, you've made it this far. Good for you. Now we are going to start explaining stands to you. There is this one stand that is used the most by far, as you may have gathered by how often we've already mentioned it. It is called the C-stand.

T.O.T.

Order a box of crutch tips (so-called due to their use for things that lack a tip) as a quick repair for stand legs that might scratch a set floor. Such locations include set stages and "practical" locations, such as a house, office building, or any place you could damage the floor.

C-Stand

1. The C-stand is short for *century stand*, and it gets its name (legend has it) from how long it will take you to master using it.
2. It is also called the *gobo stand*.
 a. The dictionary describes a gobo as an object used to block light from a subject, so it is only reasonable that a stand that holds a gobo is a gobo stand. Well, the C-stand is considered to be the workhorse of the industry.
3. The century or gobo stand is designed as a multipurpose support for flags, lighting fixtures, prop stands, and other items that must be held in place on set.
4. The legs are staggered in height, allowing them to fit in, around, and under furniture, props, and other lighting stands.
5. A "sliding leg," also called a *rocky mountain*, is available on some stands. This feature permits one leg to be raised so that it can rest on an elevated surface, such as a stair, counter, sink top, and so on.
6. The standard 40 in. double-raised stand can reach approximately 13 ft. 8 in. or so.
7. A century stand weighs about 11 lbs.
8. All stands are constructed of durable lightweight alloys.
9. Each of the stand's risers is a tube inside a larger tube, which will telescope about 38 in.

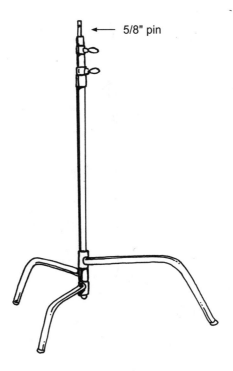

5/8" pin

Figure 62a C-stand without a head or arm.

10. The C-stand is used with a head on it called a grip or gobo head.
 a. This holds a 40 in. tube or extension arm with another head on it called a gobo head.
 b. The grip head sits on the century stand by means of a 5/8 in. diameter pin/rod, which, by the way, is the standard size for most lighting units under 2,000 watts).

T.O.T.

When you hand off a C-stand to an awaiting hand, make sure you have grasped around the C-stand main post and the long gobo C-stand arm. If your fingers are wrapped only around the center post, they will get crushed as if they were in a nut cracker.

Figure 62b C-stand head and arm.

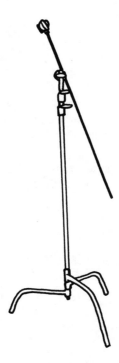

Figure 62c Full C-stand.

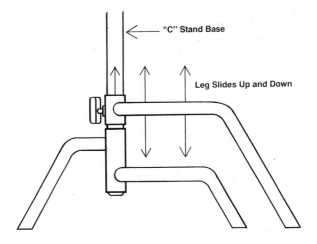

Figure 62d Rocky mountain leg.

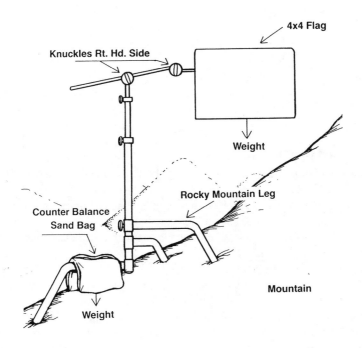

Figure 62e Stand setup for mountain locations.

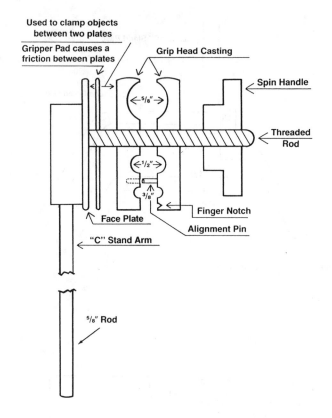

Figure 62f C-stand head.

C-Stand Operation

1. Most 2 1/2 in. grip heads and gobo heads are designed to receive a 5/8 in., 1/2 in., or 3/8 in. round accessories.
2. They will also accept an object of irregular shape, if not in the holes then between the flat plates, as shown in Figure 62f.
3. The head consists of a knob or knuckle, with an outside and inside plate that butts up to a flat portion of the head.
4. The plates keep their holes aligned by an alignment pin between the outer and inner plates, which are attached to one plate while the other plate has a hole for free floating.
5. The C-stand should always be used with the knuckle "on the right." The quickest way to show the rest of the crew that you are inexperienced is to forget that golden rule. The reason the knuckles are on the right is that any time a flag (which is a weight) is put in the head, gravity will pull it downwards. The knuckle or knob is tightened clockwise. The weight of the flag will cause the

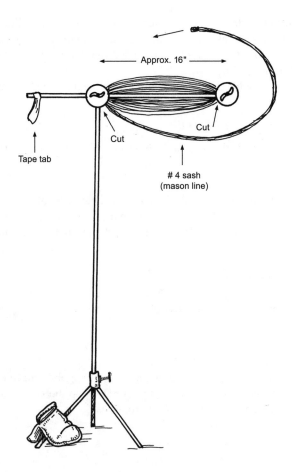

Figure 62g How to cut several lines the same length.

head to bite by pulling down (clockwise), causing a friction action and locking it in place.

6. The C-stand should be placed with the knuckles on the right with a leg placed in a forward position. This will help support the weight of an object such as a flag from falling over forward.

7. To help prevent the C-stand from falling over, a sandbag is placed on the rearmost leg to act as a counterbalance.

8. By the way, just a side note: always place a sandbag on a C-stand whatever configuration it is in. All you have to do is forget just once, and *Wham*, an accident.

If you have to put a large object in a C-stand head, such as piece of 1 in. x 3 in. lumber, always remember to install a wedge in the bottom of the head on the other side.

1. Let the head bite the 1 in. x 3 in. piece of lumber first; then slide the wedge in. Now tighten the knuckle/knob until they are both clamped in the head.
2. The wedge is used to prevent the threaded rod that holds the locked plates of the head from bending.
3. This trick also holds true when using an overhead stand (*high roller*).

T.O.T.

Tape the feet of stands that do not have plastic feet from the factory.

Okay, that wasn't so tough. As I said in the beginning of this book, I will tell you more about C-stands and how to use them after you remember what they look like. Now for the rest of the stands. They are used a lot, but not as much as that last monster.

T.O.T.

In wind, use the thickest risers possible.

T.O.T.

Use a gobo arm to stop gel from blowing. Press the gobo arm lightly against the center of the gel, putting enough pressure to stop the gel from flexing in the wind and creating unwanted sound problems.

T.O.T.

Here is a normal rule of thumb: one rise up equals 1 sandbag; 2 risers up equals 2 sandbags; and so on.

T.O.T.

Always try to place the bag on the leg opposite the weight. But if the weight is down the center, such as a light sitting on the middle of a stand, any leg will do.

T.O.T.

When you see a light being carried to a set, you should anticipate that it will need a flag. Get a flag just the size of the unit or larger, plus a C-stand and a sandbag. It is better to have it close and look like you're doing your job than to be told, "Run and get me a flag." (Remember, always bring a C-stand and bag as well.)

T.O.T.

If you have to grab a head and arm off of a C-stand, always pull it from the back of the pile.

T.O.T.

If the need does arise, a grip can put a metal scrim in a C-stand and set it in front of the light, as opposed to installing the metal scrim in the light itself.

T.O.T.

Turtle stands are low base stands used to mount lights low. If none are available, a skid plate with a junior receiver on it will also work.

Low-Boy Stand

1. A low-boy stand is nothing more than a combo/light stand—only lower.
2. It can be used as an umbrella stand, but it was designed specifically for when a combo/light stand could not be used due its height.
3. The receiver is a 1 1/8 in. hole.

T.O.T.

When you see a safety problem, always point it out to your boss.

T.O.T.

When you break down a setup, always realign the knuckles on the stand, preparing them to be ready to go back into action.

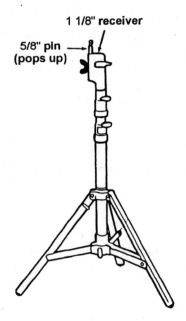

1 1/8" receiver

5/8" pin
(pops up)

Figure 63 Low-boy stand.

Reflector (Combo/Light) Stand

1. Combo reflector stands are considered to be the standard type for use with reflectors.
2. The stand was originally designed for mobile or location production, back when studios were just beginning to get away from the backlot concept.
3. The combo stand features a three-leg base with a folding brace in each leg.
4. The stand is portable, yet it has enough heft to stand a moderate gust of wind blowing against the reflector surface.
5. The name *combo* is an abbreviation for combination, referring to the fact that the stands are used to support a variety of exterior lighting fixtures.
6. The combo/light stands are available with a "rocky mountain" leg (not a sliding type leg).
 a. One leg will telescope out a tube inside a tube.
 b. The knob on this sliding leg is used to adjust the sliding leg into position to facilitate leveling on uneven terrain.
 c. The combo stand receptacle is 1 1/8 in.

NOTE: You will find that most light from 2,000 kW to 12,000 kW have a 1 1/8 in. pin.

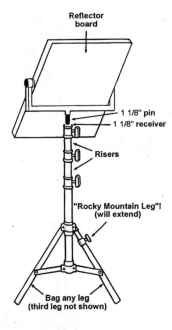

Figure 64a Reflector stand with "rocky mountain" leg.

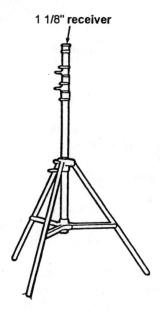

Figure 64b Reflector combo/light stand.

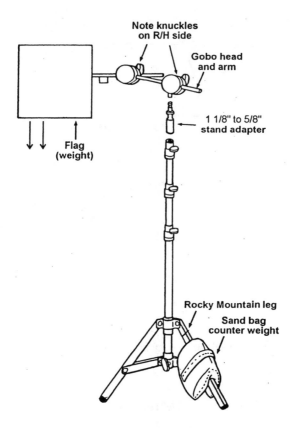

Figure 64c Reflector stand with gobo head and arm.

Overhead (High Roller) Stand

1. Although *overhead stand* is the proper name, we just call it a *high roller.*
2. There are several sizes of high rollers.
 a. They can range from junior to high to high-high.
3. Depending on what job you are doing, you will determine which one you will need.
4. These are also wide-based units that are designed for extra stability.
5. The legs slide up and down the center shaft to work in a tighter environment.
6. The high roller stands are primarily for exterior work or on stages where you need a beefy stand.
7. Some of the high roller stands have a grip head, which is a 4 1/2 in. head that is almost identical to the C-stand's 2 1/2 in. head.
8. Most new high roller stands have grip heads with a receptacle on the backside that will receive a 1 1/8 in. diameter pin.
 a. Another standard size to remember is 1 1/8 in.

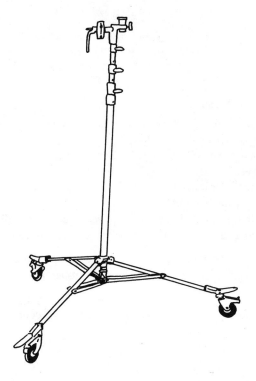

Figure 65a Overhead stand (also known as a high roller).

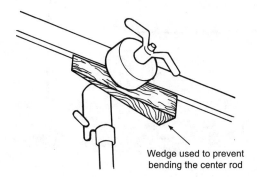

Wedge used to prevent
bending the center rod

Figure 65b Overhead stand with a wedge.

T.O.T.

Tennis balls make excellent safety tips on stands or any protruding object onto which a ball will fit after it has been punctured.

Overhead Stand Usage

1. The overhead stand or high roller is usually used to hold anything that has to go higher than a C-stand can hold it.
2. An overhead stand is also stronger, with a larger gobo head (but it does not have a gobo arm).
3. If need be, a gobo arm from a C-stand can be used by inserting it into the head of the overhead stand.
4. The high roller tubes, called risers or stems, are larger in diameter than a C-stand. For this reason it is not as apt to bend in a high wind situation.

It is a good practice not to raise the first riser above 18 in. If the high roller is stemmed (raised) completely up, the top riser might bend in a strong wind, due to the reduced diameter of the tube.

NOTE: Remember, people, it is only a tube, so use your common sense.

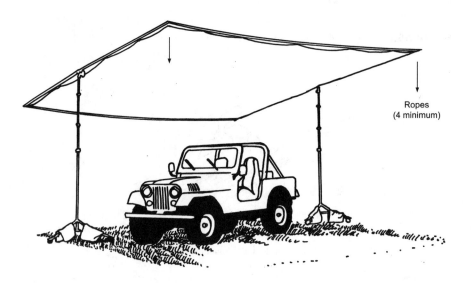

Ropes
(4 minimum)

Figure 66a Overhead frame with silk.

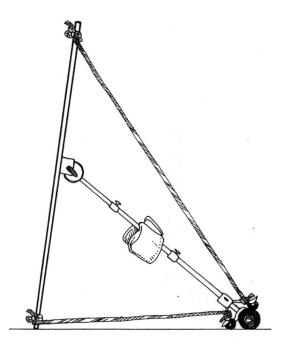

Figure 66b 12 x 12 overhead set for wind conditions.

T.O.T.
Always unlock your high roller wheels before you fold the base up. This will allow the roller to fold correctly.

T.O.T.
A junior riser can sometimes be used in a high roller or mombo combo if the stand has a junior receiver on it. This means that you can make the stand taller. Make sure you bag it heavily.

Stand Extensions

1. The stand extension will add extra height to various light and grip stands.
2. The extension attaches directly to a 5/8 in. pin or a 1 1/8 in. receiver, depending on the style of stand.
3. The extension comes in various lengths.

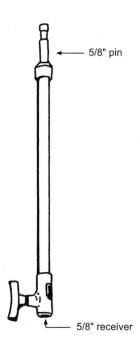

5/8" pin

5/8" receiver

Figure 67 Stand extension pin.

4. If it's a 5/8 in. pin, it can be 3 in., 6 in., 9 in., or up to 18 in. long.
5. If it's a junior riser or junior stand extension, then it usually comes in a 36 in. rod that terminates in a 1 1/8 in. receiver.

T.O.T.

A stand extension works in place of a short rod (norms pin).

T.O.T.

A lot of grips have 3 or 4 rods of aluminum or steel that are 5/8 in. in diameter and about one foot long. Some grips have even drilled 1/8 in. diameter holes through the rod about 1/2 in. from the end for safety pins. These rods are great for hanging lights from a C-stand or gobo head.

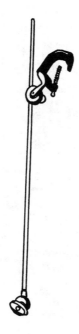

Figure 68 Studio overhead grip arm on pipe clamp.

Studio Overhead Grip Arm

1. A studio overhead grip arm is an overhead C-clamp that terminates in a century-stand-like grip head with an extension arm.
2. This unit can be clamped onto a pipe or a grid to hold flags, scrims, and other items.

Taco Carts

The Grip Senior and Junior—also known as the *taco cart*—is made by Backstage Equipment. These grip carts are designed by Carrie Griffith, a key grip who knew just what grips needed and the owner of Backstage Equipment. The following carts are used daily by several departments (grip, electrical, and props), just to name a few. Remember that all the carts can be special ordered to your design as well.

The Grip Senior
The Grip Junior
The Large Grip Cart (Modern style)
The Small Grip Cart (Modern Style)
The Century Stand Cart

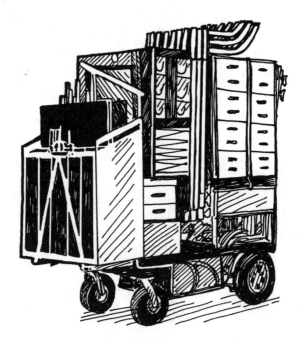

Figure 69a The Grip Senior (also known as the *taco cart*).

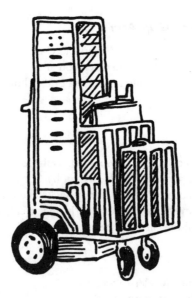

Figure 69b The Grip Junior.

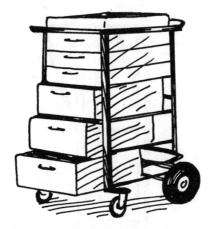

Figure 69c Small cart.

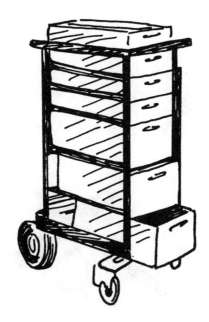

Figure 69d Large cart.

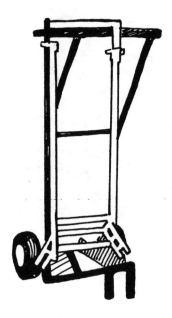

Figure 69e The century stand cart.

T-Bone

1. The T-bone provides rigid support for the low positioning of junior and senior lighting instruments.
2. The T-bone may be nailed to the floor. (If it's not nailed, ALWAYS BAG IT.)

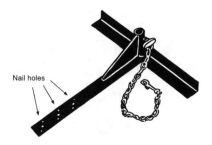

Nail holes

Figure 70 T-bone.

T.O.T.

Use sunglasses if no contrast filter is around to check for cloud. Hold them at arms length and look at the *reflection only* of the sky and the clouds in the shaded glass. Never look directly at the sun!

Telescoping Hanger—Stirrup

1. Telescoping hangers are designed for hanging lighting fixtures from overhead grid pipes, extending these fixtures well down into a set.
2. The hangers can be adjusted for length and also permit pivoting around the vertical axis of the C-clamp.
3. The single hangers have a maximum length of 3 ft., and the double telescopes from 3 ft. to 6 ft.
 a. The hangers end in a ½ in. x 13 in. pitch female thread, into which a stirrup or other accessories can be bolted.

T.O.T.

Don't move, and don't talk to or make eye contact with actors, during filming.

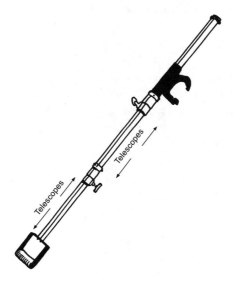

Figure 71 Telescoping hangers.

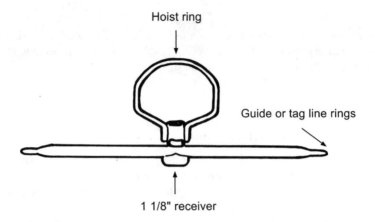

Figure 72 Trapeze.

Trapeze

1. As the name suggests, a trapeze is designed to swing over a set where no over-head light is available, or where the grid is too high.
2. By attaching a chain to the center of the horseshoe, the trapeze can be dropped onto the set.
3. You can also use a rope on a trapeze.
4. The rings on either end receive ropes that are used to center the fixture.

T.O.T.

Good safety practice: When you are letting a cameraperson off of a riding crane, step on the arm, have another grip take the place of the cameraperson, lock the brakes, put the arm on the chains, and reduce the lead or mercury for counterbalance.

T.O.T.

Always carry ear plugs in your personal bag.

Trombone

1. Trombones are named for the way in which they bend or telescope.
2. They are designed to hang from a set wall and to adjust to the width of the wall.
3. A rubber ball on the telescoping shaft keeps the mount from marring the wall surface.
4. The only difference between the baby and the junior trombone is the mounting device: a 5/8 in. pin or a 1 1/8 in. receiver, respectively.

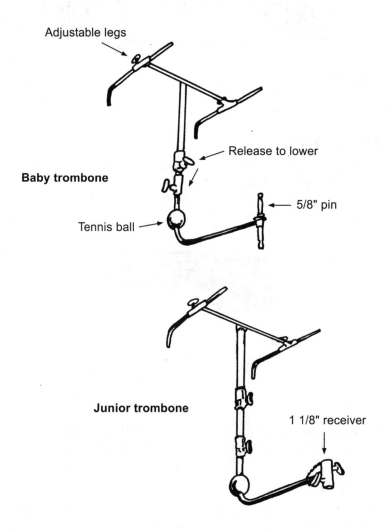

Figure 73 Trombones.

Tube Stretcher

1. Tube stretchers are made out of pipe instead of wood.
 a. Basically, they fit inside a wall spreader and do the same thing as a wall spreader. (See wall spreader section.)
2. I strongly suggest not going over a 16 ft. spread.

Figure 74 Tube stretchers.

Tubing Hanger

1. A tubing hanger is used to support overhead frames or other types of rigging.
2. One end fits into a 4 1/2 in. grip head.
3. The opposite terminates in a clamp designed to hold pipe or tubing 1 in. to 2 in. diameter O.D. (outside diameter).

Figure 75 Tubing hanger.

Turtle

The turtle base stand is perfect to mount a large lamp very low. The one pictured in Figure 76 is equipped with wheels. They also make them without wheels.

Umbrella

Okay, here's a tough one. This is called an umbrella. You guessed it, it's nothing more than a large picnic-like umbrella. And who usually gets it? The director or cameraperson. (Remember, these are the guys and gals who called you.)

Figure 76 Turtle base.

Figure 77 Umbrella on low umbrella stand.

Wall Sled

1. The wall sled is a mounting device designed to support lighting equipment from a set wall without the necessity of nailing directly into the wall.
 a. The weight of the fixture exerts pressure to force the sled against the wall.
 b. The weight of the entire unit is supported by a chain or a rope that is secured to the top of the set.
2. The baby wall sled is equipped with dual 5/8 in. pins.
 a. While the first pin is holding a lighting fixture, the other may be utilized to hold a grip arm or head.

The junior and senior wall sled are the same in size. Both of them have 1 1/8 in. receptacles. Now, usually when we refer to "baby," we are talking about a 5/8 in. pin, and when we refer to junior, we are talking about 1 1/8 in. (a little side note for you).

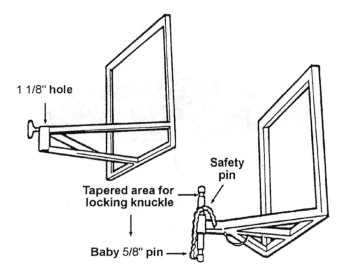

Figure 78 Wall sled.

Wall Spreader

1. Wall spreaders are used to suspend grip and lighting equipment wall-to-wall by inserting a precut 2 in. x 4 in. or 2 in. x 6 in. into the mounts, then wedging the complete unit between the walls.
2. Supporting pressure is extended by a screw device. Caution must be taken in not applying too much pressure.
3. It is also recommended that wall spreaders should be positioned in direct line with the wall studs.

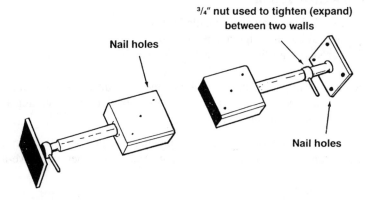

Figure 79 Wall spreaders.

Wall Bracket (Set)

1. Similar in design to baby plates, wall brackets are fitted with 1 1/8 in. receivers.
2. The junior wall plate can be nailed in either a vertical or horizontal position.
3. The set wall bracket provides an extremely stable base for mounting a fixture on top of a set wall.

T.O.T.
Ensure that all electrical open-ends are taped off. An electrician will or should do it.

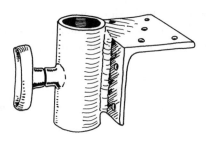

Figure 80 Wall bracket (set).

Wall Plate—Junior

1. Junior wall plates may also be called set wall brackets.
2. They are similar in design to a baby plate.
3. These products are fitted with a 1 1/8 in. receiver. (Hey, there's that number again.)
4. The junior wall plate can be nailed, in either a vertical or horizontal position.
5. The set wall bracket provides an extremely stable base for mounting a fixture on top of a set, wall, and so on.

I will show you the use of all this equipment as we go along. If you run out of baby plates, drop a spud adapter (stand adapter) in it, and then you have a beefy baby plate.

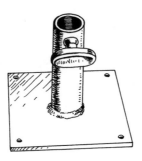

Figure 81 Wall plate (junior).

T.O.T.

P.O.V. (point of view) = What a person is seeing from their perspective.

Wedges

1. This is exactly what you think it is—a wedge.
2. A wedge is usually 10 in. x 4 in. x 1/16 in. and tapers to 1 in. thick.
3. You will find it to be one of your most used pieces of equipment.

T.O.T.

Cut two full wedges to 3/4 in. at their highest point. This is a great way to get on the dolly.

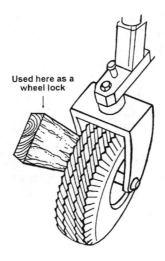

Figure 82 Wedge, used here as a wheel lock.

Western Dolly

A western dolly is somewhat similar in design to the doorway dolly, but the western is much larger and is capable of transporting a heavier load. Its larger wheels offer a smoother, steadier ride than the smaller dollies. The western can be fitted with flotation track wheels and (unlike the doorway) can be operated on curved track.

Figure 83 Western dolly.

Applications for the western dolly include use as a camera dolly, equipment transporter, or low platform behind a camera car.

The push bar can be tilted down 34 degrees by use of the tilt adapter for operator convenience. The bar can also be side-mounted for close shots. When the western dolly is used inverted, the platform clearance is raised for use over rough terrain.

Two recent additions to the western dolly include the turret assembly and the pop-off wheels. The turret assembly allows for the mounting of two seats and a complete camera configuration supported by a Mitchell base. This is the standard mounting base for most cameras—it is flat with a key slot. The pop-off wheels allow for the quick removal of the dolly wheels for easy storage. The axle is captivated into the wheel assembly to prevent the axle from becoming separated from the wheel upon removal.

Expendables

Automatic Tape Gun (ATG) Tape

Automatic Tape Gun (ATG) Tape is a clear, double-sided sticky tape. When using this tape, it is best to use only a short strip of it, approximately 1 in. to 2 in. long. It's like that old commercial—"a little dab'll do ya." This stuff works great. Use it on wood or glass, or for putting up gels—although remember that it can make a gel unusable if the sticky tape touches the wrong spot.

Remove the old gel from ATG tape by simply pulling off the sticky tape. Some tape will remain on the gel, but most of the tape will remain on the surface to which the gel was applied. To remove this remaining tape, use about a foot or so of gaffers' tape. Stick it on the ATG double-face tape (the sticky stuff) that was left behind, rub your finger on the back of the gaffers tape, and press firmly so that it will stick to the ATG tape. Now simply pull the tab on the gaffers' tape. When the gaffers' tape is removed, the ATG tape should come with it.

Actually, you will have to press the gaffers tape on the ATG tape several times to remove all the ATG tape. (Sort of like removing lint from your clothes.) By the way, grips always try to clean up their mess. That's what the real Pros do!

T.O.T.

Use photo mount spray to attach gels to windows. This is a great way to make a gel stay in place when gelling in a high-rise building.

T.O.T.

Put a tiny tab (about an inch) of ATG tape on the baby plate back to help hold it in place while you put in the screw.

T.O.T.

ATG tape is sometimes called snot tape.

Baby Powder

We use baby powder on a dolly track (steel and wood) to prevent the wheels from squeaking when rolling along the track.

T.O.T.

Spray oil or talc powder on the dolly wheels as you roll the dolly up and down the track. This will transfer the lubricant to the needed area and make less of a mess.

Bead Board

Bead board comes in 4 ft. x 8 ft. sheets of foam about 3/4 in. to 1 in. thick, although it does come in thinner or thicker sheets as well. It has a very porous surface that does not bounce all the light.

T.O.T.

Bead board can be used to insulate a wall or door if you are having a sound recording problem.

T.O.T.

Tape foamcore to the back of bead board to give it rigidity in a windy area. This will help prevent the bead board from breaking in half.

Black Wrap

Black wrap is nothing more than an aluminum foil coated with a heat-resistant, dull (matte) black surface on both sides. It has many uses. I use it as a heat shield to prevent a hot light from blistering wood or paint from their surfaces. Just tear off a sheet like you would aluminum foil and place it between the lamp and a wall. It will act as a heat sink and a reflector of the heat at the same time, and it will act as a cutter of light to prevent spill from the wall without bouncing back any light (as regular aluminum foil would). It can also be used on a flag that may be required to be too close to a light. This usually saves the flag from burning.

T.O.T.

Use aluminum foil or black wrap (black foil) as a heat stopper. A sheet may be laid on top of a light to act as a heat shield to prevent blistering paint or cracking windows (if it is used behind a light).

T.O.T.
Never form-fit foil to a light, because it will destroy the light. Black wrap a light loosely. If wrapped too tightly, it will cause the globe to heat up and burn out.

Bobinett

Bobinett is the mesh veil-like material that we use to make our scrims (single or double nets). We order it by the yard. We also stretch it over a neon light to lower the light intensity a little. (Note: Neon lights cannot be fully dimmed.)

Butcher Paper

Butcher paper comes in rolls of paper approximately 100 ft. x 3 ft. wide. This is used to cover walks, floors, or painted surfaces. It is just a heavy plain brown paper.

Clothespins—C-47s

The clothespins we use, which we also call *C-47s*, are the wooden clothespins with the metal springs. We use these to hold cut pieces of gels in place on the light doors, or any place else that a clamp action is needed. I've been told that the nickname C-47 began because the old major studios used to keep such clothespins in bin #C-47—but who knows for sure?

T.O.T.
Wooden clothespins are sometimes called bullets or C-47s.

Drywall Screws

Drywall screws are very sharp-pointed screws in different lengths that are used with battery-powered screw guns.

T.O.T.
Slightly angle a dry wall screw, about 5 degrees to 10 degrees off normal (90 degrees from level), when screwing it into a stick of 1 in. x 3 in. lumber. This helps prevent the lumber from cracking.

T.O.T.
Circle your screws in set walls.

Dulling Spray

Dulling spray, as its name implies, will dull down a surface, such as chrome or a mirror, giving the surface a fogged look. It is often used to prevent reflections such as a stage light bouncing off an object, or to mark or hide a camera's own reflection during filming. Next time you watch a movie, look at a mirror on a car or the contour of a car fender; chances are it will look like it has a morning dew on it (even if it's 97 degrees outside!). Dulling spray wipes off with a clean cloth without leaving much more than a light wax-like surface residue.

A warm, moist towel will usually remove all traces of dulling spray. If you run out of dulling spray and you need something, anything, to get rid of a "hard kick" (a reflection, usually from the sun or a lamp), you can be a genius—the hero of the hour—just by asking a makeup person for some hair spray. It will work—not as well as dulling spray, but well enough to get the shot. A light coat or mist of streaks and tips will work too.

Duvatyne

Duvatyne is a tough canvas-like black cloth. It has been saturated with a fire-retardant chemical from the factory. It is used to make the flags and cutters we use in the motion picture industry. We also carry a roll of Duvatyne when we go on location. The roll comes 48 in. wide by whatever length you order (it is usually sold by the yard). We use Duvatyne to black out a window and give the appearance of nightfall outside during a daytime shot. Sometimes we use Duvatyne as a shoulder pad or a scratchproof cloth. It will be a very handy and often-used item in your inventory. By the way, it does not work as a spill wipe or a cleanup rag, due to its fire-retardant chemicals.

T.O.T.

To make a Duvatyne Poncho, peel off about 4 ft. to 5 ft., cut a hole approximately 18 in. from one end, and use as a large black bib for reflections of the people behind the camera.

T.O.T.

If you are working on the set, I suggest that you wear dark clothing to avoid reflection problems.

Foamcore

Foamcore comes in a 4 ft. x 8 ft. sheet. It is a thin piece (3/16 in., approximately) of foam laminated on both sides with a strong paper that has a glossy white

finish. It is used to bounce (redirect) light from the source onto an object. Foamcore comes in two colors:

1. White-on-white, which means white on both sides.
2. Black-on-white, which means black on one side and white on the other.

The dull black side is often used as a teaser, or a cutter of light.

T.O.T.
To give the light effect that cars or people are casting shadows on a subject, create a windmill that has a center-mounted pin. Now cut out 3 in. x 36 in. slots from a 4 ft. x 4 ft. piece of foamcore, then spin it slowly in front of a movie lamp.

T.O.T.
Poor man's light process: Cut a 4 ft. x 8 ft. foamcore to 4 ft. x 4 ft. Put it on a gobo arm like a windmill. Cut holes through it. Shine a light through the holes as it spins.

T.O.T.
Sometimes it is wise to cover a painted surface with foamcore to deflect the direct heat from a lamp. Remember, a heat shield will reduce heat, but it is even better to be overprotective.

T.O.T.
Use florists' frogs (bases for flower arranging) on foamcore and a show card. They look like 20 #4 nails standing tips up in a lead base. We use a range of sizes, from 1 in. to 4 in. They are round, square, or rectangular, but it does not matter what the base shape is, as long as they fit into the area needed. (Used to hold foamcore in place to bounce light onto the subject.)

Grip Chain

Grip chain is what most grips in the industry use to secure (tie down) almost everything, ranging from a large light stand to a chain that has to stay in place. It is a must on all shoots. It is also called *sash chain*.

Laminated Glass

Laminated glass is used to protect the camera's lens (see Lexan), if you cannot get or afford Lexan. The laminated glass we use is usually a 24 in. x 24 in. piece of glass attached to a sheet of 1/2 in. plywood with a square hole cut through it (approximately 20 in. x 20 in.). If you attach the glass with cribbing, you can cut the cost down and do pretty much the same job. The reason we prefer to use Lexan is that it is lighter and faster to work with—and this is a business where speed and safety go hand in hand.

Layout Board

Layout board is a thin (approximately 1/16 in.) piece of cardboard that comes in 4 ft. x 8 ft. sheets. It is used to cover floors and surfaces to save them from being marred.

Lexan

Lexan is clear plastic that we use in front of the camera to help protect the operator and camera from an explosion that is being filmed or from a gun shot near the camera. Lexan comes in 4 ft. x 8 ft. sheets of various thicknesses. I feel the safest when the Lexan is at least 1/2 in. thick. To cut Lexan, use a combination saw blade on a 7 1/4 in. circular saw. Use a carbide-tipped blade. Let the blade settle its way through the plastic; then make your normal cut through the plastic.

T.O.T.

Lexan is sometimes used for explosion-proofing a camera. It is also used for coffee tables and bank security.

Penny Nails, #8 and #16

At about 2 1/2 in. long, #8 penny nails are smaller than #16 penny nails, which are about 3 1/2 in. long with a little thicker shank and a wider head. These nails are common or duplex (double) head nails. (The word "penny" comes from the weight of the nail from days of yore.)

T.O.T.

If you hammer a nail tip before driving it into a piece of lumber, it aids in preventing the wood from splitting.

T.O.T.

I highly recommend that you use a double-headed nail such as a #8 or #16 duplex, when using grip chain (sash chain) to secure a stand on a parallel. The drywall screws that are now being used seem to have their heads pop or break off. I always use two nails at both ends of the chain. The first nail starts and secures the chain to the wood base. I place the second nail up the chain a couple of links, and drive it in to tighten any slack from the chain.

Plywood

Always use at least 3/4 in. A/C plywood. It is strong enough to support the weight of a dolly. The reason we use A/C is that the A-side of the plywood is very smooth and will act as a good tracking surface. The C-side has knots or is rough, but that's Okay. This side will lay on the ground. Birch plywood at 3/4 in. is super smooth and strong, but twice the price.

T.O.T.

Always use A/C plywood or A/D plywood for dolly track.

Pushpins

A pushpin is used a lot to put up gels on wooden window frames. Always put a small tab of tape on the gel where the pushpin is going to enter. This will prevent the gel from tearing where the pushpin has pierced it.

Sash Cord #8

Sash cord #8 is a clothesline type of white cloth (not vinyl) cord that is used for many purposes. It is also called *cotton cord*.

T.O.T.

Wrap all rope and cable in a clockwise direction. This way the next technician will wrap it in the same direction, preventing tangles. Wrap rope in a 2 ft. loop and cable in a 14 in. to 16 in. loop—about the size of a basketball hoop.

T.O.T.

Put a safety rope on all lights that are hung.

Show Card

Show card comes in 32 in. x 40 in. cards. Those that are dull black on one side and white on the other are most often used, although they come in a rainbow of different colors. Show card is made of a cardboard-like material that is a little thicker than a cereal box, about 1/16 in. It is used to bounce (redirect) light in a small quantity. Show card can easily be bent or curved to bounce light around both the side of an object and the front at the same time. It is sometimes laid in an actor's or actress's lap to create a fill light on their clothes or faces. It is a soft look. It is often called art card.

T.O.T.
Clip a show card to a flag to create a support backing for setting in a stand.

T.O.T.
Use a metal scrim to draw a circle on foamcore or a show card.

Silicone Spray

This is a dry type of lubricant. It is used where you cannot use an oil spray. I use it on steel dolly track in the dirt, because dirt will not stick to the track as easily as it does with spray oil, but this is only my personal preference.

Spray Glue

Spray glue is a strong aerosol spray glue. It is fast and works great wherever you may need to glue something.

Spray Oil

Spray oil is an oil that is used to lubricate any moving part so that it will work properly. It also aids in preventing a squeak or noise during a sound take.

Staples

Staples are used like pushpins to install gels. It is faster and easier to staple up a gel, but harder to save the gel when you remove it.

T.O.T.

When giving a staple gun to someone, *always* bring refills. If you don't, I promise you the stapler will run out every time. Shoot a long staple on an angle, which is the best way to get the staple back out.

T.O.T.

Always use a tab of tape to staple through the gel; otherwise it will tear very easily.

Stove Pipe Wire

Stove pipe wire is a black multipurpose wire that is sometimes called baling wire because it is the same as the wire used on bales of hay.

T.O.T.

If a lamp is hung overhead, make sure the electrician, gaffer, or grip puts a safety on it.

Streaks and Tips

This is actually a spray-on hair dye that comes in a multitude of colors. This spray also washes right out with soap and water. We use it in the industry to tone down a bright object such as a white picket fence that may look too white for the camera; we just spray on some streaks and tips, like a spray paint mist. The mist, when it settles on the fence, will dry almost on contact, causing the fence to take on the tone of the color spray used. This is sometimes called "aging the fence," so that it will look more real, used, or older to the camera. We also use streaks and tips, such as the color gray in an actor's hair at the temples, to age the actor. Remember, it will wash off with soap and water.

Tapes

T.O.T.

Tab your tape at the roll's end; this way it is ready to peel off easily.

T.O.T.
Remember! Tape will gather moisture, so remove it when you're finished with it.

Camera Tape

Camera tape is like gaffer/grip tape, only it comes in 1 in. wide rolls. Usually we use black or white tape, although it comes in several colors. It is mostly used by the camera assistants to reseal film cans after they have been opened.

T.O.T.
Always mark damaged equipment with white tape. This is standard throughout the industry.

Double-Faced Tape

This tape comes in two forms. One type is a sponge-like foam about 1/8 in. thick with a sticky surface on both sides. The other is a thin cellophane-like material with a sticky surface on both sides that is sometimes called carpet tack tape. Double-faced tape of both types is used to tack something down, to hold it in place during and after a shot.

Gaffer/Grip Tape

Gaffer/grip tape 2 in. wide. This tape is a cloth-type tape. It looks like the air conditioning duct tape most of us have seen. It comes in various colors, although usually grey is used. It is used wherever a strong tape is needed.

T.O.T.
Put gaffer tape over the thread on hard wheels and electric scissor lifts to prevent tire tracks on painted surfaces.

Paper Tape

Paper tape usually comes in 1 in. and 2 in. widths, although you can order it wider. It is much like masking tape, only we order it in black. It has a matte finish, which means that the surface seen by the camera will just be a dull dark area. Stray light will not bounce off the tape unless it is aimed directly at it.

T.O.T.

Use low-tack blue tape. It sticks great and is easy to remove without pulling the paint off. It comes in several widths. Most paint stores have it. It is sometimes called seven-day tape, because its adhesive will not leave any gummy residue. When it is peeled off after sticking to a surface for a week, there is nothing left behind.

T.O.T.

To reduce unwanted light from a fluorescent light tube, you can tape 1 in. to 2 in. of black photo tape right on the tube. This will act as a flag as well.

T.O.T.

When flying a rag in a frame or just hanging it, face the ribbon (the color canvas edge that supports the grommets) of the single, double, or silk away from the camera.

T.O.T.

Photo black paper tape is preferred over black masking tape for two reasons. The photo black tape will almost disappear on film due to its matte backing, whereas the masking tape has a shiny back surface. Also, the glue on masking is white, and the glue on photo tape is black.

T.O.T.

Always use paper tape on a painted wall or a surface where the paint or finish might pull off with a stronger tape such as gaffer/grip tape.

Visqueen

Visqueen is plastic that comes in different thicknesses, widths, and lengths, and in clear or black. We use .006 mil x 20 ft. x 100 ft. rolls.

T.O.T.

To create a rain hat for a camera, you can use a gel frame with a gel on it or visqueen or any other material that is safe for rain.

Knots

There are several knots that can be tied, but in the film industry, there are at least four knots that you will use on a daily basis. They are as follows:

1. The bowline
2. The clove hitch
3. The half hitch
4. The square knot

Each one of these knots is a must-know knot. Sure, it is great to know more types, but these are the most common.

Bowline Knot

This knot is used to hang anything that is a dead hang, or a straight pull-down. After you have read the instructions on how to tie this knot, practice it several items. Learn to tie it with your eyes closed. Practice until it becomes second nature.

NOTE: Never walk away from a knot if you are unsure of it. Call for help or ask someone's advice to check whether it is correct. Your life may depend on it. So you aren't dead wrong! I recommend you get a book on knots. (The old Boy Scout manual gave me a good start.)

Clove Hitch Knot

The clove hitch is the knot most commonly used to tie-off a dead hanging object. Always put a half-hitch in your rope tail after you have secured the knot. This is a little extra safety.

Half Hitch Knot

The half hitch knot is nothing more than an extra little safety tie in your locking knot. You use a half hitch every time you tie your shoes.

T.O.T.

A quick safety tie-off is to tie a half hitch in a #8 sash cord, then put a drywall screw with a large area washer on it through the center of the knot. Now screw the screw into the set's 1 x 3 lumber for a good bite, then tie off the lamp.

1. The loop

2. Slip end through loop
from bottom

3. Wrap end around line

4. Slip end back down
through hole

5. Pull end up

Pull down tightening knot

Figure 84 How to tie a bowline.

1. Lay rope over pipe, attach a weight to end to keep taut during practice.

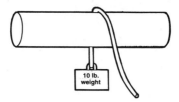

2. Wrap rope around pipe, then lay across the top of rope with weight.

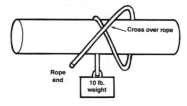

3. Lift the crossover rope and slide the rope end underneath the crossover rope.

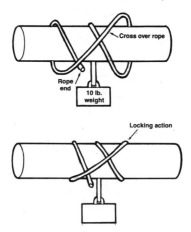

Figure 85 How to tie a clove hitch.

1. Lay black lace over white lace.

2. Start to tie a half hitch, wrapping the white lace around the black lace.

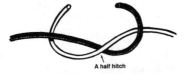

A half hitch

3. Now back loop the black lace around the white lace.

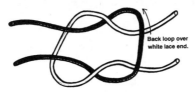

Back loop over white lace end.

4. Pull both black lace and white lace in opposite directions.

Figure 86 How to tie a square knot.

Square Knot

The square knot is the knot most used to tie up a bundle of cable. First you wrap the excess of the long tie around the loop of cable, then you tie a square knot. This knot is a strong locking knot, but very easy to untie quickly. This knot is also commonly used to secure bundles of tubes together, like a 12 x 12 frame tube.

T.O.T.

For visual safety reflectors for rope, put tape tabs hanging down about 8 in. to 10 in. long, double over, and tape them to themselves. This is so a person does not trip or get caught by the neck.

T.O.T.

When you use sailboats for backings, and sometime translights, you should use a rope to tie the center off high in the perms to keep it from sagging.

T.O.T.

Count the length of a rope by the span measurement of your arms. (Measure from fingertip to fingertip with arms spread eagle.) Now grab rope and start to loop it after each span count. For example: a 6 ft. span means ten loops, which is approximately 50 to 60 ft. It's a ball-park measurement.

Basic Tool Descriptions

Standard Screwdriver (Common or Blade Type)

A standard screw driver, also known as a *common* or *blade* type, usually has a shank (the shaft) ranging from 3 in. to about 12 in. long. They have longer and shorter ones available as well. The tip, which is also called the blade, has a wide face and a thin blade. There are also screwdrivers with a thin face and a wide blade.

Phillips Screwdriver

The most common Phillips screwdriver is a number two tip (a 30-degree tip). If you use a number one (which is a smaller tip, but still a 30-degree angle) in place of the needed #2, it will strip out the screw head and eventually the screwdriver tip itself. Always ensure that the tip is correct and is completely and squarely set in the screw's head. This position is called normal or 90 degrees to the surface. The screw's head is horizontal, and the screwdriver shank is vertical. This position should prevent a skipping or stripping out of the screw's head. If you hear or feel a chatter or grinding sound when using a hand or power driver, stop and reset the blade/tip to the normal (90 degrees) position, then proceed.

T.O.T.

Let's say that the screw is stuck in the wood. Here is a trick that I sometimes find will work to loosen the screw. Put the hand-driven screwdriver tip squarely (90 degrees) in the slots on the head. Apply a counterclockwise pressure with one hand, and tap the top of the screwdriver handle with a hammer lightly with the other while you're turning it. If you cannot get enough counterclockwise pressure on the handle while trying to unscrew it, grab the shank (shaft) of the screwdriver with a pair of vise grips. This should give you more turning pressure. Keep tapping while applying counterclockwise pressure.

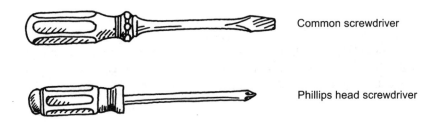

Common screwdriver

Phillips head screwdriver

Figure 87a Common and Phillips head screwdrivers.

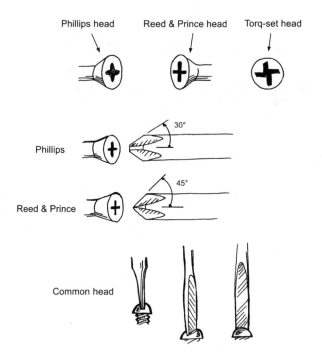

Figure 87b Screwdrivers.

Reed and Prince Screwdriver

The Reed and Prince screwdriver tool looks very much like a Phillips screwdriver except that the Reed and Prince tip has a sharp point (a 45-degree angle tip). In contrast, the Phillips screwdriver has a blunt or flat tip. Ensure that you have the correct tool on your tool belt (Phillips #2). There will be very little use for the Reed and Prince—but I have one standing by in my hand-carry toolbox just in case.

T.O.T.

If the screw bit spins in the head of the screw while driving it in, it is not what is called normal to surface, or a 90-degree angle. Don't let it grind. It will round out the slot.

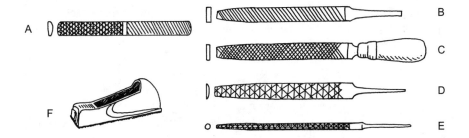

Figure 88 Files.

Files

I use a four-in-one file, which is quite handy. Keep one in your tool box. There are four types of files you should know about.

1. The flat file (single cut), which is used for precise filing
2. The flat double-cut or cross file, which removes material faster than single cut.
3. The round file (rat tail). If the file is round and has a slight taper to the end opposite the handle, it is usually referred to as a rat tail file.
4. The hand carriage rasp file.

NOTE: Never use a file without a handle.

When you are filing, do not rush. Smooth slow strokes will give you a better finish. Slightly angle the file to the material when you file. Slow strokes give the cut material a chance to fall from the teeth.

Hacksaw

There are several types of blades and lengths. I carry a compact handle style. On the blades, the teeth style is called the *set*. The teeth are bent out wider than the blade so as to cut and allow the blade not to bind. The set causes a wave look when looking at the blade. The pitch of the hacksaw blade is also important to know about. The number of teeth per inch is usually illustrated, for example, as 18, which means 18 teeth in one inch of blade. The more teeth per inch makes a smoother cut. Remember, when you are cutting steel, aluminum, or PVC, it is recommended that you cut at the rate of 32 to 40 strokes per minute. Don't try to cut like you have a date in 5 minutes. All that does is heat up the blade and jam up the teeth. A nice slow, even

cut will keep the blade somewhat cold and allow the cuttings to fall from the teeth. The hacksaw is used to cut metal and or plastic. The hacksaw blade is usually 10 to 12 in. long. The blade will fit on the saw with its teeth (cutting surface) facing down, up, or sideways. The teeth of the blade, when installed properly, will face forward (away from the handle).

T.O.T.
If you can afford it, buy yourself an electric *rotozip*. It is an excellent tool to cut a little mouse hole in a set wall. Save the panel that you cut out and tape it to the back of the set wall near the hole in case it has to go back in.

Lineman Pliers

This pair of pliers is great for heavy-duty cutting or bending, or to grip an object. They are equipped with serrated jaws (teeth) as well as a cutting device for cutting light or thin metals or wire. They usually are about 9 in. long.

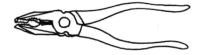

Figure 89 Lineman pliers.

Torpedo Level

Torpedo levels are great levels. They are made from plastic or metal and fit easily into your tool belt. They are approximately 9 in. long.

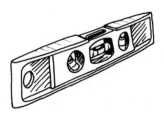

Figure 90 Torpedo level.

T.O.T.

To lift up the front of a dolly to get up over a curb, put the back lifting bars in Fisher ten (camera dolly), then stand on them. This will offset the weight enough to raise the front of the dolly.

Crosscut Saw

The crosscut saw, or common all-purpose saw, is a must-have item. I carry a

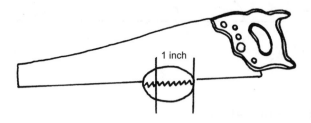

Figure 91 Crosscut saw.

short version in my tool kit. Crosscut saws were designed to cut across the wood's grain. They come in different sizes, from 20 in. to 26 or 26 in. I recommend an eight-point saw. Eight points means that you have eight points (valleys) with seven teeth (points or peaks) in one inch of the saw blade. This is used most often for rough framing. If you must have a cleaner (smoother) finish, step up to a ten-point saw and cut more slowly.

T.O.T.

When cutting a piece of wood with a skill or circular saw, raise the blade so that only the tips of the blade will protrude through the wood while cutting. This will help prevent the blade from binding in the wood.

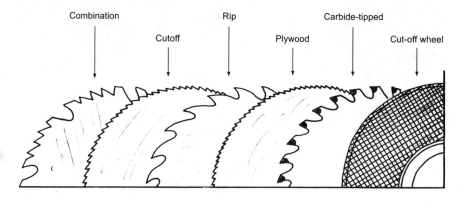

Figure 92 Circular saw blades.

Circle Saw and Blades

There are several types of circle saw blades. I will only show you a few to get you started. The combination shown in Figure 92 is the blade that usually comes with the saw. I recommend that you also obtain a carbide tip blade; this blade will be the most useful.

Drill Bits

When using a drill bit, always mark the material with a small dent or dimple. This will ensure that the drill bit does not walk (move) off of the intended area to be drilled. If you are going to drill steel, *drill slowly* while applying pressure. This will actually cause the drill to work better. The bit will not heat up and dull the tip.

NOTE: ALWAYS WEAR YOUR SAFETY GOGGLES WHEN DRILLING.

When drilling aluminum, drill at a higher speed. Ensure that your drill bit is perpendicular to the surface. This position is called *normal to the surface* (90 degrees or a right angle).

Matt Knife

The matt knife or utility knife is a tool you will use virtually every day. You will cut gels, filters, show card, and foamcore with it.

Figure 93 Matt knife.

T.O.T.
It's up to you if you put a lanyard (short cord) on your tools in your pouch. Some folks make a small loop that goes over their wrist while working high in the perms, green beds, or from a tall ladder. There are two schools of thought on this issue:
1. If you drop the tool, it should not fall.
2. If you fall and the lanyard gets hung up, it could be a different problem.

Tape Measure

I recommend that you get yourself a good strong 25 ft. to 30 ft. tape with a locking tab. Learn to read a tape properly. They are usually divided in 16ths of an inch. You can get them with metric as well.

T.O.T.
An average credit card is 3 3/8 in. long and 2 1/4 in. wide. You now have a second measuring device in your pocket. (P.S., as I mentioned earlier, a dollar bill is 6 in. long.)

T.O.T.
The spread of most folks' arms is pretty close to their height (measure your span and see). This means that you always have a tape, well, handy.

T.O.T.
If you need an exact measurement to be marked on a piece of wood to be cut, never use the beginning or tip of your tape measure. Measure from the number 1, then subtract an inch.

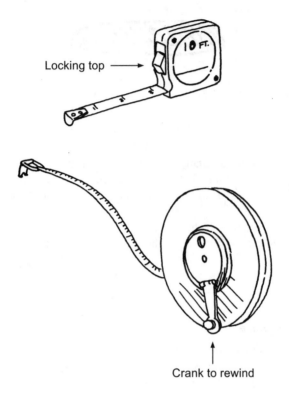

Figure 94 Reel tape measure.

Reel Tape Measure

This type of tape measure comes in 50 ft. and 100 ft. lengths. They are very handy for set work.

> **T.O.T.**
> Practice walking off an area after you know the exact distance. Do this four or five times, then note how many steps it took. You'll be able to walk off an area and get a ball-park measurement after you calculate what each step represents. I usually err on the long side. It is better to have a little extra than to be short. This doesn't mean you shouldn't have the right tools for the job, but this is a quick fix when you need it.

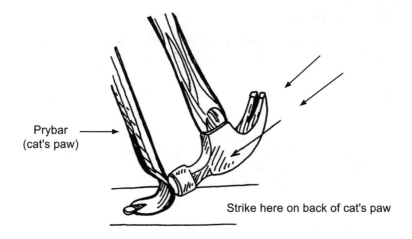

Prybar
(cat's paw)

Strike here on back of cat's paw

Figure 95 Claw hammer.

Claw Hammer

There are two basic types of claw hammer: the *curved claw* and the *ripping claw* (straight claw). The curved claw is better for leverage to pull nails. The straight claw is the one I use with a convex (bell-shaped) face on the hammer head. It allows me to drive a nail flush with little or no marring. There is also a *mesh* or *waffle-faced hammer*. This type is used mostly for driving large-headed nails during framing work. The mesh will help prevent the hammer from glancing off the nail head. There are many head weights for hammers; pick one you can handle. I use a 16 oz. Estwing.

See Figure 95 for an illustration of how to use a claw hammer and a *cat's paw*, which is a pry bar.

T.O.T.
I recommend an Estwing hammer. Get a straight claw type, which is easier for pulling nails. I use a smooth face. (I don't want to leave marks.)

Personal Tools

Here is what I think you should start with when building your tool belt. These are general recommendations and the minimum needed.

Personal Tool Belt

Padded suspenders, if you use them
Pouch with several compartments
Large 90-degree ring hammer holder. (Easy to remove and install your
 hammer when you're up on a ladder.)
30 ft. (3/4 in. to 1 in. wide) tape measure
Gloves ("hand shoes")
Hammer, 16 oz.
4-in-1 screwdriver
Allen wrench set
Pliers (rubber-insulated handles)
Dikes (rubber handles)
Needlenose (rubber handles)
Mini flashlight
2 in. black photo tape
Clothespins (C-47s)
Mat knife
Level (torpedo)
Level (bull's-eye)
Nail and screw pouches (this does not mean you have to carry 5 lbs. of each;
 carry about a dozen)
#8 and #16 penny double-headed nails
#8 drywall screws (1 in., 1 5/8 in., 2 in., 3 in.)
Scissors (I like a small pair)
Mini vise grips
Leather-man knife

Everyday Basic Tools for a Grip's Toolbox

I suggest that you carry the following tools in a hand-carried toolbox or tool (ditty) bag.

Look, guys and gals, this does not mean you have to carry all of them on you physically, just make sure that you have these available near the set.

(1) hammer—claw type
(5) common screwdrivers—different sizes
(1) Phillips head screwdrivers—different sizes
(1) Reed and Prince screwdriver

(1) Staple gun

(1) Allen wrench set, 1/16 in. to 5/8 in. standard

(1) Socket set, 3/8 in. drive, ¼ in. up to 1 in.

(1) Open-end box set, ¼ in. to 1 in., extra 3/8 in., 7/16 in., ½ in., and 9/16 in. open-end box—a box ratchet very handy (Note: 9/16 in. wrench is the most used; have 2.)

(1) Rubber-handled pliers/lineman pliers

(1) Channel locks—rubber handle

(1) Vise grip

(1) 30 ft. tape measure

(1) Torpedo level, 6 in.

(1) Hacksaw

(1) 4-in-1 file

(2) Crescent wrench—opens to 1 in.

(1) Needlenose pliers—rubber handle

(1) Matt knife

(1) Flashlight

Cam wedges

Clothespins

Pushpins—box of 100

Safety pins—20

Baling wire spool—50 ft.

Staples—spares

#16 double-head nails

#8 double-head nails

Drywall screws, 1 in., 1 5/8 in., to 2 ½ in.

Chalk—white or yellow

Automatic tape gun (ATG)

3/8 in. drill bit—standard size

¼ in. drill bit

T.O.T.

Only buy quality tools. Cheap ones will fail you when you need them most. (I promise you this).

Mike Uva's Tool Belt

Add or subtract what you want to carry from the following list of tools, which are just a few suggestions. The following is my personal idea of what a tool belt should include. Whatever you decide to carry, DO NOT EVER SHOW UP WITHOUT YOUR TOOL BELT.

The following tools are the ones that I personally carry when I work as a hammer (grip). (So if you want to be like Mikey . . . just kidding). Here it is:

Padded suspenders for my tool belt
Pouch with several compartments for nails and screws
Large 90-degree ring hammer holder (easy to remove and install hammer)
Estwing hammer (16 oz.)
9/16 in. open-ended box wrench
½ in. open-ended box wrench
7/16 in. open-ended box wrench
3/16 in. Allen wrench (a ratchet drive or ¼ in. drive will do nicely here, and
 it is light enough for your belt)
9/16 in. ratchet box wrench
Carpenter pencil
Crescent
Allen wrench set
Pliers (rubber-insulated handles)
Dikes (rubber handles)
Mini flashlight
30 ft. (3/4 in. to 1 in. wide) tape measure
Gloves ("hand shoes")
Clothespins
#16 double-head nails
#8 double-head nails
Drywall screws, 1 in., 1 5/8 in., to 2 ½ in.
4-in-1 file
4-in-1 screwdriver
Leatherman knife in a pouch on my belt
Matt knife (I also carry a Spyderco knife. It's great, because you can open it
 with one hand. This is very handy if you're in the ozones or hanging on
 with one hand and having to cut something loose).
#3 safety pins
#6 drywall screws, from 1 in. to 4 in.
8 duplex nails
#16 duplex nails
2 in. black photo tape
Scissors

Power Tools

These are the tools I will carry in a milk crate that I bought:

A 7 ¼ in. circular saw—110 volt A/C electric type (I carry a worm drive
 model for power cutting)
Power screwdriver—battery operated
Jig saw, electric—any good one
Drill with ½ in. chuck-reversible electric, variable trigger speed

Useful Items to Also Carry

Compass with 360-degree plate—use to check sun direction on location
Pair of sunglasses

Recommended Personal Gear

Clothing for Sets

Personal bag—Always have your bag close by.
Rain gear—You may be on a set that has a rain scene, or it may just rain on
 what was a sunny day.
Change of clothes—You sometimes get filthy or wet.
Ball cap, and/or hat
2 pairs of sunglasses (they break or get lost)
Aspirin
Toothbrush
Battery-operated clock

Clothing for Location

Location gear is the same as set clothes but with more changes:

Bathing suit—hotels have pools and spas
Plug-in clock with battery pack—Always use 2 clocks, 1 electric and 1 battery
 or wind-up. I use the large number type. That way I don't have to wake
 fully up and strain to find my clock.

NOTE: Never fully rely on a desk wake-up call. That's like certain death. You
would not jump without a reserve chute would you?

All your hygiene needs
Aspirin—I will usually use an Excedrin PM the first night in a new bed in a
 hotel (check with your doctor first)
Two pairs of work shoes—Rotate them daily. Your feet sweat and get the
 shoes moist. Don't get raw feet.

I always tell my grips to "plan for the worst and hope for the best." If you fol-
low this advice, you won't be let down—I promise you!

I also carry an empty soft-sided zip-up duffel bag inside my travel bag. This
way I have something to carry any presents home in. Trust me, you will say to your-
self on many occasions, "Hey, I'll probably never be in Moscow, Russia again," or,
"What's the chances of me ever coming back to Lawrence, Kansas?" In Moscow I
bought several Russian army hats and several nesting dolls (painted dolls inside
dolls, sort of like a barrel of monkeys in the U.S.A.) You'll make good money, and
you'll spend good money.

T.O.T.

If you have a scuba card, photocopy it, because you have to Fax a copy to production now and then so they can rent equipment.

T.O.T.

Copy your passport, driver's license, and social security card. Keep them in a safe place. You will usually have to provide a copy of these items for payroll purposes—either your passport or your license and social security number.

T.O.T.

Make sure you have an up-to-date passport. I had mine for 10 years and never used it. Then wham! I filled it up in a short time and had to get a second one. Jobs just pop up sometimes. Production loves to see that you have your stuff together. It makes for a lasting impression. I play a little game; it's called anticipation. Everyone is impressed with a person who is together. I know I harp a lot, but if just one thing from this book makes you look good, then I feel you have got your money's worth. I will eagerly share what little experience I have to anyone who wants to help themselves. But like most things in life, there are no free rides!

Personal Electronic Equipment (a Must)

It is essential to carry your own electronic equipment, particularly a statewide pager (if possible) with voice mail. If you only have a numerical pager, you usually get the number, call it back and ask, "did someone there page me?" If you're calling a large production office, the receptionist may not have been informed that a page was sent to you. You may miss the call— which could have paid for a full year of voice mail service. So be smart, and get a voice mail pager.

Cell Phone

A new era has arrived. If you don't answer the phone or quickly return a page, the calling party is under pressure to fill the slot with whomever else is available. This is true whether you're a newbie trying to break in or a regular trying to get more work. Once again, trust me on this. I have been on both sides of the fence. I have been personally told that production knows if I do not get back to them in 5 or 10 minutes after they have paged me, they know that I am not in a place to call them back. That is a good reputation to have. I am a fanatic about returning a call quickly for work.

Once again, I promise you that if your work is good, your attitude is great, and you return calls very quickly, you want to project a sense of "Ready, willing, and

able." A future employer is very impressed by that. In a short time you will get known for quick replies. Here is an illustration for you. When you look in your phone book for a person to replace your glass window, and the first company either doesn't answer or you get their answering machine and they don't call you right back, I bet you go right down the list. It's human nature. I don't mean to sound preachy. I am just trying to get you your first job and propel you to the next—and next and next. (Good luck!)

T.O.T.
When there is a need for safety, a grip or anyone can yell "Cut!"

Call Sheet

In this section I will refer to an example of an empty call sheet (Figures 96 and 97). A call sheet, as the illustration shows, has all the information that the technicians and actors will need for the next days work. I have numbered each item on the call sheet that I feel should be explained. This sheet of paper is a very important item in the everyday life of a grip. Once you learn to read it, you will see how it aids you in preparation for your job.

Front Side of Call Sheet

1. Day of shooting: For example, day #1 of 50 days.
2. Picture: Name of the film or commercial.
3. Production no.: Films or commercials are given numbers for identification.
4. Director: Name of the director.
5. Extra line for added information.
6. Crew call: The word "call" or "call time" is the time to report to work. The word "set" describes whatever or wherever you are shooting. Either a stage or even a forest can be called a set (it has been said, "the world is a stage").
7. Shooting call: The lights, camera, and actors should be ready to shoot at this time.
8. Date.
9. Set description: This will explain to you if the shot is a day or night shot, if it's interior or exterior, and a brief summary of what action is to take place.
10. Scene: This is the scene from the script that has its own number for editing the film. You can turn to this scene number in your script and know exactly the dialog and the action that should take place.
11. Cast number: Each cast member is numbered, starting from the lead person (usually #1) to whatever bit (smaller part) player is in the shoot. This allows everyone to see which character (actor/actress) is playing (acting) with another player (actor/actress).
12. D/N tells you day or night.
13. Pages: This will usually tell you how many pages or eighths of a page will be shot for a certain scene. (Note: A script page is usually broken down into eighths of a page.)
14. Location and phone: The street address and the phone number of the place (location) of where a film or part of a film will be shot.
15. Cast and bit: The cast is an actor or actress's real name, and they are also assigned a number, as mentioned above. Bits mean bit parts of usually a small scene played by a different person for each bit.
16. Character: The character name from the script.
17. P/U or pickup: The time at which an actor or actress is to be picked up from his or her hotel if on location, or from his or her home if the need should arise. (Actors and actresses usually have very busy schedules, and they may need that extra few minutes of time to study their part while being driven to the set.)

Front Side

UVA'S
CALL SHEET

1 DAY OF SHOOTING W/A *5*

PICTURE *2* PROD. No. *3* DIRECTOR *4*

CREW CALL: *6* SHOOTING CALL: *7* DATE *8 8*

SET DESCRIPTION:		SCENE NO:	CAST NO:	D/N:	PAGES:	LOCATION	PHONE NO:
9		*10*	*11*	*12*	*13*	*14*	

CAST AND BITS:	CHARACTER:		P/U ●	RPT TO ●	ON SET
15	*16*		*17*	*18*	*19*

ATMOSPHERE AND STAND-INS:		COMMENTS	REPORT TO	ON SET
20		*21*	*22*	*23*

ADVANCE SCHEDULE:	SPECIAL INSTRUCTIONS:
24	*25*

26	*27*	*28*
ASSISTANT DIRECTOR	UNIT MANAGER	APPROVED

Figure 96 Call sheet.

18. Report to MU (report to makeup): Scheduled to allow the extra time it sometimes takes for makeup to be applied to an actor/actress.
19. On set: The time the actor/actress is to report to the set in costume, with makeup on, knowing their lines, ready to rehearse, then shoot.

Back Side

W/A _____

PICTURES PRODUCTION REQUIREMENTS — PICTURE _____

DIRECTOR _____ 1 PROD. No. 2 CALL TIME 3 DATE 4

CAMERA	Time	No.	MAKEUP	Time	No.	RESTAURANT	Time
Camera Pkg.			Makeup Artist			From Commissary	
Other Cam. Pkg.			Extra MU			From Caterer	
Cameraman			Extra MU			Breakfast for:	
Operator			Body MU			Lunches for:	
Extra Operator			Hairstylist			Dinners for:	
1st Asst. Cam.			Extra Hair			Gals. Coffee	
Xtr 1st Asst. Cam.			Extra Hair			Doz. Donuts	
2nd Asst. Cam.						Tables & Chairs	
Xtr 2nd Asst. Cam.						POLICE	
			WARDROBE			Flagman	
			Costumer			Set Watchman	
SPECIAL PHOTOGRAPHIC			Mens Wardrobe			Night Watchman	
Cameraman - Process			Ladies Wardrobe			Uniformed Police	
Matte Supervisor			Extra Wardrobe			Studio Firemen	
Port. Proj.							
Moviola							
1/2/3 Head Proj.			SOUND				
Projectionist							
Stereo Mach./Proj.			Mixer			HOSPITAL	
			Mikeman			1st Aid Man	
			Cableman			MUSIC	
TECHNICAL			System			Piano/Player	
Key Grip			Playback Mach./Oper.			Sync Man	
Best Boy			Batteries/Hookup			Sideline Musicians	
Dolly Grip			Radio/Mic.			LOCATION	
Comp. Grip			Walkie Talkie			Location Manager	
Dolly			Electric Megaphone			Police	
Greensman			Wigwags/Phone			Fireman	
C.S.E.						Permits	
Painter							
Plumber							
Propmaker Constr.						TRANSPORTATION	
Special Effects Foreman			STILL			Trans. Coord.	
Effects			Still Man/Still Equip.			Trans. Capt.	
Single Dr. Rm.			EDITORIAL			Sedan	
Mltple. Dr. Rm. No.			Film Editor			Station Wagon	
Makeup Tables						Mini Van	
Wardrobe Racks for: No.			PROPERTY			Crew Cab	
Schoolroom for No.			Property Master			Buses	
Tables & Benches for No.			Asst. Prop Man			Pick-up Truck	
Heat Stage No.			Lead Man			Picture Cars	
Heaters			Swing Gang			Prod. Van	
			Draper			Honey Wagon	
			AHA Representative			Grip Trk/Trlr	
			Animal Handler			Prop Trk/Trlr	
ELECTRICAL			Wranglers			Ward Trk/Trlr	
Chief Light Technician			Live Stock/Animals			Sound Trk	
Best Boy						Elec. Trk/Trlr	
Lamp Opers.						Generator Trk/Trlr	
Gen. Operator						Crane & Oper.	
Wind Mach.			PRODUCTION			Water Wagon	
Wind Mach. Oper.			1st Asst. Dir.			Make Up Trlr.	
Local No. 40			2nd Asst. Dir.			Greens Trk/Trk	
Batteries			2nd 2nd Asst. Dir.			Insert Car/Lights/Gen.	
Camera Mechanic			Addit. 2nd A.D.			Construction	
Air Conditioning			D.G.A. Trainee			Special Effects	
Booster Lights			Script Supervisor			Motor Homes	
Work Lights			Prod. Coord.			Camera Truck	

Figure 97 Back side of call sheet.

20. Atmosphere and stand-ins: The actors' doubles who will stand in for lighting the scene. Extras or background people are the atmosphere.

21. Comments: This pertains to transportation; what vehicles are due where at what time.

22. Report to: Where to go.
23. On set: When to report to the set.
24. Advance schedule: Tells the crew what to be prepared for on the next day's shoot.
25. Special instructions: Alerts crew if special rigs, rain gags, mounts, and so on will be needed.
26. Assistant director: Names of assistant directors.
 27. Unit manager: Name of unit manager.
28. Approved: Signed by the unit production manager (UPM) or 1st AD.

Back Side of Call Sheet

1. Director
2. Producer
3. Call time
4. Date

Each department is categorized by number (column marked "A") and time (column marked "B").

The number ("A") column is used for the number of camera packages required, the camera operators required, and so on for that one day of shooting (e.g., there might be an action stunt requiring as many as six cameras, camera operators, grips, etc.)

The time ("B") column indicates the time the crew is to report to the set. This may be the time that only one person or many people are due at the set, at the same or at different times.

For example, a camera package due time may be 7:00 A.M., and the 1st assistant camera operator due time may also be 7:00 A.M. But the rest of the crew may not be needed for half an hour, so the grip department due time may be 7:30 A.M. Get the picture? (I love using these bad puns!)

T.O.T.

When filming at night and the director does not want steam to be expelled from the actor's mouth during a take, make a suggestion that the actor put a piece of ice in his or her mouth just before acting. This will reduce the steam for a few moments.

Filters and Gels

Fluorescent Light Filters

Standard cool-white or daylight fluorescent tubes offer a reasonable approximation of photographic daylight except for their excessive green content. Two separate techniques are available to deal with this situation: balance all sources to the fluorescent, or balance the fluorescent to the sources. Rosco Product 3304 is applied to windows or daylight sources and 3306 to 3,200 K sources, respectively, to balance them to the fluorescent lights. Rosco Products 3308, 3313, 3314, 3310, and 3311 are applied to the fluorescent lights to convert them to either 3,200 Kelvin or nominal daylight. All roll materials are 54 in. wide, 100 sq. ft, and are optically clear.

No.	Name	Description
3304	Tough Plusgreen	Converts daylight to match fluorescent.
3315	Tough 1/2 Plusgreen	Adds partial green to daylight and 3,200 K sources for balancing with fluorescent and discharge lamps. Equivalent to CC15 Green.
3316	Tough 1/4 Plusgreen	Adds partial green to daylight and 3,200 K sources for balancing with fluorescent and discharge sources. Equivalent to CC075 Green.
3306	Tough Plusgreen 50	Converts 3,200 K sources to match cool-white fluorescent.
3308	Tough Minusgreen	Converts cool-white fluorescent to nominal daylight by absorbing excess green output.
3313	Tough 1/2 Minusgreen	Partial green absorbing filter equivalent to 0.15 cc Magenta. Useful on some fluorescent types or discharge sources.
3314	Tough 1/4 Minusgreen	Partial green-absorbing filter equivalent to 0.075 cc Magenta. Useful on some fluorescent types or discharge sources.
3310	Flourofilter	Converts cool-white fluorescent to 3,200 K.
3311	Fluorofilter	Same as 3310 in 4 ft. sleeves for covering lamps.

T.O.T.

Put tape on gel, then staple or pushpin gel up. This prevents tearing.

T.O.T.

Mark gel on a frame in the corner with gel name and type with magic markers. This will not show when projecting a light through it.

Arc Light Filters

Rosco's Cinegel System offers a wide range of filters for carbon arcs, HMI, CID, and CSI lamps. They vary in the character and the amount of color correction provided to deal with the ages of the lamps in use and other operating conditions. All materials are 100 sq. ft. and are fabricated in a deep-dyed base for optical and high-heat stability.

No.	Name	Description	Width
3107	Tough Y1	A pale straw filter used in the U.S. on HMI or white flame arcs to absorb UV light and reduce Kelvin for daylight balance.	30 in.
3110	Tough WF Green	Because of generally higher ambient Kelvin, preferred in Europe for the same purpose as Tough Y1.	48 in.
3106	Tough MTY	A single filter combining MT2 and Y1 for correction or 5,500 K white flame arcs and HMI to 3,200 K.	54 in.
3102	Tough MT2	When used in combination with Y1, converts white flame arcs to 3,200 K. Also useful as an amber conversion filter on HMI and CID conversion.	54 in.
3115	Tough 1/2 MT2	A partial amber conversion for use on arcs and HMI.	54 in.
3116	Tough 1/4 MT2	Pale amber correction for arcs and HMI.	54 in.
3134	Tough MT 54	A pale straw correction for white flame arcs or HMI.	48 in.
3114	Tough UV Filter	A clear, slightly tinted filter that absorbs 90% of UV wavelengths below 390 nm. For absorbing UV output of arc sources.	54 in.

T.O.T.

A roll of gel will usually run about 25 ft. long and about 4 ft. wide. This will give you enough gel to cover six 4 x 4 frames.

Tungsten Conversion Filters

Rosco Tungsten Conversion Filters convert incandescent 3,200 Kelvin sources to nominal daylight. These filters offer a deep-dyed base for optical clarity and high-heat stability. They are 54 in. wide and 100 sq. ft.

No.	Name	Description
3202	Tough Blue 50 (Full Blue)	Boosts 3,200 K to nominal 550 K daylight
3204	Tough Booster Blue (Half Blue)	Boosts 3,200 K to 4,100 K
3206	Tough 1/2 Booster Blue (Third Blue)	Boosts 3,200 K to 3,800 K
3208	Tough 1/4 Booster Blue (Quarter Blue)	Boosts 3,200 K to 3,500 K
3216	Tough 1/8 Blue (Eighth Blue)	Boosts 3,200 K to 3,300 K

T.O.T.

Tape gel to face of frame on Zenons (high density lamp); try not to go to the glass.

Neutral Density Filters

RoscoSun Neutral Density Filters reduce the level of incident daylight. Two of the materials also convert daylight to a nominal 3,200 K. Except for Rosco Scrim (54 in. wide), all roll materials are 100 sq. ft, 58 in. wide, and are optically clear.

No.	Name	Description
3402	RoscoSun N3	Reduces light intensity one stop.
3403	RoscoSun N6	Reduces light intensity two stops.
3404	RoscoSun N9	Reduces light intensity three stops.
3405	RoscoSun 85N3	Reduces light intensity one stop and converts daylight to nominal 3,200 K.
3406	RoscoSun 84N6	Reduces light intensity two stops and converts daylight to nominal 3,200 K.
3809	RoscoScrim	Perforated material, 54 in. wide, reduces light

| 3762 | Roscolex N3 | Optically clear rigid acrylic panel, 51 in. x 100 in., reduces light intensity one stop. |
| 3763 | Roscolex N6 | Optically clear rigid acrylic panel, 51 in. x 100 in., reduces light intensity two stops. |

T.O.T.

Use water and a squeegee to put up gels on windows inside, when you can't get to the window from the exterior (e.g., a high-rise). Photo mount spray can also be used, or a small tab of ATG tape. If you check with the DP and ask what they are seeing, you can sometimes use photo black tape. (It will look like part of the window frame.)

T.O.T.

To reduce a bright spot on a translight (e.g., a spot light in the picture), cut Neutral Density (ND) to the approximate shape and tape it on with cellophane or ATG tape tabs. Clean it up before you roll it up and send it back. You can also use Bobinett material.

T.O.T.

To cut a gel, such as a neutral density (ND), for the inside of a lamp shade that will be seen on camera, here's a trick that will help. Roll the shade on a flat piece of ND while marking the gel with a marker. The shape will fit pretty close with just a little trimming. Now just apply a little dab of ATG tape to the inside of the lamp shade, and this will hold the gel in place.

Daylight Conversion Filters

RoscoSun Daylight Conversion Filters are used when shooting in an interior at a 3,200 K balance. They are required at windows or other openings to convert incident daylight to an approximation of 3,200 K. Partial conversions are utilized where less than full correction (a cooler or bluer daylight appearance) is preferred. All roll materials are 100 sq. ft., 58 in. wide, and optically clear.

No.	Name	Description
3401	RoscoSun 85	Converts 5,500 K daylight to a nominal 3,200 K.
3407	RoscoSun CTO	Converts 5,500 K daylight to a nominal 2,900 K.
3408	RoscoSun 1/2 CTO	Converts 5,500 K daylight to a nominal 3,800 K.

| 3409 | RoscoSun 1/4 CTO | Converts 5,500 K daylight to a nominal 4,500 K. |
| 3761 | Roscolex 85 | Optically clear rigid acrylic panel, 51 in. x 100 in. Performs same function as RoscoSun 85. |

T.O.T.

Use ND gel inside a lamp shade or wall sconce glass to reduce light if no dimmer can be used.

Basic Grip Truck Package

Company name _____

Company's phone # _____

Date equipment ordered _____

Job name _____

Job # _____

Your name _____

Your home phone # (___) ___-____

Your home Fax # (___) ___-____

20 ft. x 20 ft. **Total Requested**

Frame_____

Silk _____

Black (solid) _____

Grifflon (b/w) _____

Lite grid (half) _____

Full grid _____

Single_____

Double _____

Single (white) _____

Bleached muslin _____

Unbleached muslin _____

12 ft. x 12 ft. **Total Requested**

Frame_____

Silk _____

Black (solid) _____

Grifflon (b/w) _____

Lite grid (half) _____

Full grid _____

Silver grifflon _____

Gold grifflon _____

Single_____

Double _____

Single (white) _____

Bleached muslin _____

Unbleached muslin _____

8 ft. x 8 ft. **Total Requested**

Frame_____

Silk _____

Black (solid) _____

Double _____

Single_____

Grifflon (b/w) _____

Grifflon (silver) _____

Grifflon (gold) _____

Lite grid (half) _____

Full grid _____

Bleached muslin _____

Unbleached muslin _____

6 ft. x 6 ft. **Total Requested**

Frame_____

Silk _____

Black (solid) _____

Double _____

Single_____

Grifflon (b/w) _____

Grifflon (silver) _____

Grifflon (gold) _____

Lite grid (half) _____

Full grid _____

Bleached muslin _____

Unbleached muslin _____

4 x 4 Floppy Flags **Total Requested**
(floppy drops down, toward the pin)

4 x 4 Singles_____

4 x 4 Doubles _____

4 x 4 Silks _____

4 x 4 Half silks _____

4 x 4 Empty frames _____

4 x 4 Grifflon (on a frame)_____

4 x 4 Lavenders _____

4 x 4 Wood cukes _____

4 x 4 Celo cukes_____

2 x 3 Flags and Nets **Total Requested**

2 x 3 Solids _____

2 x 3 Singles_____

2 x 3 Doubles _____

2 x 3 Silks _____

2 x 3 Half silks _____

2 x 3 Empty frames _____

2 x 3 Grifflons (on a frame) _____

2 x 3 Lavenders _____

2 x 3 Wood cukes_____

2 x 3 Celo cukes_____

18 in. x 24 in. Flags and Nets **Total Requested**

18 in. x 24 in. Solids _____

18 in. x 24 in. Singles_____

18 in. x 24 in. Doubles **Total Requested**

18 in. x 24 in. Silks _____

18 in. x 24 in. Half silks _____

18 in. x 24 in. Empty frames _____

18 in. x 24 in. Lavenders _____

18 in. x 24 in. Wood cukes_____

18 in. x 24 in. Celo cukes _____

Blades, Sticks, and Cutters **Total Requested**

3 in. x 36 in. Sticks (wood) _____

6 in. x 48 in. Sticks (wood) _____

10 in. x 42 in. Cutters_____

12 in. x 36 in. Cutters_____

18 in. x 48 in. Cutters_____

24 in. x 48 in. Cutters_____

24 in. x 60 in. Cutters_____

24 in. x 72 in. Cutters (floppy type) (flop to side) _____

Flexarms, Scrims, and Solids **Total Requested**

10 in. x 12 in. Singles_____

10 in. x 12 in. Doubles_____

10 in. x 12 in. Solids

10 in. x 12 in. Silks _____

10 in. x 12 in. Lavender _____

Dots and Fingers _____

One set of dots and fingers (15 dots and 10 fingers) _____

Stands **Total Requested**

High Rollers _____

C-Stands (standard 40 in.) _____

Rocky Mountain type _____

Spring type _____

Turtle base type _____

C-stands (low) _____

Combo stands _____

Low combo stands _____

Apple Boxes, Cribbing, and Wedges **Total Requested**

Full apple _____

Half apple _____

Quarter apple _____

Eighth apple_____

Crates of 1 in. x 3 in. cribbing _____

Crates of 2 in. x 4 in. cribbing _____

Crates of wedges _____

Cup blocks_____

Step blocks _____

Ladders **Total Requested**

4 ft._____

6 ft._____

8 ft._____

10 ft._____

12 ft._____

Extension (24 ft.) (30 ft.) (36 ft.) (Check one) _____

Lumber **Total Requested**

1 in. x 3 in. x 16 ft. _____

2 in. x 4 in. x 16 ft. _____

1 in. x 12 in. x 16 ft. _____

Track **Total Requested**

2 in. x 12 in. x 16 ft. _____

4 ft. x 8 ft. x 3/4 in. a/c quality plywood _____

Carts **Total Requested**

Grip cart (Taco) _____

Sandbag cart _____

Hand truck _____

Doorway dolly _____

Western dolly _____

Mounting Equipment **Total Requested**

C-clamps w/ pins (4 in.) (6 in.) (8 in.) (10 in.) (12 in.) _____

Junior C-clamps (6 in.) (8 in.) (10 in.) (12 in.) _____

C-clamps, no pins (2 in.) (4 in.) (6 in.) (8 in.) (10 in.) (12 in.) _____

Furniture/bar clamp (12 in.) (24 in.) (36 in.) _____

Chain vise grip w/ pin _____

Chain vise grip no pin _____

Mafer clamps _____

Gator grip w/pin _____

Bead board holder _____

Baby pin offsets _____

Junior receiver offsets _____

Spud adapters _____

2 in. x 4 in. wall spreaders _____

Baby nail-on plates _____

Junior receiver nail-on plates _____

Baby risers (6 in.) (12 in.) _____

Junior risers _____

Putty knives w/ pin _____

Junior set wall plates _____

Turtle stands _____

Miscellaneous Grip **Total Requested**

Furniture/sound blankets _____

Large sandbags _____

Small sandbags _____

Umbrella _____

1/4 in. rope _____

3/8 in. rope _____

1/2 in. rope _____

Grounding rods (Ford axles) _____

Sledge hammer _____

Lawn tools, shovels, pick, rakes, and brooms _____

4 x 4 Reflectors (Silver) (Gold)_____

Hand reflectors (Silver) (Gold) _____

4 x 4 Mirror _____

41/2 in. Grip head _____

Baby pipe clamp _____

Junior pipe clamp _____

T-bone _____

Tree branch holder_____

Flexarms _____

Ceiling scissor clips_____

Short arms and heads_____

Parallels _____

Tops _____

Leveling legs _____

Feet _____

Wheels_____

Post _____

Cross safety rails _____

Grip clips #1() #2() #3() _____

Crossover Mats _____

Grip saver _____

Rubber mat _____

Condor mount _____

Cardellini clamp _____

Foamcore plates_____

Easy-Up_____

12 x 12 Mirror tiles _____

Camo net _____

Metal flags_____

Boldi-Gold heat flags _____

Grip Review Test

1. Whose job is safety on the set? Page 17
 A. The assigned safety officer.
 B. All personnel.
 C. The grip department.
 D. The fire chief of the city you are filming in.
2. What is a good rule of thumb when sandbagging a C-stand? Page 114
 A. That's not my job.
 B. Only one bag is needed, ever.
 C. No bags are needed if the stand is properly set.
 D. 1 riser up = 1 bag; 2 risers up = 2 bags; etc.
3. What leg of the C-stand should the sandbag (ballast) be placed on? Page 113–114
 A. The longest leg.
 B. The highest leg
 C. The one opposite the weight (flag).
 D. The forth leg, "always."
4. What is a good practice to use on an exterior shoot, when setting a 4 ft. by 4 ft. flag? Page 118
 A. Only film in 15 mph or lower winds.
 B. Use a combo stand with a 4 1/2 in. gobo/grip head for stability.
 C. Never film near airports, ever.
 D. Use smaller flags for safety, "always."
5. Why does the film industry use duvatyne in the making of flags? Pages 70 & 140
 A. Duvatyne is treated with a fire retardant.
 B. It is cheaper than silk.
 C. It is the darkest black material available.
 D. Because it was designed by the famous Key Grip "John, I know it all."
6. What is a good practice when skinning an empty frame? Pages 67 & 173
 A. Use only leather.
 B. Mark the corner of the gel with a marker, denoting what the gel is on the frame.
 C. Always make up two sizes.
 D. Use only paper tape.
7. Which knot is considered a dead hang knot? Page 148
 A. Hang man noose.
 B. Bowline.
 C. Square knot.
 D. Clove hitch.

8. What's a catwalk? Pages 8 & 45
 A. An exterior walkway of a tall building; a ledge.
 B. An area above a set, for lights, greens, or what have you.
 C. A place where only small grips can climb.
 D. There is no such thing as a catwalk.
9. What is sometimes referred to as snot tape? Page 137
 A. 2 in. photo tape.
 B. A runny nose.
 C. Double-sided gummy tape, also known as *ATG tape*
 (automatic tape gun tape).
 D. Foam carpet tape.
10. What is the average size of a rag that fits a 12 ft. x 12 ft. frame? Pages 77 & 104
 A. 12 ft. x 12 ft.
 B. 8 ft. x 8 ft
 C. 11 ft. 6 in. x 11 ft. 6 in.
 D. 10 ft. x 12 ft
11. Why is there usually a 4 ft. yellow or red perimeter line painted
 around the interior of a stage? Page 60
 A. For staging grip gear.
 B. Camera is assigned to this space only.
 C. So the producer does not have to step over any
 equipment.
 D. In the case of a fire with heavy smoke, you can crawl
 to the wall and feel your way to the exit.
12. When is it time to suggest safety to the key grip? Page 115
 A. Place safety concerns in a suggestion box nightly.
 B. Suggest safety "only" to the producer.
 C. As you see the need.
 D. Fix it yourself.
13. What is an onkie-bonk? Page 46
 A. A pair of scissors.
 B. A platypus.
 C. A baby plate.
 D. A C-stand.
14. What's a hard mark? Page 209
 A. Water stains on glass.
 B. A really tough stop for an actor to hit while acting.
 C. A tape mark on the deck or a fixed object on set.
 D. Two pounds of rocks used on all movie sets.
15. What is the recommended minimum number of ropes tied
 onto a 20 ft. x 20 ft. frame set vertical? Pages 103 & 120
 A. 1
 B. 17
 C. 4
 D. 12

16. Who can put a metal scrim in front of a light? Page 115
 A. A grip can, using a C-stand.
 B. The electrician.
 C. The gaffer.
 D. Any of the above.
17. Name a few types of rain hats. Page 147
 A. Answers B, C, and D.
 B. An umbrella will work.
 C. You can use a 4 ft. x 4 ft. frame with gel or visqueen on it.
 D. Any material that is safe and will protect the lamp.
18. What should you check for before removing a fly-away set wall? Page 73
 A. Seams in the corners.
 B. Lights mounted on the fly-away wall.
 C. Answers A, B, and D.
 D. Any reinforcing or cross-bracing of said wall.
19. What is a must when flying a lamp over a set? Page 143
 A. Use only 5-pound lamps and under.
 B. Put a safety rope or cable on the lamp.
 C. Insure that the doors are safely placed on the lamp.
 D. Both B and C.
20. What is lexan sometimes used for? Page 142
 A. Coffee tables.
 B. Windows in banks.
 C. Answers A, B, and D.
 D. Explosion-proofing a camera for a shot.
21. Whose voice should all new grips listen for? Pages 46 & 90
 A. The Key Grip.
 B. The Gaffer.
 C. The DP.
 D. All of the above.
22. Why do we tape foamcore to bead board? Page 138
 A. It is used this way to replace a show card.
 B. To prevent the bead board from breaking in half.
 C. To use it as a filter on lights.
 D. This is really not recommended.
23. What is a cyclorama?
 A. A roller rink.
 B. A circular stage
 C. A 60 ft. high x 60 ft. wide x 60 ft. long stage.
 D. A set wall with a curved bottom that meets the floor.
24. What are bullets? Page 139
 A. Rubber bands.
 B. C-47s.
 C. 9 mm rounds.
 D. All the above.

25. What's a platypus? Page 46
 A. An onkie-bonk, also known as a bead board holder.
 B. Vise grips with wide plates attached to the mouth.
 C. A special lock-holding device for foamcore or show cards.
 D. All of the above.

26. What is a clapper/loader? Page 207
 A. An audience on drugs.
 B. The camera assistant.
 C. A special effects machine.
 D. A noisy camera for TV.

27. What is a hot set? Page 209
 A. A movie set doing a fire effect.
 B. A set in which filming has been started, then stopped,
 then filmed on again later.
 C. A set with huge hot light shining on it.
 D. A set on which no one is allowed.

28. What does MOS stand for? Page 210
 A. "Move Out Side" for next take.
 B. Roll the sound machine.
 C. Supposedly "mitt out sound," that is, no sound recording.
 D. None of the above.

29. What's a taco cart? Page 123
 A. Lunch wagon.
 B. A three-wheeled dolly.
 C. A flag box.
 D. Grip or lighting supplies on a rolling cart.

30. Who is sometimes the unofficial safety expert on set? Page 65
 A. The AD.
 B. The Key Grip.
 C. The Gaffer.
 D. The Director.

31. When can a grip yell cut during the filming of a scene? Page 167
 A. When safety is involved.
 B. Never.
 C. Anytime.
 D. When he has written the script.

32. What could possibly happen if a light does not get bagged? Page 113
 A. A blow-up.
 B. A fall.
 C. It would not work.
 D. The stand knuckles could slip.

33. Who can and will usually safety a light hung overhead? Pages 73 & 143
 A. The grips.
 B. The electricians.
 C. The gaffer.
 D. Any of the above.

34. Will a pole cat hold the weight of a 2,000-watt lamp? Page 85
 A. Possibly, but it's not recommended.
 B. Yes, anytime.
 C. Only if you nail the cups to the wall.
 D. Only a 12k or larger will work.
35. What is a pre-rig? Page 10
 A. Loading a special effects rig.
 B. Setting a light on top of a building.
 C. Rigging onstage or on location in advance of a shoot day.
 D. None of the above.
36. When can a C-stand be used as a menace arm? Page 108
 A. To support a small lamp.
 B. To hold a branch.
 C. To extend over a person or set.
 D. Any of the above.
37. What is the difference between a gobo arm and a
 century stand arm? Page 108
 A. One is longer than the other.
 B. There is not any difference.
 C. They're two different parts entirely.
 D. There is a 4 in. difference on the type-one style.
38. Can a C-stand arm be used in a high roller? Page 120
 A. On occasion.
 B. Yes.
 C. Never.
 D. In an emergency.
39. Can a junior riser be used in a high roller? Page 121
 A. Yes, sometimes.
 B. Only with a spud adapter.
 C. If you don't have parallels.
 D. Never.
40. What should be done to a C-stand arm that protrudes
 outward from the stand? Page 120
 A. Put a safety tape on it.
 B. Cut it off.
 C. Use only the proper arm.
 D. Never use in this configuration.
41. What's a mombo combo? Page 121
 A. A huge high roller.
 B. A 20 in. C-stand.
 C. A combo stand.
 D. A baby plate.
42. Why do we use cup blocks? Page 60
 A. To drink out of.
 B. To prevent movement.

C. To elevate things.

D. B and C.

43. What are the four common sizes of apple boxes? Page 42

 A. 1 in. by 2 in., 4 in. and 8 in. by 12 in. by 20 in.

 B. 2 in., 9 in., 14 in., and 22 in. x 8 ft. x 8 ft.

 C. 3 ft. x 3 ft. by 3 ft. x 3 ft.

 D. Does it have to be an apple box?

44. What is a pancake's other name? Page 42

 A. 1/4 orange.

 B. 1/8 apple box.

 C. Dust and moisture.

 D. Flower and water means a flapjack.

45. What does feather a flag mean? Page 208

 A. Scrape the edge.

 B. Wing the flag away from or close to the lamp.

 C. Use a white solid

 D. Cut a hole in it.

46. What should a grip do when asked for a single 18 in. by 24 in. scrim? Page 100

 A. Bring it quickly.

 B. Bring in a larger one as well.

 C. Bring in a 18 in. x 24 in. double as well.

 D. Bring a flag.

47. What is a cookie? Page 59

 A. Something that's also known as a chocolate chip.

 B. A chief.

 C. A flag.

 D. A cutout pattern of wood or screen.

48. What does it mean to lose the cookie in front of a light? Page 210

 A. Remove it.

 B. Add a second cookie.

 C. Add a single to it.

 D. Go eat.

49. What is the hole used for in a pin on a baby plate? Page 41

 A. Bad weather.

 B. A safety wire or pin safety.

 C. To tie it to the lamp.

 D. A drywall screw hole.

50. What should be inspected on a baby pin? Page 41

 A. The base plate.

 B. The pin's weld.

 C. The safety hole.

 D. The rental price.

51. What is negative fill? Page 210

 A. Reduces light on one side.

 B. Adds fill light.

C. Will not help filming.

D. Nothing.

52. What is an opal?

 A. A gem.

 B. A diffusion for a light.

 C. A car.

 D. Means, "Okay, Pal, Aim Light."

53. How can you tell a bleached muslin from an unbleached muslin? Page 105

 A. It will be written on the bag.

 B. The rental house is never wrong.

 C. One has more of a yellow tint or coloring to the material (unbleached more yellow).

 D. The rental price is different.

54. What's a floppy 4 x 4? Page 27

 A. 2 ft. x 3 ft. flag.

 B. 4 ft. x 4 ft. net.

 C. 4 ft. x 4 ft. plywood.

 D. 4 ft. x 4 ft. flag with a 4 ft. x 4 ft. piece of extra material attached.

55. How many layers of material is a double net? Page 101

 A. 1

 B. 2

 C. 2 + 2

 D. 5 layers.

56. What happens when too many nets are used together? Page 102

 A. It lets more light in.

 B. Never use in this configuration.

 C. Use only silks.

 D. A moray pattern will show in shadow form.

57. What might you use to make a window pattern shadow show on a wall?

 A. 1 in. x 3 in. lumber.

 B. Empty frame and tape.

 C. An actual window.

 D. Any of the above.

58. What's a wall sconce? Page 213

 A. A donut stuck to a wall.

 B. A floor lamp.

 C. A wall-mounted lamp.

 D. None of the above.

59. What is one way that you might take down a bare lightbulb in a scene? Page 145

 A. Unscrew it.

 B. Remove the entire light fixture.

 C. CTO its light fixture.

 D. Lightly spray dark streaks on it.

60. What's ATG tape used for? Page 137
 A. Attaching gel to frame.
 B. Attaching 1,000 H paper to a window.
 C. Both A and B are correct.
 D. Installing carpet.
61. Why is photo black tape preferred over black masking tape? Page 147
 A. It has a nonreflective matte surface with a
 black gum sticky side.
 B. It is cheaper to use.
 C. You can get it at any store.
 D. None of the above.
62. What is grifflon used for? Page 76
 A. Negative fill.
 B. Bouncing light.
 C. A rain hat.
 D. All of the above.
63. What's a charlie bar used for? Pages 108 & 206
 A. A gobo arm.
 B. A C-stand.
 C. A girly bar.
 D. A wooden stick used to make a thin shadow.
64. What's a lavender used for? Page 101
 A. Cuts light in half.
 B. Going out on Friday nights.
 C. Used as fill light.
 D. Reduces direct light by about 15%.
65. What is a high roller? Page 118
 A. A Las Vegas gambler.
 B. A C-stand.
 C. A large baby pin.
 D. A heavy-duty stand used for heavy objects.
66. What stand might you use over 10 ft. up in heavy wind? Page 120
 A. A C-stand.
 B A blade stand.
 C. A high roller.
 D. A combo stand.
67. What could you use if a turtle stand was not available? Page 115
 A. A skid plate with a junior plate attached.
 B. A C-stand arm.
 C. A sandbag on top of the light.
 D. All of the above.
68. What type of ladder is recommended with electrical work? Page 83
 A. Steel.
 B. Aluminum.
 C. Fiberglass.
 D. PVC.

69. What should be used on a house beam when using a
 bar clamp on it? Page 73
 A. Tissue paper, always.
 B. Christmas wrapping.
 C. Two pieces of cribbing.
 D. One wedge.
70. What are two other names for C-stands? Page 108
 A. Gobo stand.
 B. Century stand.
 C. Blade stand.
 D. A and B are correct.
71. How many gobo arms are there on a C-stand? Page 109
 A. 1
 B. 2
 C. 3
 D. 11
72. What is a speed rail grid? Page 9
 A. A race track.
 B. Pipes hung above a movie set for lighting it.
 C. An electric grid used for high-voltage lighting.
 D. A car on the freeway at a full stop.
73. What's a triple header?
 A. Three ball games in a row.
 B. Three baby pins on a single bar used for lighting.
 C. Three lights on one pin.
 D. Three combo stands.
74. What could I use to make a combo stand into a baby light stand? Page 118
 A. Cut off the legs.
 B. Use a spud adapter.
 C. Build a skid plate.
 D. None of the above.
75. When would a putty knife be used on the set? Page 94
 A. For fixing holes in the walls left by lousy grips.
 B. In knife throwing acts.
 C. To attach a small lamp to the pin on the putty knife,
 pressed or wedged in a crack.
 D. Answers A and B are correct.
76. What is a lollipop? Page 81
 A. A combo stand.
 B. A sucker given to a small child.
 C. A 4 1/2 in. gobo head that fits into a 1 1/8 in. receiver.
 D. Two metal plates held together by a bolt 1 in. by 3/8 in.
 (diameter) by 16 pitch (number of threads).
77. What are five nicknames for a grip clip? Page 78
 A. Pony clamp.
 B. Handy clamp.

 C. Hargrave.

 D. Spring clamp.

 E. A number 1, 2, 3, or 4.

 F. All of the above.

 G. A and C only.

78. What's a lenser? Page 209
 - A. A flag used to shade the lens.
 - B. An eyebrow to shade the lens.
 - C. A handheld flag to shade the lens.
 - D. All of the above.

79. Can a baby plate be used in a high roller? Page 42
 - A. Sometimes.
 - B. Never.
 - C. Yes.
 - D. What's a baby plate?

80. Can a baby offset be used in a high roller? Page 89
 - A. Yes.
 - B. No.
 - C. Only junior offsets are allowed.
 - D. If it is under 2 pounds.

81. What does flashing mean? Page 208
 - A. Exposing the film in a dark room.
 - B. Something a streaker does.
 - C. Taking a flash photo on a set.
 - D. Getting a premonition.

82. What's a menace arm?
 - A. An arm on a clock set to get you up early?
 - B. A sharp stick protruding outward at eye height.
 - C. An arm with a heavy light hung overhead from a stand.
 - D. Belongs to Dennis the Menace.

83. What will ND 3 do for lighting? Page 210
 - A. Add 3 stops of light.
 - B. Reduce 3 stops of light.
 - C. Reduce the light 1 stop.
 - D. Add 1 stop of light.

84. What is a nickname for an apple box? Page 40
 - A. Beach box.
 - B. Human lifter.
 - C. Manmaker.
 - D. Drawers.

85. What are the four to six smaller holes on the base of a
 baby plate used for? Page 42
 - A. Safety holes.
 - B. There is only one hole.
 - C. There are no holes.
 - D. For screws or nails.

86. What is the tapered area on a baby pin used for? Page 42
 A. Allows a light to fit on the pin.
 B. Allows rotation of light without it falling off.
 C. A hand hold.
 D. None of the above.
87. The bar adapter pin can be used on a gobo arm! Page 43
 A. True.
 B. False.
88. Where do you usually use a grip bazooka? Page 45
 A. On studio perms.
 B. On a battlefield.
 C. On snow shoots.
 D. With a camera.
89. What is a platypus clamp? Page 46
 A. A duck clamp.
 B. A C- stand.
 C. A spud adapter.
 D. A bead board holder.
90. What could you use to get rid of glare from a hanging
 picture hung on a wall? Page 49
 A. A cup.
 B. A wedge.
 C. A wad of tape.
 D. All of the above.
91. What are pipe-faced C-clamps used for? Page 51
 A. To crush (smash) into the door or door frame.
 B. On a pipe, pole, or round stock to prevent slippage.
 C. On plywood only.
 D. To hold duvatyne down.
92. What can be used as a camera wedge if none are available? Page 52
 A. A wad of paper.
 B. A bent show card.
 C. C-47 (a clothespin half)
 D. All of the above.
93. What is a good practice when putting tape on a painted
 surface? Page 147
 A. Use duct tape.
 B. Use PVC tape only.
 C. Use ATG tape first.
 D. Use paper tape.
94. What will prevent "popping" (unlocking) of a chain vise grip? Page 54
 A. Putting another grip chain on the handle.
 B. Wrapping tape around both handles.
 C. Using rubber bands.
 D. Super glue.

95. Can a clipboard be used as a flag? Page 55
 A. Never.
 B. If made from flag material.
 C. Yes.
 D. If USMC approved.
96. What "might" happen if black wrap is wrapped too tightly
 around a lamp? Page 139
 A. Nothing.
 B. It is Okay if the lamp is a rental unit.
 C. It might cause the lamp to overheat.
 D. Use plastic visqueen only.
97. What is a cucoloris used for? Page 58
 A. To create a shadow pattern.
 B. To block all light.
 C. To hange light color.
 D. As a breath mint.
98. The closer a cucoloris is to the "light source,"
 what happens to the pattern? Page 59
 A. The shadow will get softer on the object.
 B. It will catch on fire.
 C. The shadow (pattern) will get darker or more
 pronounced on the subject.
 D. Nothing happens.
99. What piece of grip equipment might be used to prevent
 a wheeled object from rolling? Page 135
 A. A cup block.
 B. Sandbags.
 C. Wedges.
 D. Any of the above.
100. What might be another name for dots and fingers? Page 63
 A. Little flags and nets.
 B. Pickles and apple set.
 C. Little gel frames.
 D. Light stoppers.
101. What is a good practice when "skinning" (putting gel on
 a frame) an empty frame? Page 67
 A. Cutting small wind holes in it.
 B. Marking the corner with a marker that describes
 which gel is on the frame.
 C. Using on only Hollywood gels.
 D. Drywall-screwing the gel to the frame through tape
 to prevent the gel from tearing.
102. How can you suspend a lamp or light in an office from a
 false or "drop ceiling"? Page 63
 A. With a baby plate.
 B. With a C-stand arm.

C. By using a drop-ceiling clip

D. With wire #14.

103. What size is the receiver hole on a 45-degree-angle drop down? Page 64

 A. 1 in.

 B. 2 in.

 C. 3 in.

 D. 1 1/8 in. (standard junior/senior size)

104. What is a gobo? Page 68

 A. A tree branch.

 B. A flag.

 C. Any object used to block or reduce light.

 D. All or any of the above.

105. What is another name for a flexarm? Page 71

 A. A knuckle arm.

 B. An articulating arm.

 C. An elbow arm.

 D. Any of the above.

106. What color tape is "usually" used to mark a burnt-out (B.O.) or bad piece of equipment? Pae 146

 A. White.

 B. Black (bad guys usually wear black).

 C. Yellow.

 D. Red (it usually means stop, don't go).

107. Why do we sometimes use cribbing when using a furniture clap? Page 72

 A. It increases the foot size on the pressure plate.

 B. It helps prevent the foot or pressure plate from punching a hole in the surface.

 C. It helps distribute the pressure more evenly over a greater area.

 D. All of the above.

108. What is another name for a grip clip? Page 78

 A. A Hargrave.

 B. A handy clamp.

 C. A spring clamp.

 D. A pony clamp.

 E. Brinks and Cotton.

 F. Any of the above.

109. A number 1 Hargrave grip clip is _____ Page 78

 A. the largest.

 B. the smallest.

 C. the most common.

 D. hardly ever used.

110. What is a pole cat? Page 85

 A. A mean, lowdown, dirty, dog person.

 B. A lightweight, thin-walled tube that adjusts to fit doorways, either vertical or horizontally.

C. A member of the *catus house petus* family.

D. An extremely skinny stage cat, used to rid mice from stages.

111. What is a meat axe? Page 85
 A. Something that cuts through meat.
 B. Something that is used with an apple box.
 C. A long gobo-headed pole with either a C-clamp or a pipe-clamp mounting base that is used on green beds or stages.
 D. A scissor clip.

112. Where can you use a putty knife with a pin? Page 86
 A. On a door frame or window sill.
 B. In a C-stand.
 C. In a parallel screw jack.
 D. There is no such item.

113. What size or type of wrench do you use on the securing bolt of a baby pipe clamp? Page 92
 A. A 1 1/2 in.
 B. A 1/2 in. open-ended wrench.
 C. A water-pipe wrench.
 D. An underwater wrench.

114. What is another name for a grip scrim? Page 100
 A. A net.
 B. An open-ended single, double, or lavender.
 C. A nonelectrical dimmer.
 D. All or any of the above.

115. What is a good practice when a single, open-ended net is asked for? Page 100
 A. Bringing a flag as well.
 B. Bringing the same size in a double net.
 C. Bringing a junior riser.
 D. Tell them you're busy.

116. What does the red edge on a net mean? Page 101
 A. That it's hot.
 B. That it is a double net.
 C. That there is blood on it.
 D. That it is a silk.

117. What will a butterfly/overhead kit usually consist of? Page 102
 A. A single and a solid.
 B. A double and a frame.
 C. A silk and a grifflon (sometimes).
 D. All of the above.

118. What is a flex scrim? Page 105
 A. A smaller version of regular scrims.
 B. A scrim used like fingers and dots.

C. A scrim that is usually 10 in. x 12 in. in size
(sometimes called postage stamps).
D. All of the above.

119. What is a "spud" used for? Page 107
 A. Nothing.
 B. Potato salad.
 C. It converts a 1 1/8 in. hole to a 5/8 in. baby pin.
 D. It punches holes in leather.

120. What is a gobo stand used for? Page 108
 A. Windows.
 B. Exterior use only.
 C. To hold a flag, nets, and other items.
 D. There is no such thing.

121. What size is the center rod on a C-stand? Page 108
 A. 40 in.
 B. 20 in.
 C. 12 in.
 D. 5/8 in.

122. In what direction do we wrap rope and cable? Page 143
 A. Counterclockwise.
 B. Clockwise.
 C. Over and under.
 D. Back and forth.

123. Why do you use a wedge in a C-stand or high roller? Page 113
 A. It puts pressure on the pin.
 B. Use only a small camera wedge.
 C. It prevents the threaded rod from being bent.
 D. It is required.

124. Why do we put tape tabs on a gel before we staple or
push-pin it to a frame? Page 145
 A. Because it makes the gel fireproof.
 B. Because it prevents noise.
 C. Because it covers up old holes.
 D. Because it prevents the gel from tearing.

125. Why do we fly a silk or muslin with the seams up? Page 103
 A. It just "seams" right.
 B. Because the seams might cast a shadow if they're
 on the side closer to the subject.
 C. We don't; we should only use seamless material.
 D. It does not matter either way.

126. Why is it a good practice to raise the first riser only 18 in.
on a high roller? Page 120
 A. Because it is only 18 in. long.
 B. Because it helps prevent bending the thin hollow tube.

 C. It will only rise 8 in.

 D. It doesn't matter; it's a rental.

127. How long is a junior riser usually? Page 122

 A. 3.6 in.

 B. 3.6 ft.

 C. 36 ft.

 D. 36 in.

128. What is one major difference between a baby and a junior trombone? Page 129

 A. The way it is nailed to a wall.

 B. The tennis ball.

 C. The receivers are different; one is a pin and the other is a junior receiver.

 D. None of the above.

129. Why do we elevate electrical connectors in the rain? Page 41

 A. It prevents them from getting wet in the rain, if water puddles around the connections.

 B. They must be lifted 18 in.

 C. Only a quick locks.

 D. To reduce electricity flow.

130. What is a legal milk crate?

 A. A crate that you found.

 B. A crate that you bought—it's not stolen.

 C. A crate that has proper I.D. numbers.

 D. A crate from which you have removed all of its former markings.

131. What is the lead side of a reflector used for? Page 95

 A. To weigh the board down.

 B. To reflect hard light.

 C. To give the light a cookie effect.

 D. To block light.

132. Can a reflector slip-on scrim be used on the soft side of a reflector? Page 97

 A. No, it will remove loose leaf off the soft side.

 B. Yes, it will stop the loose leaf from blowing off.

 C. Only if you staple it on.

 D. Yes, if you own a reflector-recovering company.

133. What's a stove pipe wire? Page 145

 A. Something that cleans your pipe.

 B. A 7-19 flexible wire.

 C. The wire used on stoves.

 D. A multipurpose bailing or black flexible wire.

134. What knot is considered the dead hang knot? Page 148

 A. The clove hitch.

 B. The half hitch.

C. The bowline.

D. The safety knot

135. What knot is considered a safety knot after you have tied a
clove hitch knot? Page 148

 A. The half hitch.

 B. The clove hitch.

 C. The bow knot.

 D. The bowline knot.

136. What does plus green do? Page 172

 A. Adds yellow to red and blue.

 B. Converts daylight (5,600K) to match fluorescent light.

 C. Adds black and blue.

 D. None of the above.

137. What does minus green do? Page 172

 A. Converts cool white fluorescent to normal daylight.

 B. Nothing.

 C. Something.

 D. None of the above.

138. What does Rosco Scrim do? Page 174

 A. Reduces light by 1 stop.

 B. Adds light by 2 stops.

 C. Reduces the light intensity by 2 stops with no effect
on the Kelvin temperature.

 D. Reduces glare.

139. What does a full CTO do? Page 175

 A. Converts 5,600 Kelvin to 3,200 Kelvin.

 B. Turns light blue.

 C. Turns light pink.

 D. It changes nothing.

140. What does a full CTB do? Page 174

 A. Converts 3,200 Kelvin to 5,600 Kelvin.

 B. Converts C-stands to combos.

 C. Changes the direction of the light.

 D. Adds 2 stops of light.

141. What does ND6 do? Page 174

 A. It stands for neutral density Item 6.

 B. It reduces the intensity of light by 2 stops.

 C. It adds 1 stop to light.

 D. It converts blue light to white light.

142. What is a cutter used for? Page 68

 A. Carving beef.

 B. None of these answers is correct.

 C. It is used as a gobo.

 D. It is a whisky drink.

Grip Test Answer Sheet

1.	B	40.	A	79.	D	118.	D
2.	D	41.	A	80.	C	119.	C
3.	C	42.	D	81.	A	120.	C
4.	B	43.	A	82.	C	121.	D
5.	A	44.	B	83.	C	122.	B
6.	B	45.	B	84.	C	123.	C
7.	B	46.	C	85.	D	124.	D
8.	B	47.	D	86.	B	125.	B
9.	C	48.	A	87.	A	126.	B
10.	C	49.	B	88.	A	127.	D
11.	D	50.	B	89.	D	128.	C
12.	C	51.	A	90.	D	129.	A
13.	B	52.	B	91.	B	130.	B
14.	C	53.	C	92.	D	131.	B
15.	C	54.	D	93.	D	132.	A
16.	D	55.	B	94.	B	133.	D
17.	A	56.	D	95.	C	134.	C
18.	C	57.	D	96.	C	135.	A
19.	D	58.	C	97.	A	136.	B
20.	C	59.	D	98.	A	137.	A
21.	D	60.	C	99.	D	138.	C
22.	B	61.	A	100.	A	139.	A
23.	D	62.	D	101.	B	140.	A
24.	D	63.	D	102.	C	141.	B
25.	D	64.	C	103.	D	142.	C
26.	B	65.	D	104.	D		
27.	B	66.	D	105.	D		
28.	C	67.	C	106.	A		
29.	D	68.	A	107.	D		
30.	B	69.	C	108.	F		
31.	A	70.	C	109.	B		
32.	B	71.	D	110.	B		
33.	D	72.	A	111.	C		
34.	A	73.	B	112.	A		
35.	C	74.	B	113.	B		
36.	D	75.	B	114.	D		
37.	B	76.	C	115.	B		
38.	B	77.	C	116.	B		
39.	A	78.	F	117.	D		

Quick Reference Conversion Charts

Fluid

U.S.	METRIC
1 fluid oz.	30 ml
2 fluid oz.	60 ml
2.5 fluid oz.	80 ml
8 fluid oz.	240 ml
1 pint	475 ml
1 quart	946 ml
4 quarts, or 1 gallon	3,784 ml, or 1.9 liters

Weights

U.S.	METRIC
1 oz.	28 grams
2 oz.	57 grams
3 oz.	85 grams
4 oz.	113 grams
5 oz.	142 grams
6 oz.	170 grams
7 oz.	198 grams
8 oz.	227 grams
8.8 oz.	250 grams, or 1/4 kilogram
16 oz., or 1 pound	454 grams
35.3 oz.	1,000 grams, or 1 kilogram
71 oz.	2,013 grams, or 2 kilograms

Length

U.S.	METRIC
1/16 in.	2 mm
1/8 in.	3 mm
3/16 in.	5 mm
¼ in.	6 mm
3/8 in.	9 mm
½ in.	13 mm
¾ in.	1.9 cm

1 in.	2.5 cm
1.5 in.	4 cm
2 in.	5 cm
12 in., or 1 foot	30.5 cm
36 in., or 1 yard	91.4 cm
39.37 in.	100 cm, or 1 meter

Temperature

FAHRENHEIT	CELSIUS
0	−18
+ 2	−17
4	−15.5
6	−14
8	−13
10	−12
12	−11
14	−10
30	−1
32	0
40	+4
50	+10
60	+15.5
70	+21
80	+27
90	+32
100	+38
110	+43
120	+49
130	+54

Mike Uva's Suggested Books

The following books are those I think every grip should have on hand:

Carter, Paul and George Chiang. *The Backstage Handbook: An Illustrated Almanac of Technical Information*, 3rd ed. Broadway Press, 1994.

Cassidy, John. *The Klutz Book of Knots: How to Tie the World's 25 Most Useful Hitches, Ties, Wraps, and Knots*. Klutz, Inc., 1985.

Gibson, Charles E. *Handbook of Knots and Splices and Other Work with Hemp*.

Glover, Thomas. *Pocket Ref*. Sequoia Publishing, 1997.

Hughart, Jill, Brooke Karsnitz, and Anne Boyd. *LA 411*. LA 411 Publishing Company, 2001.

Malkiewicz, Kris, Leonard Konopelski, and Barbara J. Gryboski. *Film Lighting: Talks with Hollywood's Cinematographers and Gaffers*. Simon & Schuster, 1992.

Taub, Eric. *Gaffers, Grips, and Best Boys*. St. Martin's Press, 1995.

Glossary

Terms Used Daily

I have here listed some terms or words that you might hear daily in the course of your stay in the film and television business. A few of these terms may be exclusive to the grip department. But for the sake of giving you an overall flavor of a working set, I felt you should also be aware of some other general words that are used almost daily. For example, you're a grip who is asked to work the "sticks" for the camera department. Or the AD yells, "Tail Slate!" Or you may hear something like, "Hey Sue, grab a Gary Coleman, with a postage stamp, and put an ear on the third zip light." Or, "Lamp right next to the egg crate, then drop some beach on that hog trough before they pull the buck." Without this Glossary you'd be asking yourself, "Say *what?*" But read on and you'll know what's going on.

ABBY SINGER The shot before the last shot. A nickname given due to an Assistant Director who would always yell, "Last Shot," but it never was. The very next shot was in fact the last shot.

AGE This term is used to refer to the process of making a new object, say a mailbox, look older; giving something a used look, such as old clothes, a sign, and so on.

AMBIANCE Sound recorded in the area in which filming was done. This "quiet" sound that is recorded is added to set the mood of a scene.

B-TEAM The stand ins used for blocking and lighting a scene.

BABY A 1,000-watt lamp.

BACK TO ONE Go to your start position.

BACKING A scenic piece behind a set window or open door; also called a *drop*. A photographed or painted canvas background used on movie or video sets and seen outside windows or doors.

BAIL The U-shaped metal arm that a movie lamp sits on. The bottom of the U has either a male pin or female receiver for attachment to a stand or hanger device.

BASE CAMP The place where all the production vehicles are located; sort of like a mobile headquarters.

BASTARD SIDE A term used for *stage right*.

BATTENS A sandwich configuration attached along the top length of a cloth drop or *backing* using two pieces of wood (1 in. x 3 in. or 2 in. x 4 in.) to let it hang (or be flown) from the *green beds*.

BEACH Slang for a sandbag.

BEAVER BOARD Usually a 1/8th apple box with a baby plate nailed onto it, for placing a lamp at low angles; also called a *skid plate*.

BECKY A fixed-length mount bracket shaped much like a trombone. The wall attachment has feet that are the only things on this bracket that adjust, and the receiver is a fixed height (about a foot down using the bottom pin).

BELLY LINES Ropes strung (usually about 10 ft. apart) under the large silk, grifflon, or black under flyaway kits.

BLACKS Drapes used to hide or mask areas not to be shown on film or stage.

BLOCK AND FALL A rope and pulley system that allows you to lift a heavy object with less pulling force.

BLOCKING A rehearsal for actors' places and camera movements.

BOGGIE WHEELS Wheels that do not usually come standard with a dolly. They are used to adapt a dolly to a specialty track, such as a pipe dolly, sled dolly, or tube track. There are several types or sets of boggie wheels.

BOOTIES Surgical-style paper shoes that are put on over your street shoes before walking on a dry painted surface; prevents a mar or a scuff.

BOSS PLATE A metal plate attached to the stage floor of a set to hold a set wall or scenery in place.

BOTTOMER Flags off or blocks unwanted light from the bottom of a light source. Also called a *bottom shelf.*

BOUNCE Light that has been redirected before it hits the subject. It is shone on foamcore or a show card or any surface that then redirects (bounces) it onto the subject. (See *fill light.*)

BRANCH-A-LORIS When a limb or branch from a tree is placed in front of a light to cause a pattern.

BROWNIE A nickname for the camera.

BRUTE A carbon arc lamp that runs on 225 amps.

BUCK A car that has been cut in half or had the roof cut off for filming the inside of the vehicle, such as showing a center console or dashboard.

BULL PEN A slang word used for the area where all the grip equipment is staged (set up); also called the *staging area.* The place is usually as close to the set as possible and ready to work.

BUTTERFLY KIT Assorted nets, silks, solids, and grifflons used for light control, that usually come in 5 ft. x 5 ft. or 6 ft. x 6 ft. frame sizes. Commonly, a 12 ft. x 12 ft. or 20 ft. x 20 ft. set is also called a butterfly kit, but it should be called an overhead kit. The term *butterfly* now generally means a kit containing (1) single, (1) double, (1) silk, (1) solid, (1) frame, and (1) grifflon.

CAMERA LEFT A direction to the left of what the camera sees.

CAMERA RIGHT A direction to the right of what the camera sees.

CANS Headsets used to hear what is being recorded for the film.

CEILING PIECE A frame built from flat 1 in. by 3 in. lumber with lumber gussets covered on one side with muslin cloth (usually seamless).

CELO A cucoloris made of wire mesh material used to give a pattern of bright and dark spots when used in front of a light.

CHARLIE BAR A 1 in. to 6 in. wide by 3 ft. long strip of wood with an attached pin that is used to create shadows on an object (also called *thin* or *long flags*, or *gobos*).

CHEATED The process of avoiding an object for a better shot, or moving it from the camera's view.

CHECKING THE GATE The process of checking the pressure plate in the camera that holds the film in place for any film chips, dirt, or debris. This is accomplished after each scene.

CHERRY-PICKER Also called a *condor* (see below).

CHROMATRANS Usually a picture of city landscapes, but also pictures of the country, airports, and so forth. It looks like a giant photographic slide that is lit from the back. They come in all sizes from small to 30 ft. x 100 ft. or larger. There are daytime and nighttime chromatrans, which are also called *translights*. They are usually transported rolled up in a large cardboard tube and hung from grommets.

CLAPPER/LOADER Another name for a *camera assistant*.

CLEAR LUMBER Lumber without any knots in it; normally used for dolly track

CLEAT A point to tie off a rope, usually an X-shaped or a cross-shaped piece of wood nailed to a stage floor.

CLOTHESLINE A rope or cable strung about neck height (as in the old clothesline days). Always hang some tape from it, making it visible so that no one will get hurt.

COLOR TEMPERATURE The warmth or coolness of a light that is measured in degrees Kelvin. 5,600K is considered daylight (blue) and 3,200K is a tungsten (or white light)

COME-A-LONG A hand-cranked cable that can pull heavy objects closer together; functions like a wrenching block and fall.

CONDOR A machine with a telescoping arm on it that also booms up, down, left, or right. Used a lot for lighting platforms. Also called a *cherry-picker.*

COURTESY FLAG A flag set for the director, DP, talent, agency, or anyone who needs shading.

COVE A tent for a window or doorway to make it night during the day.

CRAFT SERVICES A table of food and sweets set out for the entire film cast and crew.

CROSSING What is spoken or yelled out by someone crossing in front of a lens if there is not any filming going on, but the cameraperson is looking through the eyepiece. A courtesy to the cameraperson.

CUT Setting a flag in front of a light to cut or remove the light from an object. A *hard* or *sharp cut* means making a hard shadow close to the object; a *soft cut* means holding the flag or scrim closer to the light source.

CYC-STRIPS A single lamp or several lamps placed in one housing fixture.

DP Director of photography.

DAILIES Film shot the day before that is shown to the director, cameraperson, and crew. A review of that day's work to ensure that no reshoots are needed. Sometimes called *rushes*.

DAPPLE Shadows made as if by a branch with leaves on it.

DEAL MEMO A written paper describing what money you have accepted for your service.

DECK POLE A pointed stick about 4½ ft. long that sticks through holes along the green beds and to which an arm and flag can be attached.

DINGO A small *branch-a-loris*.

DOWN STAGE Closer to the camera or audience.

DUTCH ANGLE Camera angle created by leaning the camera sideways either left or right for filming in that position.

E-Z-UP A pop-up style tent that will usually come in an 8 ft. x 8 ft. or a 10 ft. x 10 ft. size used for overhead shade. (There are also larger and smaller sizes available.)

EAR A flag that is put up on the side of a light to block light. Also called a *sider.*

EARS ON This instruction means turn your handheld walkie-talkie on.

EASY-OUT A tool that looks like a reverse drill, which is used to get out broken bolts. To use, drill the broken bolt with a small bit, then put easy-out in the drill hole and twist out the broken bolt.

EGG CRATE A soft light-control frame that directs light so that it does not spill off the subject. Looks like a rectangle box with several dividers spaced evenly in it, hence the name.

EYE LIGHT A light that gives the eyes of the subject a sparkle (also called an *obie light*).

F-STOP A measurement of a camera lens aperture. Lens are rated by speed, which determines how much light they can gather. A lens that can film with a minimum of F/1.4 is considered faster than a lens that films with a minimum of F/8. For example, F/1.4 means that less light is needed for a correct exposure, and F/8 means that more light is need for a correct exposure.

FEATHER A process in which a flag is set in front of a light source, and as you move it closer to or further from the light source, the flag will feather, soften, or harden the shadow on the surface of an object.

FERNELL The glass lens in front of a movie lamp used to spread or focus the light.

FILL LIGHT Light added to the opposite side of a subject to "fill in" the shadows made from the key light (main light on subject).

FIRST TEAM The talent; the heroes (see *hero*); the actors who will be filmed. Also known as the *"A" Team*.

FLARE A distracting light or distorting glare formed on the film when an unwanted light shines into the camera lens.

FLASHING What is called out before someone takes a flash photo. This lets the gaffer know that one of his or her lights has not burned out.

FLOAT A FLAG To hand-hold a flag as the camera is moved; to float with the camera, blocking unwanted light flares. *Floater* also refers to a handheld flag or net that will move with a actor during a take.

FLOOD A light that spreads illumination widely over all the subject.

FLY IT OUT Instruction to pull something out of the scene.

FLYING IN Fetching a requested object in an extremely quick manner.

FLYING THE MOON A light source that is flown over an exterior location by a cable on a crane. To create the light, a bunch of lights are hung on pipes installed into a box frame, then a muslin (rag) cover is wrapped around it.

FRAME LINE The very edges (top, bottom, and sides) of what the camera will see.

FREEBIE PSA A public service announcement; a film project for which the crew usually receives no pay. (It's a way to give something back to the industry for being so good to you.)

FULLERS EARTH Used to make blowing dust in the background or to dust down or age a person or object.

GAFFER The head electrician.

GAFFER'S TAPE Duct-tape-style tape; also called *grip tape* or *cloth tape*.

GARY COLEMAN A short C-stand, about 20 in. high.

GEL A transparent cellophane material used for changing the color of a light, either for visual effect or for film exposure correction.

GHOST LIGHT A single large lightbulb mounted on its own wooden stand that is usually left on a stage that's not being used. It is said that it keeps friendly spirits illuminated and the evil spirits away; it also helps people see the set objects lying on an unlit stage.

GOBO HEAD Used as a clamping device for holding equipment. Also called a *grip head* or C-stand head.

GRAZE Going to the craft service food table.

GREEK IT OUT To disguise a word to make a logo unrecognizable. For example, "Coca Cola" might become "Ooko AA Cola."

GRIP HEAD A C-stand head, also called a *gobo head*, that is used as a clamping device.

GRIP RADIO TALK "10-100" means "going to the restroom"; "10-4" means "I understand"; and "what's your 20?" means "where are you?"

GRIP TAPE Duct-tape-style tape; also called *gaffer's tape* or *cloth tape.*

HAIR IN THE GATE When a piece of debris or a film chip is lodged in the corner of the pressure plate gate. Also means that as insurance against that chip or debris that may have scratched the film emulsion, the last shot must be reshot.

HAND SHOES Leather gloves.

HARDMARKS Permanent objects or tape marks placed by the camera assistant.

HEADACHE When you hear this it means "Duck!" — something has fallen from overhead.

HEMP Usually rope from ¼ to 1 in. thick.

HERO The product of a commercial, such as a perfectly prepared hamburger, a toy, or a color-corrected label of a product. Whatever it is, it is perfect (why it is called a hero) for the shot and for filming a commercial.

HIGHLIGHT Used to brighten an area of an object, or to emphasize an interesting part with light.

HISTORY An instruction or comment that means remove it from the set; lose it; it's only a memory; it's gone; it's vapor.

HMI (Halogen Mercury Incandescent) A hydragyrum medium-arc lodid lamp that usually burns at 5,600 degrees Kelvin (also known as *blue light*).

HODS A three-sided bounce usually made from bead board (polystyrene) used to carry mortar or plaster; it is about 18 in. long x 12 in. wide, with a 12 in. x 12 in. cap on one end.

HOG TROUGH An L-shaped or V-shaped brace made by nailing, screwing, or gluing two sticks of 1 in by 3 in. lumber, a process that strengthens an otherwise flimsy piece of lumber by giving it a backbone.

HOT SET This means don't move anything; there's more filming to be done.

IDIOT CHECK Sending a grip out to search the set for any equipment that may be left behind after you have finished the shoot and before leaving the location.

INCANDESCENT LAMP A lamp with a 3,200 degree Kelvin temperature (also called *white light*).

JUICER An electrician; also, electrical sparks.

JUNIOR A 2,000-watt lamp.

KICK A sparkle off an object or person; it may be desired, or it may need to be removed. This term can also be used when an object has shine on it, or when a shine is to be redirected onto it from another object, as in the case of a reflection.

KILL THE BABY This instruction means turn off the one-kilowatt lamp.

KNEE CAPS When you hear this it means heads up, equipment coming through.

KODAK MOMENT A chance to take a picture with the talent (actors and actresses); same as a *photo op.*

LACE-OUT To lay out equipment so it can be easily counted, such as on a prep or wrap day on a stage, or returning from a show.

LANYARD A cord on tools for working high in overhead perms. In case you drop a tool, it will not fall to the deck.

LEAK A small amount of light that has gotten past the flag or gobo.

LEGAL MILK CRATE A crate not stolen from a store but rented or bought outright.

LENSER Something used to shade the camera lens, such as a flag, a camera-attached shade called an eyebrow, or even a handheld flag.

LEXAN Plastic sheet material that comes in a 4 ft. by 8 ft. sheet in many different thicknesses (1/8 in., ¼ in., ½ in., 1 in., etc.) for bulletproofing—well, not really, but it is

used to protect the camera and personnel from explosions. It is optically clear and highly recommended.

LIMBO TABLE A table with a 90-degree sweep that is usually used for product shots. The back part stands straight up, then curves 90 degrees to form a table on which the product is placed.

LINE OUT This is called out from overhead when a rope or line is let out.

LOSE IT This means remove it from the set, or from the surrounding area; it's no longer needed.

LUAN A plywood-like material that starts at about 1/8 in. thick and is used to make set walls. It can be a three-ply timber that is still lightweight, paintable, and stainable. It is sometimes called *Philippine Mahogany.*

MAKE IT LIVE Set the object in place.

MARTINI SHOT The last film shot of the day. Slang for the next shot will be "in a glass," or the wrap shot.

MICHAEL JACKSON Alluding to Jackson's song "Beat It," this means get out of the way.

MICKEY MOLE A 1,000-watt lamp.

MICKEY ROONEY A nickname for a small creeping motion of the dolly; a slight, little, slow movement.

MIGHTY MOLE A 2,000-watt lamp.

MOLELIPSO A 1,000-watt to 2,000-watt lamp used mainly for performances; the spotlight.

MOS Stands for "mitt out sound" and means not a sound take or recording.

MOUSE The shadow of the microphone.

MULLIONS The boards that hold each pane of glass and give a French-window effect.

ND A neutral-density filter in a soft-rolled gel that also comes in large plastic sheets as well as small sheets. These are used to reduce the brightness of a lamp or light source, like sunglasses.

NECK DOWN A slang term that means you have been hired from the neck down. In other words, don't think, just do.

NEGATIVE FILL A black surface used to remove unwanted light close to the actor.

NET The scrims (nonelectrical dimmers) used to reduce the light on an object in small amounts.

NEW DEAL This scene is over, and we are starting on a new setup.

NG This stands for "No Good."

NODAL POINT The dead center of the camera lens if the camera were to rotate in a 360-degree twisting motion.

NOOK LITE A light with 650-watts to 2,000-watts, on average.

OBIE LIGHT A small light placed just on top of the camera to add a sparkle to the talent's eyes, or used as a fill light.

ON STAGE Instruction meaning to move toward the center of the set or stage.

ONE-LINER A breakdown of the script that will inform the crew about what scenes will be shot that day. It will have the scene number and a bit of the story line or action that will occur.

OPERATOR The camera operator; can also be the director of photography, but does not have to be. The camera operator and the director of photography are usually two different people on a movie.

OVERCRANKING Process that speeds up the frame rate of film through the camera. When the film is processed and projected at normal speed (24 Frames Per Second, or FPS), the action then appears to be in slow motion.

OVERHEAD KIT A kit of light-control items in a set of 12 ft. x 12 ft. or 20 ft. x 20 ft. frames of (1) single, (1) double, (1) silk, (1) solid, (1) frame, and (1) grifflon. Commonly referred to as a butterfly kit, although overhead kit is more descriptive.

OZONE The open area between the wood beams that make up the perms. This is the area over which we will throw ropes to rig either lights or green beds, or to set wall tie-offs and other elements.

P-TON A sharp flat peg with a ring welded to it for a rope to tie off to. It can be hammered into small cracks in cement or asphalt without much damage.

PAN A camera move that rotates the camera left or right.

PARABOLIC REFLECTOR The part of the lamp behind the glove (lightbulb) that is used to gather and reflect the light onto a subject.

PHIL-LOPPY A 4 ft. x 4 ft. floppy-type flag made of a white-out bounce material; excellent for bounce or fill (contributed by Phil Sloan, Local 80 Key Grip).

PHOTO FLOOD GLOBES Normal-looking lightbulbs that give off a brighter light. (They have a very short useful life.)

PHOTO OP A chance to take a picture with someone you would like to be seen with, such as an actor or actress.

PIPE GRID A series of pipes, most often connected together for strength and rigidity, that is usually hung by chain above a movie set.

PLAYBACK The video recording of a scene just shot.

POOR MAN'S PROCESS Filming a stationary vehicle by passing a light, shadow, or background object on the camera viewing side being photographed; gives the impression that the vehicle is in motion. A slight shaking or a lever under the frame of the car that gives it a small jolt every so often also works well.

POV Point of view; the perspective from which a person or character in a film sees.

PRACTICAL A light fixture in the film frame such as a table, floor, or wall lamp.

PREP To prepare for a job; for example, checking out the equipment or camera to ensure that they are in good working order for the job that you are going to begin.

RAGS The following materials are referred to as rags because they do not usually have a permanent frame affixed to them: muslin (bleached or unbleached), nets (single or double), silks, solids, or grifflons.

REEFING The proper way to fold a large rag (e.g., a grifflon, black, or any material that requires folding).

ROPE WRENCH A knife to cut the rope.

SAIL BOATS Long adjustable poles, raised like a mast on a sailboat, that are welded to a very heavy base on wheels; used to hoist or fly a backing or translight, making it mobile.

SCAB PATCH A patch laid over a hole like a Band-Aid. For example, a 2 in. x 4 in. x 16 ft. piece of lumber laid end to end to total 32 ft. long, then a third 2 in. x 4 in. x 16 ft. piece of lumber is laid equally on both ends and nailed together. Both examples are called scabbing. A *sandwich* is the same as a scab patch except that it's nailed on two sides with two pieces of scab lumber.

SCENE DOCK A storage place for several wall flats. You can also "temporarily" store a removed wall on set next to a working wall with hog troughs or set braces; this is also called scene docking.

SCOUT To go to different places or locations to check out an area.

SCRIMS Scrims are used to reduce light. Scrims are made not only from net material but also from wire mesh that fits right in front of a light.

SEAMLESS PAPER A wide roll of paper used for a background, such as what is often used in a portrait shot.

SET CONSCIOUSNESS Be very aware of where your equipment is on set. This awareness will make or break you; if you are not aware of where your equipment is when called for, you can look pretty bad.

SET DECORATOR The person who will decorate the set with the right objects for the story line. This will make a scene look real to the viewing audience.

SHEAVE The wheel in the pulley that allows the rope or wire to ride smoothly.

SIDER A flag that is put up on the side of a light to block light; also called an *ear.*

SKID PLATE A 1/8th apple box with a baby plate on it, used for setting lamps at low angles. Also called a *beaver board.*

SLEEPER TRACK A framing track to reinforce the foundation under the dolly or crane track. Usually made of 4 ft. by 8 ft. frames of straight kiln-dried lumber (no warping).

SLOW IT DOWN Take it down; knock it down. These all mean to "reduce" something; usually refers to bringing down the intensity of a light.

SNOOT A device shaped like a funnel or coffee can hooked on the front of a lamp to focus the light on one area.

SOFFIT The outcropping of a set wall, also called a header, where a movie light can be set.

SOFT A gentle pleasing light.

SOFTLIGHT A light with a range from 650 watts to 4,000 watts, on an average; also known as a *zip light.*

SOLDIER-UP This means to set up more stands in rows ready for action.

SPAN SET A loop of extremely strong material wrapped around a frame or beam that is going to be hoisted up by a winch or crane; comes in 1 ft. to 20 ft. loops, but can come larger upon request.

SPARK The electrician, or the juicer.

SPEED What the cameraperson and the sound person may call out when they have their equipment running at the desired speed or operating RPM for filming.

SPILL Setting a light or using natural sunlight in such a way that the light is directed onto an object allowing the light to spill or leak off onto something else.

SPOT To direct all light to one point on the subject.

SQUEEZER An electrical dimmer.

SQUIB A small explosive device (which can be activated accidentally by pressing the talk button on your walkie-talkie). Used to make a bullet hole or wound during a scene. Used by the special effects crew.

STEVE-A-DOOR A hand truck.

STORYBOARDS Cartoon-like strip drawings used as a representation for the shoot and indicating the camera angles or framing.

TABLE IT To lay something flat or parallel to the ground, such as a reflector or 12 ft. x 12 ft. butterfly frame.

TAG LINES Ropes (usually ¼ in. hemp) that are tied to a lamp hanger (trapeze) and used to pan or tie off a lamp. They are also used to tie off rags on frames.

TAIL SLATE To hit the camera sticks after the scene has been shot. The slate is turned upside down, with the wording facing the lens. Then the hinged sticks (also known as the *tail sticks*) are slapped together.

TAKE A scene that is shot.

TAKE DOWN To reduce the light on an object by use of nets, scrims, dimmers, or wasting or spilling some of the light.

TALENT A term used for the actors.

TEASER A piece of equipment used to cut light, like a flag.

TILT To move the camera up and down in a tilting motion.

TOE NAIL To put either a nail or a screw at the very edge of an object to secure it temporarily in place.

TOPPER A flag or net used to flag off or block unwanted light from the top of a light source. Also called a *top shelf.*

TRACK SYSTEM An overhead track used to hang backings that can be easily moved, changed, and replaced.

TRUSS A triangular metal structure used to span a large area. Sometimes called a *rock and roll truss* for hanging lights.

TURN ON TWO BUBBLES Turn on two lights in the same lamp.

TWEENIE A 650-watt lamp.

UP STAGE Instruction meaning move toward the back of the set or stage. Comes from older stages that were built with a higher or raked upwards incline toward the rear or back wall and away from the audience.

WAFF To lightly fan, smoke, or move a curtain sheet to create the effect of a breeze.

WALL BRACE A metal rod flattened on each end with holes drilled through it that is used to attach a set wall to a wood slatted floor. A hog trough can also be used (see *hog trough*).

WALL FLAT A scenic, covered wall usually made from 1 in. by 3 in. covered in thin plywood-type material, called *luan.*

WALL JACK A two-wheeled brace or jack used to transport a large set wall.

WALL SCONCE A lamp hung on a wall; a practical fixture.

WARNER BROTHERS A term used for an extreme close-up of a person; it means to crop a little off the top of an actor's head with either a shadow or the lens itself. A nickname due to the style of photography years ago.

WASTE Process to reduce light on a subject. You shine all the light on the subject, then slowly turn the light so that some of the light will miss or fall off the subject.

WATCH YOUR BACK Although this is pretty much impossible, it usually means that someone with equipment is coming from behind you to pass and get the equipment to or from the set.

WHIP-PAN A fast pan of the camera causing a blur in the motion.

WIG-WAG The red flashing light outside of a stage indicating that filming is going on.

WILD CEILING or WILD WALLS Walls that are made to move separately from each other to allow filming from different perspectives within a set room.

WING To set an object such as a flag in front of a light, then moving it further away or closer in a semicircular motion.

WIPE An image that moves across the frame during filming and is used to hide a cut during editing.

WRAP To put away all the equipment or quit for the night. To go home.

ZIP CORD A lightweight electrical cord that looks like an extension cord. It comes in different gauges and is usually black, white, or brown in color, but it can be ordered in other colors as well.

Index